DEVIL ON THE STAIRS

Exhibition Tour

Institute of Contemporary Art

Philadelphia, Pennsylvania

October 4, 1991–January 5, 1992

Newport Harbor Art Museum

Newport Beach, California

April 16–June 21, 1992

This publication was prepared on the occasion of the exhibition "The Devil on the Stairs: Looking Back on the Eighties," organized by the Institute of Contemporary Art, University of Pennsylvania.

The exhibition and its accompanying catalogue have been made possible by the generous support of the National Endowment for the Arts; the Pennsylvania Council on the Arts; the Institute of Museum Services, a federal agency; and the friends and members of the Institute of Contemporary Art.

Library of Congress Catalogue Card No. 91-76000

Design: Keith Ragone

Editing: Gerald Zeigerman

Typography: AdamsGraphics, Inc.

Printing: The Winchell Company

Photographic credits

Unless otherwise noted, photographs were provided by the lenders. Exceptions or special credits are as follows (numbers refer to pages):

Peter Bellamy, 42 (top); Geoffrey Clements, 31; D. James Dee, 36 (bottom), 49, 55 (bottom), and 56; Susan Einstein, 54; Lee Fatherree, 52; Bill Jacobson Studio, 37; Philippe Migeat, 60; Phillips/Schwab, 33 (bottom); David Reynolds, 43 (top); F. Scruton, 59 (bottom); Jim Strong, 35 (top); Ellen Page Wilson, 50; Zindman/Fremont, 35 (middle) and 46.

DEVIL ON THE STAIRS

LOOKING BACK ON THE EIGHTIES

BY ROBERT STORR
in collaboration with Judith Tannenbaum

INSTITUTE OF CONTEMPORARY ART

UNIVERSITY OF PENNSYLVANIA

CONTENTS

FOREWORD

We are still attempting to compose adequate questions with which to address the eighties—that strangely convenient time byte so laden with significance that it demands scrutiny and verification as to its meaning. This is the third exhibition in this country to explore the decade: "Culture and Commentary—A Perspective on the Eighties," at the Hirshhorn Museum, was the first; "The Decade Show—Frameworks of Identity in the 1980's," at the Studio Museum in Harlem, the Museum of Contemporary Hispanic Art, and the New Museum of Contemporary Art, was the second; and now, "The Devil on the Stairs: Looking Back on the Eighties." Our title is taken from the French phrase *l'esprit de l'escalier*—that remark that comes to one when the opportunity to make it has been lost.

The problem with the eighties, to paraphrase Brendan Behan, is that there was too much of it. The panoptic view it requires is difficult at such close range—less a matter of temporal distance, more of associative implication. We are all absorbed by the decade—its art, theories, politics, events. Aroused by the spectacle, impotent in our suspicions, we were enthralled as the pace moved from fast to frenzied. We were mesmerized by this informational supernova, and gaze still upon its diminishing light, trying to name our sense of loss and assess where the significance of art lay amid it all.

To examine that reverie, we have invited two individuals who, because of the duality of their practice, oscillated between the outside and inside of the art world during this period: a painter-curator and a critic-poet.

As a curator, Robert Storr believes in the primacy of the art object, a polemical position to postmodernism. Within this exhibition, his vision of fracturing style and category into an almost cubistic proposition is predicated on emphasizing the myriad subtleties and correspondences that crackle among the artworks, offering the viewer a complexity and a sophistication of response. His accompanying text, he declares, is not art criticism; rather, it is a commentary on categorization and criticism, unconfining and expansionist. We are indebted to him for sharing his perspective with us.

Peter Schjeldahl's literary contribution eschews his role of shoot-from-the-hip eighties art critic. Here is the voice of a poet, a middle-aged white plainsman coming to terms with art, New York, and himself. We are grateful for his eloquence and probity.

Judith Tannenbaum, ICA's associate director, has worked closely with Robert Storr on this exhibition, playing devil's advocate to his devil. Having overseen all of the logistical arrangements for the exhibition's loans, she also was responsible for the production of the catalogue. We applaud her wisdom and dedication. Ably sharing in these tasks were Melissa Feldman, associate curator, and Jane Carroll, registrar. Their commitment and professional expertise were essential to the realization of the project, and their efforts are deeply appreciated. The entire ICA staff, in fact, must be commended for its strong commitment to this exhibition. Each and every one deserves special praise.

In the spring of 1992, this exhibition will be presented at the Newport Harbor Art Museum. I wish to acknowledge the enthusiasm and cooperation of its director, Michael Botwinik, and his colleague Ellen Breitman. Moreover, the presentation at each venue could not take place without the extraordinary generosity of the numerous lenders. We are also grateful to our professional colleagues, of whom there are too many to name, for their gracious assistance in every aspect of the organization of this exhibition.

"The Devil on the Stairs: Looking Back on the Eighties" and its accompanying catalogue have been made possible by the generous support of the National Endowment for the Arts; the Pennsylvania Council on the Arts; the Institute of Museum Services; and the board, friends, and members of the Institute of Contemporary Art. We are indebted to them for their continued commitment.

Patrick T. Murphy
Director

This exhibition differs in approach and structure from others that attempt to come to terms with, or revise our understanding of, a particular period of art activity. The radicalism of Robert Storr's working method lies simply in his acceptance of pluralism as a fact of both art and life and in his ability to see how certain issues overlap and interconnect, instead of separating and isolating them. By grouping artworks in thematic clusters, this exhibition cuts through the categories or isms with which the artists represented have been identified previously. Works created by individuals who belong to different generations, live in different countries, work in different media, and have different aesthetic and ideological affiliations are placed in conversational groupings—thus revealing the unexpected relationships and underlying issues they have in common. Rather than being didactic or autocratic, the curator allows the artworks and artists to speak for themselves and to one another.

Can one cut through the categories and eliminate the facile labels—which get attached so quickly and seem to stick whether or not thay are enlightening—without merely substituting another set of similarly restrictive and irrelevant labels? Storr's intention is not to rewrite art history (although that may happen in the process) but to reveal, at a fundamental level, what it was that most concerned visual artists in the eighties—from formal issues about artmaking to political content.

The majority of artists in this exhibition arrived on the scene or came of age in the eighties, and are now in their late thirties or forties (the same generation as Storr). Also included, however, are a number of artists who achieved recognition in prior decades and are now in their fifties, sixties, or older. They are represented because their work exerted an important influence on artists who matured during this period, or because their own work found a new direction or achieved a new level of development. (Other senior artists continued to exhibit widely and enjoy positions of stature, but their work did not have the same significance to the artists who came of age in the eighties.) By and large, the artists in this show have been prominent figures in the art world, exhibiting nationally and worldwide in galleries, museums, and international expositions. Although there may be a few apparent omissions and a few unpredictable inclusions, the curator's choices reflect mainstream art activity, for the most part— even if a certain amount of the work did not start out in the mainstream. The exhibition does not aim to present what has been ignored or written out.

It is our hope that, first and foremost, "The Devil on the Stairs" will prove to be a resonant and stimulating visual experience. By bringing together so many remarkable works, by affording them the opportunity to bounce off one another, we can encourage viewers to come to terms with a multiplicity of ideas that permeated the decade.

It was a special pleasure to work with Robert Storr on this project. The sensitivity, thoughtfulness, and integrity that were evident in his intellectual shaping of the exhibition also characterized the more mundane aspects and alterations involved in making those ideas reach fruition. Often, my primary job was to keep up with Rob as his mind continuously clicked—sending creative sparks in new directions, yet, wondrously, never losing sight of the greater picture.

Judith Tannenbaum
Associate Director

ACKNOWLEDGMENTS

This exhibition has enjoyed a long gestation. It began as a conversation in a Korean restaurant near Cheltenham Avenue in Philadelphia and developed in fits and starts over the course of two years, during which much changed in the world and in my situation. Judith Tannenbaum has played a key part in all aspects of the project. The initial exchange was with her and it was she, as acting director of ICA, who extended the invitation to curate a show. Not long after we got started, I was offered a museum postion elsewhere and a date for another exhibition was set that matched almost exactly the deadline for this one. As a consequence, virtually the entire task of corresponding with lenders and artists as well as all the logistical planning fell to Judith and associate curator Melissa Feldman. In every practical and in many intellectual respects, therefore, this exhibition has been a collaborative undertaking from start to finish.

For their generosity toward this effort to play devil's advocate, I wish to express my gratitude to each of the participating artists and lenders, to ICA's staff, to its patrons and supporters, and to its director, Patrick Murphy. I also wish to thank poet Peter Schjeldahl, who got me started as a critic in time to have my say while the eighties happened and who, more than any other writer, caught the eager and edgy tone of the decade. My warmest thanks go to my working partners, Judith and Melissa, whose very good deeds in this cause should save them from damnation.

This show is for Peggy Squires and Shelley Abelson, who showed me the many kinds it takes.

Robert Storr

LENDERS TO THE EXHIBITION

Mr. and Mrs. Harry W. Anderson, Atherton, California

Thomas Ammann, Zurich

Arts Four, Paris

Jürgen Becker, Hamburg

Barry Blinderman, Bloomington, Illinois

Norman and Irma Braman, Miami

Eli and Edythe L. Broad, Los Angeles

Leo Castelli, New York City

Francesco and Alba Clemente, New York City

Douglas S. Cramer Foundation, North Hollywood, California

Elaine and Werner Dannheisser, New York City

Carroll Dunham, New York City

Arthur and Carol Goldberg Collection, New York City

Betty Harris, Chicago

Barry and Arlene Hockfield, Penn Valley, Pennsylvania

Lannan Foundation, Los Angeles

Louise Lawler, New York City

Raymond J. Learsy, New York City

Evan Lurie, New York City

Ezra Mack, New York City

Vijak Mahdavi/Bernardo Nadal-Ginard, Boston

Achille and Ida Maramotti, Albinea, Italy

Earl and Betsy Millard, St. Louis

Burt Minkoff, Steven Johnson, and Walter Sudal, New York City

PaineWebber Group Inc., New York City

Mr. and Mrs. John Pappajohn, Des Moines

Richard and Lois Plehn, New York City

Principle Management, Ltd., Dublin

Refco Group, Ltd.

Fredrik Roos Collection, Switzerland

Saatchi Collection, London

Katherine and Keith Sachs, Rydal, Pennsylvania

Andres Serrano, New York City

Martin Sklar, New York City

Laurie Simmons, New York City

Speyer Family Collection, New York City

Art Spiegelman, New York City

Michael and Cynthia Sweeney, New York City

Larry Warsh, New York City

Donald Young, Seattle

Private collections

Musée National d'Art Moderne, Centre Georges Pompidou, Paris

Museum of Modern Art, New York City

The Saint Louis Art Museum

Solomon R. Guggenheim Museum, New York City

Josh Baer Gallery, New York City

Mary Boone Gallery, New York City

Paula Cooper Gallery, New York City

Ronald Feldman Fine Arts, New York City

Barbara Gladstone Gallery, New York City

Galerie Lelong, New York City

Metro Pictures, New York City

Laurence Miller Gallery, New York City

Robert Miller Gallery, New York City

Pace Gallery, New York City

Pace/MacGill Gallery, New York City

Sperone Westwater Gallery, New York City

Stux Gallery, New York City

John Weber Gallery, New York City

Michael Werner Gallery, New York City

ARTISTS IN THE EXHIBITION

John Ahearn

Ida Applebroog

Richard Artschwager

John Baldessari

Jean Michel Basquiat

Joseph Beuys

Ross Bleckner

Jonathan Borofsky

Louise Bourgeois

Francesco Clemente

Richard Deacon

Eric Fischl

Robert Gober

Nan Goldin

Leon Golub

David Hammons

Keith Haring

Jenny Holzer

Jörg Immendorff

Ilya Kabakov

Mike Kelley

Anselm Kiefer

Komar & Melamid

Jeff Koons

Barbara Kruger

Louise Lawler

Sherrie Levine

David Levinthal

Brice Marden

Allan McCollum

Ana Mendieta

Elizabeth Murray

Bruce Nauman

Adrian Piper

Sigmar Polke

Martin Puryear

Gerhard Richter

Tim Rollins + K.O.S.

Susan Rothenberg

Robert Ryman

David Salle

Chéri Samba

Andres Serrano

Cindy Sherman

Laurie Simmons

Lorna Simpson

Nancy Spero

Art Spiegelman

Jeff Wall

The Witness Project

David Wojnarowicz

THE DEVIL ON THE STAIRS:
LOOKING BACK ON THE EIGHTIES

t is a matter of the sudden understandings and discontents that hit you on the way out. The French name for this muttering mental state is *l'esprit de l'escalier.* In America, it is called the devil on the stairs. The personification of all the nagging doubts that seize the mind as the door to a previous encounter shuts and you head down to the street, normally this meddlesome character would be a nemesis. On this occasion, the devil on the stairs is our muse. Any traffic with the devil involves risks, and in the present context, the desire to be retrospectively right is the principal temptation. The ambivalent compulsion to look backward easily confuses itself with the opportunity to win arguments and best adversaries without direct opposition. By that means, the wisdom of perfect hindsight is inherently tainted with longing for self-justification. Guilty and unfulfilled desires, tinged if not saturated with an equally problematic nostalgia for former pleasures, attend any such reflection. But some have had their say so often, at such length and have met so little objection, that it is hardly taking unfair advantage to talk back now. Against that amorphous consensus our demonic patron may boast of one undeniable virtue: a radical skepticism toward all orthodoxy. Emulating him in this respect can only lead to positive results, since weary acquiescence to or the willing acceptance of settled opinion is, finally, the cardinal aesthetic vice.

One must give the devil his due and, more important, make good use of the restlessness he stirs within us. Conceived in his needling presence, this show is about second thoughts that possess us as we turn away from the eighties. So considerably has the mood of the art world changed—although the course of events has as yet taken no clear alternate direction—that it seems we left the last decade behind long ago. Obviously, the bubbling and bubble-doomed prosperity that buoyed up even the most inert artistic products and notions of the period has come to an abrupt, stomach-binding halt. Peter Schjeldahl—whose poem for this catalogue voices both the decade's intoxicating start and its subsequent hangover—put it best. Art in the eighties, he said, "was about the sex life of money." Of course much of it wasn't. On the contrary, a great deal of art was intended as a challenge to the promiscuous enthusiasms and wild speculation characteristic of a market-driven art scene. In a larger sense, Schjeldahl was right, however. Even those who quietly held true to their own values or railed against the decadence they claimed to see around them were obliged to maintain their position in full sight of public orgies of buying and selling.

Sooner or later, almost everyone was drawn toward and into the spectacle. Not the least of the surprises of the last ten years was realizing how frequently and easily the pure mingled with the impure, the low-style postmodernist with the high-style postmodernist, the critiquers with the critiqued, as everyone examined everyone else with a mixture of genuine curiosity and raw competitiveness. Parties at fun-house discos, dinners at clubbish restaurants, and, more tellingly, group exhibitions mounted on every imaginable pretext found broad-brush mythmongers shoulder to shoulder with deconstuctors of late-capitalism, graffiti writers from S.V.A. with hardcore minimalists from Yale, confident purveyors of male fantasy with commited debunkers of male arrogance. Already, the memory of these encounters, and their incidental frictions, is fading. This, despite the fact that they were heavily documented. One has only to review the back-of-the-book snapshots and gossip bytes of the decade's art

and fashion press to recall how fluid the situation actually was. Hype, the commercial habit of broadcasting art-world comings and goings, has luckily provided us with pulp and glossy mnemonics for a Goncourt journallike cultural history of the era.

Familiarity breeds contempt, however, and fatigue stirs a corresponding impulse to pigeonhole things, the quicker to have done with them so as to be free to turn to other options or tune out altogether. At just such coincidences of irritation and lassitude, art theories exert their greatest power over popular taste. Sustained in their formative stages by an audience of specialists, while the art they profess to describe beckons and bemuses a still-undecided public, these theories represent a welcoming path of least resistance once that public's attention begins to flag and the art in question has dropped into its stylistic and thematic groove. Then the contest to once and for all set up categories and pick winners reaches its climax.

Naming is the principal means by which cultural territories are staked out and claimed and is, therefore, the ultimate source of power. Or so said Jacques Lacan, one of the many contending patriarchs whose authority was regularly invoked by postmodern theorists. Yet, no one has successfully come up with a global description or workable schema of what we have just been through. Although the decade engendered its characteristic catchphrases, so far, at least, the paternity—or maternity—of its various artistic offshoots remains open to discussion, as does their subsequent inter- and inbreeding. The most obvious symptom of the intellectual conservatism with which postmodern thinkers generally approached their subject was the rhetorical poverty of their jargon. The simplest of eighties labels lacked invention. Impressionism, fauvism, and cubism are all

instances of reductive rubrics enriching the language, regardless of the fact that they were initially coined to caricature the movements to which they were applied. Even a vague composite like abstract expressionism survived its otherwise more memorable synonym, action painting. Worse than such ill-defined movements, however, we got ill-defined "son of" movements: neoexpressionism, neoconceptualism, neogeo, and so on in a chain reaction of pre-fixed monikers. (A simple alternative might have been to index works as wet, very wet, dry, very dry, or wet/dry art.) For good reason, "Back to the Future" became a favorite title for eighties panels.

Fortunately, the art—even the most lackluster of it—generated more interest than the tags. These names stuck, though, and their abbreviated definitions effectively set the terms and limits of interpretation given to work to which they were affixed. Insofar as the eighties remain unfinished business, however, it is precisely because the labels, groupings, and chronology of events and styles we used provisionally to describe the developments of that decade largely obscure the subtler correspondences among its many tendencies and the indirect exchanges among the artists cited as its key representatives.

If anything was common to the period's various production it was the determination to break—if only briefly—with the previously prevailing logic of modernist art history. Modernist, in this sense, signifies a narrow and proscriptive formalism that had convinced many people that art's furtherance led inexorably and irreversibly to one or another kind of abstraction and from there to a diffuse but presanctioned range of alternative systems. The equation was simple and the variables metaphysical: History required that Painting pursue a

rigorous self-examination, to the point of its own extinction or reincarnation as Idea or Thing. Until the seventies, there was a feeling that even if one violated that logic for compelling, imaginative reasons, modernists working in line with art's greater destiny were in all probability still right. Unique projects and achievements outside the so-called mainstream might merit respectful interest, but they could never warrant questioning that concept's basic assumptions.

Exceptions—meaning tributary schools or eccentric individuals— proved the rule. By the midseventies, the exceptions became so numerous that the mainstream was lost in a vast flood plane of aesthetic possibilities encompassing everything from environmental work to feminist performance to new-fashioned modes of old-fashioned painting. Pluralism was at hand, and, almost immediately, a twofold attack upon it began. Conservatives, paralyzed at the prospect of having to think about contrasting or overlapping kinds of artmaking, charged that the only outcome would be degenerative, "anything goes" relativism. Among modernists on the Left, still persuaded that politically radical properties inhered in certain forms produced during art's search for its material or conceptual essence, the multiplication of aesthetic options was treated as a pernicious effect of an ever-expanding art economy. Variety, they concluded, meant greater and increasingly indiscriminate consumption, while the reemergence of particular techniques—oil on canvas, cast bronze— they damned as a backsliding and baleful return to order.

The eighties began with two otherwise adversarial camps decrying in chorus the decadence of a wide-open art world, the idea of meandering decline being the hopeless twin of the once-hopeful belief in civilizing progress along a single path. By a general agreement—one that nonetheless excluded a diverse community of artists whose "marginal" art had found a wider audience under its banner (notably, women, people of color, gays)—pluralism had devolved into an epithet for enervating chaos. Only a dominant new or neo style could clear away the manifold distractions and diversions pluralism had nurtured. Or so a considerable portion of critics seemed to feel. Among artists something different was afoot. However their will-to-power eventually manifested itself— or failed to—artists of every sort working in every medium saw the lack of consensus as an opportunity, if not an imperative, to mix and match styles and methods. The heightened sensitivity to ideological confusion, the separateness of parallel realities, and the circumstantial conflation of traditionally opposing aesthetic codes prompted a visual as well as textual speaking in tongues.

The austere paradoxes or didactic exercises of sixties and seventies text art were thus reborn as signage, scribblage, and cacophonous eye chatter. Surreptitiously inscribed or plastered onto downtown walls, briefly in evidence in the midtown babble of Times Square, then spread over acres of pristine gallery space from Soho to Fifty-seventh Street, words and hieroglyphs heralded a new sensibility at once populist and antagonistic, smart-assed and art-smart, politically savvy and deeply disillusioned, hit-and-run and here to stay. Sophistication consisted of finding the exact point at which overtaxed verbiage discharged its last poetic crackle. Lists became resonant litanies, and aggressively banal icons warped into exuberantly baroque ideographs. Here, as in all that followed, calculated misalliance of means and ends, purpose and situation made the difference between work that was coy or merely clever and that which

was genuinely seductive or disconcerting. Artistic sincerity meant being betwixt and between and, at all times, wide awake to that fact. Success depended on lessons learned and the distance marked from kindred practices new as well as old. On the whole, word artists of just prior generations had played iconoclastic "protestants" to art's "catholic" and hedonist past, opting for dour mechanical print or, at very most, a Shakerlike spareness of design. Meanwhile, the mutant letterforms that exfoliated in staggering and wondrous profusion in playgrounds and subway cars withered when transplanted to the leached-out soil of the "White Cube." Eighties artists, who turned to texts, whether sticking to typefaces or letting go the wrist, looked both ways. Mindful of the verbal gambits of the former but taking their emotional cues from the latter, they understood that the word was out and, in all dimensions, a sensuous object.

Everywhere else there were pictures. Actually, their proliferation was not sudden, nor did it date from the turn of the decade. Nineteen seventy-seven had seen the Pictures show at Artists Space, and the New Image show at the Whitney Museum followed in 1978. The second announced a new painterly painting more indebted to minimalism than in revolt against it, plainspoken in its imagery rather than grandiloquently symbolic as its expressionist successors would be; the first focused attention on a stripped-down reiteration of deliberately stereotypical images, images whose dubious or contemptible provenance became, by exposure, their content and allure. The formalist prohibition against depiction thus came under pressures from both sides, but for the second of these two groups only conditionally. Before, the rationale had been that art, or, more specifically, painting, should not serve the purposes of mimesis, because to do so meant conjuring

illusions and thereby betraying its true optical and material nature. Now, certain postmodernists declared, graven images were all right, just so long as they were not painted, since painting, rather than being a purified and so privileged medium, had at last been revealed as the most tainted of all, an exhausted form wholly compromised by class-bound taste and a false ideal of individual creativity for which it served as reliquary. A third position quickly emerged. Painting, this apologia went, was the last worst hope of art precisely because, used up as it was, the clash between its conventions and those of an equally depleted photographic tradition still threw blacklight sparks.

Closest to the reality of hybrid picturing in the eighties, this adroitly perverse compromise could not prevent the critical segregation of painting and phototextual art central to so much postmodernist theory. The mutual exclusivity of media once mandated by the pursuit of separate aesthetic essences had become a test of intellectual piety masquerading as political inevitability and virtue. Despite the increasingly plaintive announcements of its demise, however, painting was not dead but in vigorous, at times seemingly manic, remission. Those who painted best tended to be those who, having avoided painting in the early seventies, approached the medium with the least dogma, the fewest studio habits, the most uncertain expectations, and no other idea of what to do. For the happy few among the frantic many in this position, painting was a discursive technique that allowed you to make it up, and yourself, as you went along. To the extent that doing that was likened to reinventing the wheel, the prospect did not faze these artists but seemed necessary and exciting rather than ridiculous or futile. The obvious debts or accidental stylistic encounters that

their work showed matter less than the interim freedom it afforded them. And, inasmuch as anything nominally expressionistic entered into the best of these works, it did so as in stray marks or as the aftertrace of hands less intent on showing emotion than on locating an image and recording its permutations in and against space.

A new spirit in painting thus made itself known. In Europe, where that title heralded one of the first exhibitions devoted to this art-world about-face, the "new spirit" was old. It could hardly have been otherwise. In that show and others like it, recently or long-dead masters hung cheek by jowl with the young and not so young Turks; when painting struts its youth, it cannot help but show its age at the same time. However fresh the example, painting's history envelops each new work like a morning mist. What counts more than the presence of that aura is the value attached to it by the artist and the viewer, and the degree to which it clouds or illuminates the picture directly before them. Ultimately, the debate about painting in the eighties came down to the question of whether it was ever possible to dispel the aura sufficiently to find something unexpected to look at and unpredictable to think about. For every partisan of heroic or mock-heroic painting on either side of the Atlantic, there were naysayers who felt that in its degraded or self-degrading state, painting did no more than emit toxic gases of pretension and reaction. For these academics, painting's history was its undoing, and the evocation of that history by contemporary artists a self-aggrandizing fraud. At the very worst, it was said—and predicting the worst made for the best copy—the threat of imminent and ineluctable fascism lay beneath the surface of these pictures.

It did not, as things turned out—although the anxious sourness of the moment may smack of Roman or Weimar corruptions to those who rely on precedents to experience their own dread and loathing. Much of the best art of the eighties, however, did bring fascism and its analogues right up to the surface, laying out their symbols in disturbing and ambiguous array. Far more than a stylistic or marketing attribute, history was the subject of art, a subject eagerly pursued by those who hitherto had been kept ignorant or been allowed to remain complacently oblivious of the past. Previously buried in denial or obscured by cliche, history thus was dredged up, reimagined, and rewritten in every available narrative form, of which painting was not the least but also not the primary one—even among painters.

Accused of stumbling from one short-term obsession to the next, a considerable number of artists in the rising generations in fact started to take the long view. That perspective cut the scrim of their own life circumstance and pointed deep into the nearly opaque shadows behind it. The old question "What did you do in the war, Daddy?" was again heard. Despite the many smaller conflicts that had intervened, the war meant was World War II and its immediate Cold War aftermath. A few had a father to whom they could directly address the query, and occasionally he answered. Seeing the need, others set themselves up as father figures. Joseph Beuys, whose voice introduces this exhibition with a characteristically declarative irresolution, was perhaps the last major artist to have participated in the slaughter and to have done so on the wrong side. That fact was crucial to his cult, since many of the disciples that he claimed were orphans of those who had started the war, and lost it, and had left their guilt and wounds as a legacy. More often, though, the father was silent or wholly absent. The only choice was

to impersonate him in the hope of understanding his craving for, terror of, or submission to power. Or else, like a no longer innocent child, one played at war in order to feel its absurdity, exhilaration, and pain.

Nothing could have made the complexity of works in this vein more evident than the divergent ways they were received around the world. While it is nowadays commonplace to hear something called "Eurocentrism" cited as the opposite of "multiculturalism," in fact the signal encounter with cultural diversity in the eighties came with the realization that Europe and its periphery was a fractured and centrifugal, rather than neatly concentric, entity. The greater the emphasis placed on national styles or symbols, the quicker the idea of a homogeneous art public fell apart. Once pervasive and since then periodically restored to service, the modernist ideal of a pure international style frayed beyond repair. The formerly conquered were inevitably divided among themselves as well as from those who escaped the worst. Thus, art that incorporated and analyzed the cultural myths of Nazism meant different things to different people in New York, Tel Aviv, Cologne, and Warsaw—and had to. As did art that recuperated or burlesqued the symbols of Soviet society.

Nor could anything have made the United States' skewed vision of the contemporary scene more obvious than these historical simulations and pantomimes. The simple truth was that contemporary art was no longer an American province. The sudden influx of work from across the ocean taught us that. Just as some critics renewed their attacks on the postwar proclamation of the triumph of American painting and the Pax Americana, whose stalking horse the "Ab-Ex" vanguard was denounced for being, we were hit broadside by waves of German and Italian art exports, in whose trough bobbed scattered examples of English, French, and other foreign art products. New York may or may not have stolen modern art from Paris, but the new Europe was ready to get it back by leveraged buy-out. As in many cases, the American model had been restructured and perfected abroad, and the resulting goods and marketing techniques were now zeroing back in on us.

Over the horizon loomed the spectre of movements we had partly stimulated but whose later development, actual dimensions, and driving motivations largely eluded us. Back to labels. Unlike expressionism, abstract or neo or plain, pop art, as an alternately complicitous and subversive commentary on our late prosperity, seemed a distinctly American invention. Infatuated with the boomtime U.S. and determined to beat us at our own game, German magnates especially invested heavily in pop. German artists, however, slyly reworked and reapplied pop's devices to monitor a transitional Europe caught between the propaganda of commerce and that of the State, which, for Eastern Block refugees, as several of them were, denoted communist as well as social democratic bureaucracy. American pop was thus recast and renamed "capitalist realism," a play on words deftly aimed at ideological nerves in the East and the West. Consciousness of this transvaluation and the reasons for it awaited the public in this country until the eighties—as did any serious consideration of contemporary and countervailing romantic movements, and the adroit co-option of both tendencies by Beuys and his epigones. Ironically, many in America thought that all they had just discovered had just occurred, when in fact the process dated back to the sixties and had evolved parallel to and sometimes in advance of our own comprehension of the rapid turnover and

built-in obsolescence of mass cultural emblems. Over the past ten years, chasing after new art from overseas was the equivalent of careening through recent European art history in reverse. It was as if we in this country had rarely or never seen a Lichtenstein or Rauschenberg or Johns prior to 1979 and were obliged to deduce their ideas by thinking backward, from that first, belated encounter.

Any hope of making quick and orderly sense of these newly glimpsed realities was soon thwarted. Reliance on paradigms based on the historical trajectories of American styles just made matters worse, since by the late eighties, the generation of European artists who came to the fore in the late seventies was in a position to treat virtually all styles as available and coexistent. Pop art didn't banish or void expressionist painting, it made expressionism read like a pop manner. Pure abstraction did not consign realism to the dust bin of history either; realistic pictures of pure abstractions simply brought nonobjective art back to earth and into the death-shadowed present tense of photography. Systematic inconsistency of approach and self-contradictory role-playing rendered futile any effort to encapsulate these artists' personae or the characteristics of their work. Rather than affirming one identity, their art's defining factor was the ceaseless juxtaposition, overlay, and reciprocal cancellation of possible identities. Existential or symbolic games of hide-and-seek were classically modern, but suddenly artists appeared to have lost the compulsion to hide and shrugged off the obligation to seek. Instead, they preferred to scan and mimic and deface. Contrary, then, to the conservative nightmare of a featureless, leveling relativism, here was an "anything goes" (but nowhere) art that was beautifully contrived, perfectly detailed, and so all the more

relentlessly shifty and astringent.

Making two kinds of work side by side, forcing incompatible emblems, methods, or styles into close proximity, or superimposing one atop another atop another, became standard operating procedure in this country as well. Sometimes, the influence of European precedents was clear. Sometimes, the impetus was a "what if?" attitude, more or less indifferent to outside sources. In either case, the effect of isolating pictorial elements in this way, only to cram them together or oppose them, was twofold. On the one hand, it tended to energize images depleted by overuse. On the other hand, it drained the vitality from the strong ones by pitting them against each other in battles of formal and cognitive attrition. Consistently, though, it tampered with or destroyed faith in the universal value of these images and the authority of signature style.

Authorship and the cultural legitimacy vested in it were the prime focus of skepticism if not of outright attack. In olden modern times, demolition of establishment citadels was accomplished by resolute blasting and bombing; during this postmodernist round of hostilities, it proceeded by surgical, if desperately prolonged, deconstructive strikes. Complicating matters was the recognition that virtually all the combatants were moving and quite possibly phantom targets. Liberated from their linguistic and philosophical bondage to things, signs took on lives of their own. Every picture tells a story, purportedly, but at this late date in the century, one was warned against believing either the tale or the teller. A text, whether visual or verbal, "created" its author and its public, even as these two recipients conspired to express their acknowledged or unacknowledged needs through selective interpretations of its polyvalent meanings.

Throughout the eighties, circular questions of who speaks and who or what is spoken gathered mesmerizing—not to say numbing—momentum. Naturalist or documentary modes were most suspect, hence of special interest, insofar as they presumed an almost reflexive suspension of disbelief. Again, painting and photography met head-on, and rather than resolving their differences, confounded them. Vignettes rehearsed in front of the camera and decisive photographic moments rephrased in paint opened up dramatic possibilities in each medium, as well as affording ample room in which to doubt the spontaneity or disinterestedness of inventions or reportage of any kind.

Reconstituting history from incomplete evidence, while dismantling and displaying the artifice of conventional representation, demonstrated both the intense drive to secure an identity and a mistrust of the available repertory parts. Playacting emerged as a key method for unraveling the entanglement of public and private experience, and self-portraiture became a principal format. One test of the truth of mediated imagery was the degree to which it could be obviously faked and still elicit a complex emotional and intellectual response. Dolls, dress up, and staged tableaux thus became typical means for parodying stock realism, but also for making the poignancy or menace of images register upon an audience primed to reject anything that concealed its fictions or formulae. Conversely, "straight" photography benefited from no longer having to pledge itself to aesthetic modesty or poverty; in short, pictures could be as luxurious or lurid as their subjects and settings, or as cold. In the sixties, theatricality was widely considered a breach of painterly or sculptural integrity, since, it was said, self-evidence and self-sufficiency were the essential qualifying attributes of the plastic arts. The minute that

art noted the existence of, and made concessions to, the spectator, it betrayed itself. In the eighties, art rarely had an impact if it did not recognize the viewer's presence, and failed outright by merely accommodating it; rather, artists turned the spotlight around to reveal him or her as an active protagonist.

Formerly the mirror to realities beyond the ken of the average man, art was now the mirror to its immediate circumstance and motley public. Rather than represent itself, any image fixed or transmitted by any method was first and foremost perceived as a reflection of the exchange of glances between the self-conscious artist and the self-affirming viewer. So who is out there? Heretofore, the universal spectator implicitly had been male and his gaze a projection of masculine power over whatever fell within its scope. Just as naming lays claim to something, looking is a means of taking possession. Repossessing icons of demure, helpless, or willingly victimized femininity, along with their monstrous opposites, women looked back through the trick mirror of pictures—and talked back in captions—at the supposedly omniscient male, staring down his gaze and bouncing blinding rays off each of his separately focused Argus eyes.

Moving from passive objects to active subjects of art, women, and their social, psychological, and political predicament became a central eighties issue. This confirmed changes in the sexual politics of the art scene initiated in the early seventies, even as women's gallery representation diminished in proportion to that of men, and rerun machismo had a brief vogue. Alas, no sooner had the canopy of the universal been lifted, and the heterogeneous host hidden beneath been brought into the light, than another descended. This one

was called the "other," an abstraction of such amplitude and obscurity that virtually anything that was not obviously masculine or mainstream could be assigned to and lost within it. Until the very end of the decade, what disappeared most often was the work of artists of color of both sexes, artists whose "otherness" was other, richer, and more multifarious than anything suggested by the superficially unifying distinction of being non-white. Moreover, in an aesthetic climate in which texts or photomechanical techniques were the preferred if not prescribed practices for vanquishing the Great White Male, the fact that artists of color and certain women might choose traditional media meant they would be passed over by those who disdained actual differences in the hot pursuit of a word-perfect discourse of "difference." The irony is that in a period when painting was once again the arena for men with big ambitions—and was despised by some for that reason alone—much of the best, most painterly or formally radical painting was made by women. Urged to put down her brushes by a male "feminist" in a hurry to get on with postmodernism, a woman painter I know retorted, "Painting's not dead, it's just hard."

Mastery was a posture men supposedly struck in order to impose themselves and their vision on the world. Those who demonstrated the highest degree of technical mastery, however—as distinct from showy competence or desperate panache—often did so in ways that belied such bombast and on occasion lampooned it. After all, aspiring to full command of one's tools does not automatically imply putting them to the task of domination. Before all else, a masterwork is a well-made thing. Attention to craft and the semiotics of craft is as basic to a thing's aesthetic substance as its representational or symbolic codes. Painting in the eighties frequently profited from awkwardness

and the lack of agreed-upon standards or recipes for execution. Painters got into trouble when they overreached their skills to gloss the grand manner or otherwise dress up their nervous groping in the look of elegant ease. Concern with craft and the proper use or calculated misuse of materials was by contrast crucially important to sculpture in the same period. Some sculptors did all their own fitting and finishing, deriving their inspiration as much from the hands-on choices made in the shop as from any prior decision about how an idea might take final shape. Others, pragmatically minded like the minimalists although aesthetically at odds with them, wanted to get their hand out of the work or simply recognized the limits of their own artisanry and so commissioned their work's fabrication to the most exacting of specifications. The surprise that both these groups provided an art world intermittently entranced by the monotonic siren song of the antiesthetic were object lessons proving that the best critique of the debased consumer fetish was not a grim surrogate or a voice-over denial of pleasure but a work that teasingly or in all directness tested the limits of refinement and formal ambiguity. The consummate send-up of the masterful male was the achievement of rambunctious "bad boys" transfixed by the grotesque pushed to perfection and wholly professional about pushing it there. Self-mockery, travesty, and an aching sense of the gap between desire and desirability, getting love and being lovable, served to demystify the theoretical discourse of "desire," leaving behind exquisite specimens of autistic lust and uncanny violence.

Much of this work, like much else produced in the eighties, was called cynical. It wasn't. Failed irony may seem parasitical but, like the average bad mushroom, it causes indigestion and little worse. It is certainly not fatal to art. The conviction that this

inappropriately appropriated work was crassly exploitative persisted among many who contrasted it with the nobility of high modernism, conveniently forgetting in the process the nastier confections of Picabia, Duchamp, Bellmer, Oppenheim, and countless other antecedents. When the pasticheurs and ironists turned their full attention to abstraction late in the decade, the final indignity seemed at hand. Some defenders of the true faith of nonobjective painting already had called for its end, assuming that the deconstruction of its utopian premises and the diffusion of its design elements into the man-made environment made further studio involvement redundant at best. Depending on one's vantage point, the quizzical redeployment of classic modernist devices and formats was simultaneously the last straw in a long history of denigrating satires or the first hint of revived interest in those very conventions, an interest apparently startling to some who expressed it. Reductive paintings, in the meantime, continued to issue from the studios of dedicated modernists, and some of them reconfigured the components of abstraction as radically as any postmodernist detractor. Sentenced to die or survive only on short-term appeal, abstraction was nursed along in this fashion by its ambivalent prosecutors and would-be executioners, while long-standing practitioners continued to make work apparently unaware that they were laboring in a condemned prison.

Until now, I have refrained from naming any artist in the exhibition, with the sole exception of Joseph Beuys, whose disembodied presence haunts the entrance. The reasons are simple. None of the work of those included was intended to be merely exemplary of the themes it encompasses, and all the work chosen exists in a context in which the presence of other work matters more than the verbal arguments that might be attached

to it. Rather than write art criticism and select evidence to prove this or that hypothesis, or, conversely, rather than pick work that suited me and then spin explanations around it to ratify that exercise in taste, my aim from the outset was to create a parallel stream of consciousness in alternating currents of words and works. Insofar as the devil on the stairs has been my collaborator rather than my tormentor, he has served that function as a prompter, ready at all times to remind me of things I had forgotten and of ways of seeing that I had neglected to test. Other than Peter Schjeldahl, I have also deliberately avoided citing critics whose positions I have alluded to and sometimes disputed. My intention has been to recall debates without engaging in a series of intramural matches.

This show is a project-in-progress, conceived of in an atmosphere of opinion that clings to but is partially dissipated by the works present. Even now, lingering thoughts regarding race, sexuality, the economy of signs, and politics of artistic method crisscross my mental picture of the period in directions still to be explored. Instead of being neatly compartmentalized, the art of the eighties begs to be presented in mixed company. Only then does the complex dialogue that echoes from within and among its separate discourses become fully audible. Correspondingly, the paintings, photographs, and sculpture included have been gathered in clusters and organized in sequences that frequently violate chronology and, on occasion, the most obvious group affinities of style or ideology or medium, in particular those hinging on binary or dichotomous criteria. At least as important as the order in which the exhibition unfolds, therefore, is the tangency of, or overlap between, the parts. Rather than channel the traffic through a one-directional obstacle course of displays, as is fairly common in surveys, this loose structure is an invi-

tation to the viewer to skip forward and backward and so review combinations in light of, or make connections with, things found in separate areas. Although a given artist will be assigned to only one such cluster, it should become clear that in many cases, the artist might also have appeared in several other locations as well.

Altogether there are six free-floating presences and eleven collective sections. The six solitary artists are Beuys, Jonathan Borofsky, Bruce Nauman, Ilya Kabakov, David Hammons, and Louise Lawler, each of whose work has been placed near sympathetic or contrasting larger groupings but, given the concentration each particular contribution demands, apart from them. The eleven sections are as follows. The first involves artists who used words as a primary medium: Tim Rollins + K.O.S., Keith Haring, Jenny Holzer, and Jean Michel Basquiat. The second includes artists who created social tableaux that, in one way or another, annex the gallery space to the world depicted in such a way as to directly implicate the viewer in the image: John Ahearn, Eric Fischl, Jeff Wall, Leon Golub, and Adrian Piper. The third consists of work by artists who have used various formats to "remember" history they have not witnessed or draw attention to history's contemporary thrall: Anselm Kiefer, Art Spiegelman, Vitaly Komar and Alexander Melamid, Jörg Immendorff, and David Levinthal. The fourth group contains work done exclusively by women that records and returns the male gaze or supposes a female gaze in its stead: Cindy Sherman, Nan Goldin, Barbara Kruger, Lorna Simpson, and Laurie Simmons. Although several of the artists in the latter group analyze or reframe the conventional objectification of the nude or partially clad female body, those in the fifth, working from both the inside out and the outside in, define their experience of the body's

subjective as well as social predicament: Nancy Spero, Louise Bourgeois, Ana Mendieta, and Francesco Clemente. Artists concerned with the dissonance of images and their amplification or diminishment through multiple exposure make up the sixth category: Ida Applebroog, David Salle, John Baldessari, and Sigmar Polke. The seventh, represented by just two painters, Ross Bleckner and Gerhard Richter, is devoted to aesthetic split personalities who deliberately and simultaneously work in internally coherent but dissimilar styles. The eighth group comprises two practitioners of full-tilt painting: Susan Rothenberg and Elizabeth Murray. The three sculptors in the ninth cluster share among themselves an acute and firsthand appreciation of the nuances of craft and, with that, some discrete formal affinities, but otherwise follow very independent paths: Richard Artschwager, Richard Deacon, and Martin Puryear. Casually macabre or aggressively banal, the sculptors who comprise the tenth ensemble masterfully subvert public trust in the benign presence of everyday objects: Robert Gober, Mike Kelley, Jeff Koons. The eleventh group is composed of artists who, in one way or another, address themselves to the classic modernist problem of abstraction, making radically simple but objective paintings or nonobjective pictorial surrogates for paintings: Brice Marden, Allan McCollum, Robert Ryman, Sherrie Levine, and Andres Serrano.

The final section of the exhibition is devoted not to aesthetic ideas or practices as such but to a fact of life and death that no one in 1980 anticipated—AIDS—here represented by the work of activists David Wojnarowicz and Chéri Samba, as well as by the Witness Project's partial list of artists and their colleagues who have died since the epidemic began. It is impossible to estimate the ravages this disease will bring, but its effects on art and art's

capacity to speak to the larger society have become a primary focus of attention in the latter part of the decade and doubtless will continue to be so as long as the crisis lasts. Impinging on all aspects of civil and cultural life, AIDS has made it plain, as nothing else in our day, that no line drawn in speech or laws or dollars or color can protect any community from the knowledge of others it fears, nor from the hard facts of mutual dependency in the face of common, albeit unequally shared, disaster. At the outset a plague among "pariahs" and "minorities"—first, gay men, then drug addicts, then their families or partners who were, for the most part, black and Latino—AIDS has spread insidiously and rapidly from cities to towns and back again to cities and so on around the world, bringing the plight of the "margins" to the metropolitan center, and everywhere foregrounding the failures of the center to confront those problems.

How unprepared the art world was to grasp this hideous reality can be recalled from the drift of art-talk just a few years ago. Besotted by scholastics that confused the critical study of representation with the wholesale substitution of analytic discourse for all other dimensions of physical and psychic experience, some artists and art writers cheerfully announced that the body was nothing more than a text, subject like all texts to interpretation without end and the immortality of infinite media replay. Marxist aesthete Walter Benjamin's anguished but flawed prophecy of art's final dissolution and dispersal through mechanical reproduction had returned as a philo-kitsch. The suffering we have witnessed and the irrevocable losses we have experienced are the body's painful rejoinder to this sophomoric conceit. If the full extent of those losses is to be felt, however, instead of the body one must speak of and remember specific

flesh-and-blood bodies and precious, finite spirits. So, too, the courage of those who have lived with debilitating illness and the constant thought of their own likely death, combined with the depth and diversity of the art resulting from that awareness, is proof that as misrepresented by the society and as mysterious to itself as the subject may be, individuals are not ciphers; their gifts and endurance are unique, unpredictable, and frequently amazing. In short, AIDS has tested the human resources of art and the art community in ways never foreseen, and it has brought to bear a frankness, gravity, and measure that render glib abstraction and cheap apocalyptics unbearable. Threatened by the premature end of so much that is ripe or ripening, the struggle over the last word and who shall have it seems not just irrelevant but the ultimate egotism.

Hard times have hit. How hard they are and how long they last will vary according to the individuals. For society as a whole—that is, for the aggregate of individuals in difficulty or at risk, which most are—the extent and duration of the troubles remain unknown. Hearty promises of better days ahead usually come from those who want something and, to get it, need our optimistic trust. Their assurances fall on increasingly skeptical ears, however, since many are no longer sure of what they want. Some, who have had a lot already, crave nothing that anyone can give them, and all have been warned by experience—and occasionally by art—against the options offered at present. These last years have left their mark, and the impulse to dwell on what has happened is the era's final seduction. As is true of some veterans of forties cafeteria culture, fifties coffeehouse and bar culture, and sixties street culture, many who made the crowded eighties scene will inhabit it for the rest of their lives. Nostalgia, it often seems, is

the only form of history with which Americans are emotionally at ease. But if any period should leave us uncomfortable, it is the one just over. At the end of the decade and near the close of the century, the compelling reason for looking back is scarcely sentimental; it is, rather, so that we may look forward with a quickening impatience at our habitual myopia, and with stronger nerves. Besides, no advantage can be gained from scolding the past, and much of our soul can be wasted by pretending we never cared. The eighties has left us on the street—jittery, disgruntled, and still bedazzled. So be it. Here we are, and it's already well into the nineties.

Robert Storr

Ascending marble heavenly stairs toward mysterious streaming light was one idea. He had many ideas that did not survive in rooms where people chattered, crashingly ordinary people such as himself without an idea. Some days everybody was suicide fodder, fortunately too stupefied to know it.

Well into later life he retained a degree of innocence, a mist blurring the world slightly like nicotine or the dotted line in the air of a sweeter possibility that is real if you think so. He could think so though embarrassed continually by facts and continuously by the near certainty of being mistaken.

No, he said, I was not born yesterday. I was born this morning with a hangover, expecting goodness and resenting nothing. Gazes remind me that I exist. Once I encountered a rat in a midnight street and kicked at it. It reared up, fearless. It hated me. I was aghast with admiration. I want to be ratlike in that way, he said, though only if some will still love me.

He pledged allegiance to the street and to the idea that it runs north and south or east and west with stoplights red amber green according to plan. In the city everyone has a plan or is in trouble or both, but the ultimate idea had to be unplanned. It was that you couldn't expect it. It was: as quickly as possible, don't think.

It was interesting to look at pornographic images denatured in the rendering just enough not to arouse. He liked pornography, as he explained nervously with his usual double intention to beg approval and to provoke, but quailed at its power. Dispassionately to regard one's own sexual emotion definitely was an idea, wonderful for a while and then interesting and then less interesting. It seemed important to guard this idea against an idea that it was not all right, but eventually no one cared.

He was always racing to give an answer before they got tired of the question.

People learn that sex is not an idea and violence is not an idea and, if they are lucky, love is not an idea, but love is apt always to remain somewhat an idea like quailty or democracy that he wished would go away so he could miss it. The ultimate idea was never about "values" but he kept getting trapped into saying it was, as again the idea slipped away clean, dark, and inviolate.

Out there around the corner in the rain. Never far. There among moving shadows.

It was interesting to be an American without thinking about it in any detail, just abstractly magnetized by the idea "an American." The country's power was declining, what a relief not to feel guilty toward everyone everywhere, and the country was becoming poorer and more corrupt and not less stupid, and that provided a melancholy gravity. The only things truly interesting anymore were things someone

could be stuck with, such as sex and the Red River Valley, sex and Galveston Harbor, nostalgia for innocence and the Snake River. Only what was inescapable remained the same when thought about and when not thought about.

Everybody rediscovered stories. People printed and painted and photographed and telephoned and eventually faxed stories.

When did photographers stop saying "Watch the birdie" and "Say cheese," no longer saying anything but just presenting the lens's maw which reads "O"? "O" as in awe plus zero equals awe, only colder. Photographers moved in gangs over the earth killing everything into beheldness. Awe times zero equals zero, meaning photographers foolishly tried to multiply that moment that never changed. He drew a line on being over-emotional and promised no longer to be "touched" by photographs.

Sex and the Tennessee Water Gap, nostalgia for innocence and the Susquehanna River, sex and Lake Success. Death and the Mississippi River at night. Prairie. Prayer. His idea of God was the flatness of North Dakota. (Rain.)

He flogs his typical middle-aged male self-pity for poetic effects. It works. Start with the available technology: the soft tuning fork of an ache in the chest or genitals. Shame adds heat: a burning face on which to warm cold hands. Gradually a moist music or spiritual steam rises, and in that vagueness appear shapes of what does not belong to anyone.

All right, get it out of your system. Get your system out of your system. Insert knife at your throat and yank down to your crotch. Pry open. Pull out organs and throw at the audience. It's what they want, isn't it? Actually it isn't. Tears ran down his face of embarrassment to have been so in error. Now he had severe physical problems.

Suddenly it became okay, and therefore boring, to insult communism. The "post" fell off "postmodern" and the "late" fell off "late capitalism" and the other wheels fell off the other words for a situation that turned out to be what it felt like: stuck.

Things were interesting and expensive. Money gave things consequence, making them inescapable in the way that is necessary for there to be ideas. Efforts were made to relate money to other kinds of value, but the other kinds proved optional and money stood alone. Then money fell down.

It began with a smell of turpentine and ended in odorless distances.

Stuck like a car up to its hubcaps in black mud after a thunderstorm, and they have no choice but to get out and admire the landscape. Stuck like lovers together. Stuck like a childhood crush that issues in fifty years of marriage and a photograph. (Great-grandchildren.) Stuck like someone remembering these things. (Imaginary memories.)

In the streets postmen and postwomen wheeled their tricycle carts in which were publications with postage prepaid at the new higher rates. Prose in the publications indicated a rising level of discontent with the cultural hegemony of European-American males. He couldn't have agreed more. He couldn't have felt more uncomfortable, reading the publications in his apartment with sounds of the street entering from the late afternoon. He thought of males who were never comfortable, hegemony or no hegemony. He thought that a new way of being uncomfortable might present possibilities.

In the street the gazes of the desperate and cunning covered him. He strolled in a crossfire of want that evoked the idea of a commensurate satisfaction, and that could have been the ultimate idea if he understood it.

Fakeness was another idea, though a small one. Or was it an idea? Was it possible to be fake on purpose? A real fake? The problem kept him occupied through a winter, until spring reliably shocked him with the recognition of everything he had meant to live and had not lived. Reality and fakeness do not apply to unlived things. The life he had missed ballooned over him like a clear night sky in the middle of nowhere.

The marble stairs streaming with unearthly light suggested triumphant madness. Did he want to be deracinated for a while? His friends would scorn him, and he would be laying in difficulties for future years. This had the sole advantage of being a plan, akin to testing fate by methodically crossing streets against the light without looking: rushin' roulette.

He thought that nobody gave him a break, either because they didn't think he needed one, which he did, or because the giving of breaks was against their intellectual religion. Or maybe they were jerks, actually. He couldn't believe that they lacked the enlightened self-interest to help him be glorious. He helped others be glorious in order to set an example. Sooner or later it would be his turn, wouldn't it? Or maybe this was his turn the way it had to be, written in the book of giggling destiny.

He swooned whenever it was practicable, such as on the street when a cornice agreed to look perfect against a sky. It was the same with works of art, that little quick melting of tension that is swooning in action, though with art there was a backwash of thoughts whereas on the street there would be a quick, cold return of the drab and somewhat dangerous. Once he had an awful moment, thinking: I never swoon

anymore! So he experimented and found he had only been distracted, he could in fact swoon anytime apropros almost anything. He was a cheap date of the universe.

Nobody talked about form and content. They talked about subject matter. They talked about other things for which he thought the word was "design," as in conspiracies and professional know-how. Some days he felt in imminent peril of believing he had a job.

Nostalgia for innocence and the Red River of the North. When that river is flowing from right to left in front of an American and the sun is on the horizon, the person is in North Dakota and it's dawn. Having been born by a river that runs north might have made him Canadian but instead it made him contrary. That and loneliness in which self-pity would not be contained but leaked in all directions, weeping for the poor world and sun and everyone. It was about the commensurate satisfaction. It was about the baby Jesus if he could believe in God, which he couldn't. It was about picturesque effects of sorrow.

A life is supposed to come to something. It never does, but it is supposed to. Do you know why we are put here? We are put here to suppose and to suppose. The last supposition is the end. That's all. The ultimate is death, and it was time he admitted it. The ultimate will bring him up short amid his ideas about the ultimate, making a sound to get his attention. Pencils down. Time not to be. Time to be gone. And what, besides the ultimate, is death? The best excuse. The others will have to make allowances. His empty chair.

He saw how some set out to be mysterious to others and succeeded only in becoming mysteries to themselves, immobilized like cars broken along a highway where citizens zoom past with hardly a sideward glance.

He saw how some held back from the logic of their times, such as the logic of suddenly making a lot of money, and thereby lost the thread of history. He saw how others rushed forward with the logic of their times, and the thread of history strangled them.

He saw how the yearning for something to mean something was a proboscis that flailed through the world, attaching first to this thing and then to that and extracting substance that was perhaps delicious and perhaps nourishing. But the flailing never stopped. There were horrific moments when it parodied itself, waggling without an object as if futility were fun. It wasn't. It was embarrassing, and he became indignantly impatient for death to begin.

The Right aestheticized politics and the Left politicized art, and that about covered the possibilities except for the possibility of being alone. All around him people were joining something. He studied

how to join himself, learning to search in the crowd of what might be himself for the face hot with shame of one whom the others shunned.

By and by, he cooked up a satisfying sense of imminent disaster, the world reduced to lurid silhouettes by phosphorescent backlighting. It was a painting from Berlin. Lots of people got to die while he wasn't dying, and it didn't seem fair. His ability to feel sorry for himself was getting spectacular.

And what of loving? He had loved. He continued to love. It was a suspension of his possibility, cantilevered protectively over the loved one's capacity for unhappiness. She will not be unhappy as long as I live, was the motto. It seemed crazy. Why should she be deprived of unhappiness? He concluded that love and craziness were identical.

The night sky wheeled over the prairie. Tires sang along the interstate. In cities human beings engaged in behavior that as children, they couldn't have imagined without screaming. Betrayal came and went like a fashion so perennial (the little black dress) that it might as well be legally mandated. He liked all the pretty fashions, the collars waxing and waning and the nubbly fabrics, the silk, the barely audible friction of legs in hose against something silken as she strode, the unknown one, into the last evening of the world. He had a friend who went away. He had a love that continued like winter dusk. Lights came on in the buildings, blurred by the tears in his eyes until the night was one cold fire resplendently blazing.

He saw cruelty in the eyes of those who didn't exactly mean it. He saw kindness fluttering uselessly in gestures incompleted and unnoticed. He saw that it would be a good idea for God to push a reset button in the sky, starting everything over. With or without him, it didn't matter.

I want it on record, he said, that I like this planet, which is cherished by me from distant stars to the molecules of my perishing body. It isn't me, this body. Anybody else might as well have it, and the earth in which it will decay but not cease to exist, because nothing does really. He went on to claim oneness with some streaming brilliance, but his words were lost in the growing and finally deafening clamor of another day.

Peter Schjeldahl
May 1991

PLATES

Dimensions are in inches; height precedes width precedes depth.

Jonathan Borofsky
*Spinning Figure 8 with Three Chattering
Men*, 1986
Figure 8: aluminum tubing,
motor, cable; 96 x 48
Men: aluminum, wood, Bondo primer,
electric motor, speaker
82½ x 24 x 13 each
Courtesy Paula Cooper Gallery, New
York City

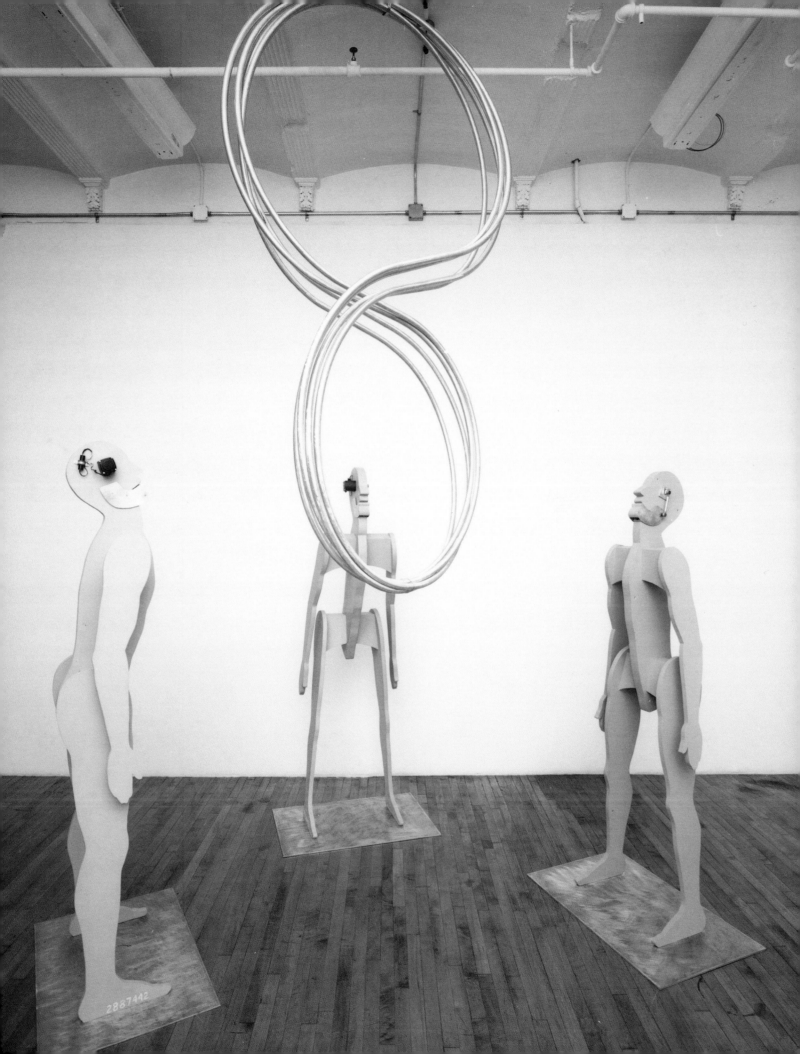

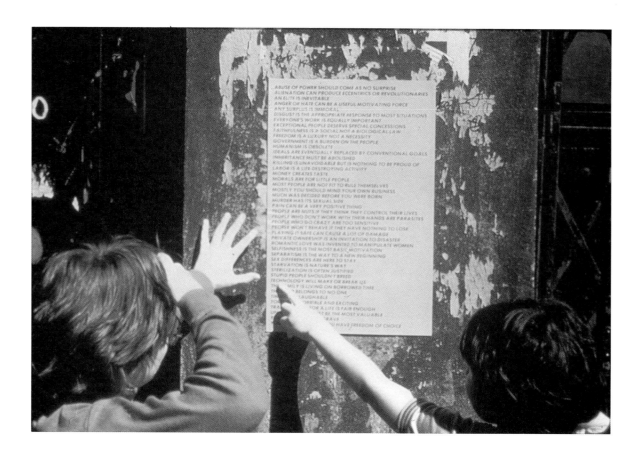

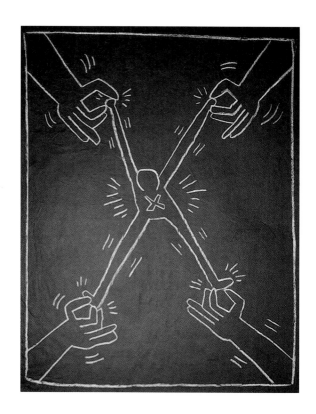

top: **Jenny Holzer**
Truisms, 1978-79
Offset posters
Set of eight; 36 x 24 each
Unlimited, unsigned edition
Courtesy Barbara Gladstone Gallery,
New York City

bottom: **Keith Haring**
Untitled, 1985
Chalk on black paper
40 x 29
Private collection
Photo: courtesy University Galleries,
Illinois State University, Normal

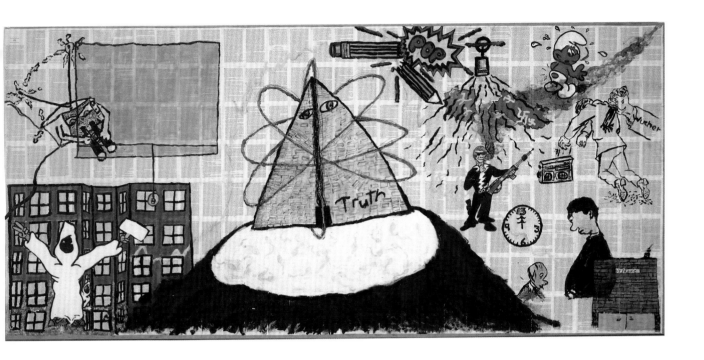

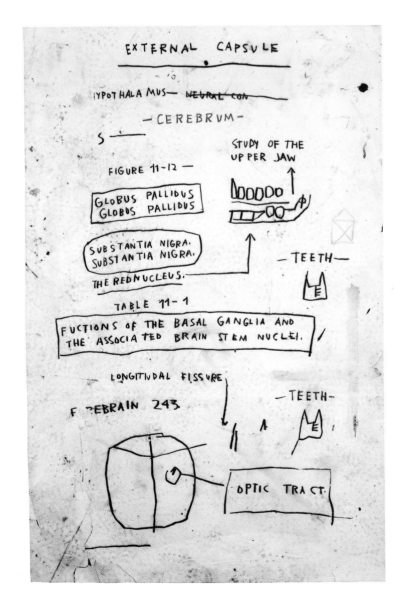

top: **Tim Rollins + K.O.S.**
Ignorance Is Strength, 1981-83
Mixed media on book pages mounted
on linen
57 x 124
Collection Barry and Arlene Hockfield,
Penn Valley, Pennsylvania
Photo: courtesy Lawrence Oliver
Gallery, Philadelphia

bottom: **Jean Michel
Basquiat**
Untitled (External Capsule), 1983
Acrylic and oilstick on paper
38 x 25¼
Courtesy Robert Miller Gallery,
New York City

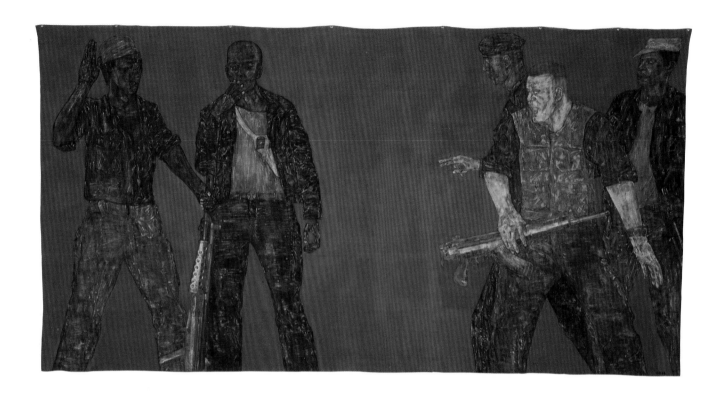

top: **Leon Golub**
Mercenaries IV, 1980
Oil on canvas
120 x 230
Saatchi Collection, London
Photo: courtesy Josh Baer Gallery,
New York City

bottom: **Jeff Wall**
Mimic, 1982
Cibachrome transparency
back-illuminated with fluorescent light,
mounted in display case
78 x 90
Fredrik Roos Collection, Switzerland
Photo: courtesy Marian Goodman
Gallery, New York City

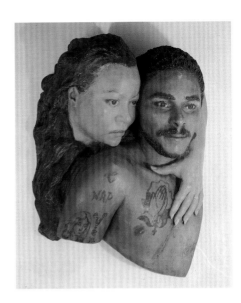

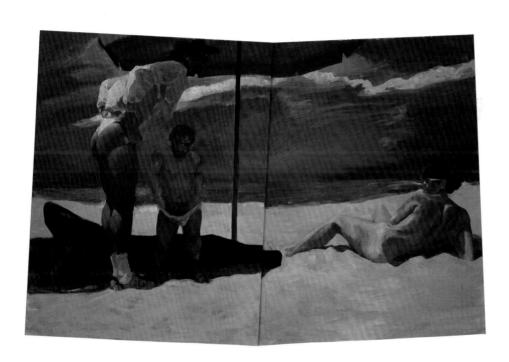

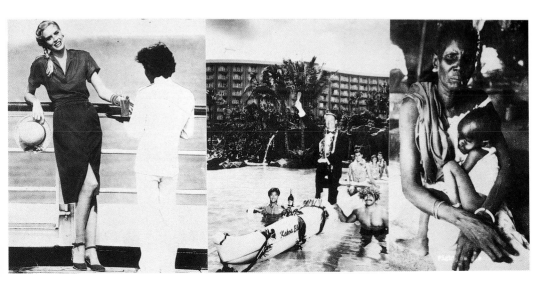

top: **John Ahearn**
Mario and Norma, 1979-83
Acrylic on cast plaster
22½ x 17 x 7½
Collection Earl and Betsy Millard,
St. Louis
Photo: courtesy Brooke Alexander,
New York City

Eric Fischl
Costa del Sol, 1986
Oil on canvas
103 x 156½
Collection Douglas S. Cramer
Foundation, North Hollywood, California

bottom: **Adrian Piper**
Ur Mutter #10, 1989
Photocollage with silkscreen text
36 x 88½
Courtesy John Weber Gallery,
New York City

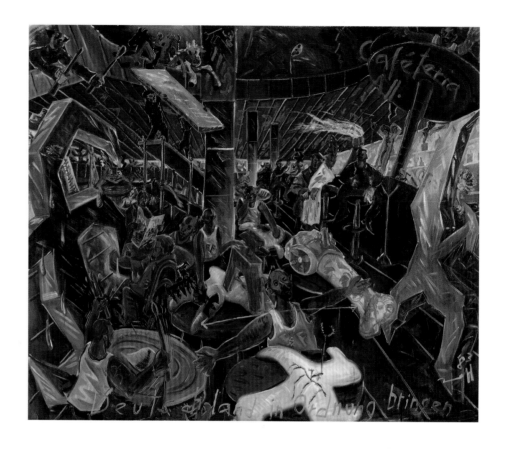

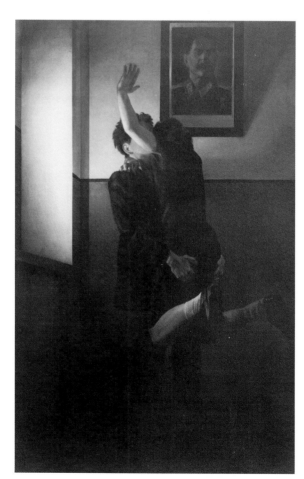

top: **Jörg Immendorff**
Deutschland in Ordnung Bringen, 1983
Oil on canvas
111 x 130
Collection Norman and Irma Braman,
Miami
Photo: courtesy Michael Werner Gallery,
New York City

bottom: **Vitaly Komar and
Alexander Melamid**
Thirty Years Ago 1953, 1982-83
Oil on canvas
72 x 47
Collection Refco Group, Ltd.
Photo: courtesy Ronald Feldman Fine
Arts, New York City

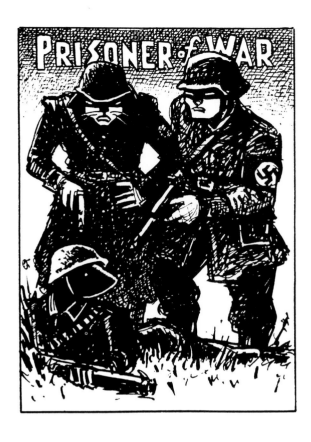

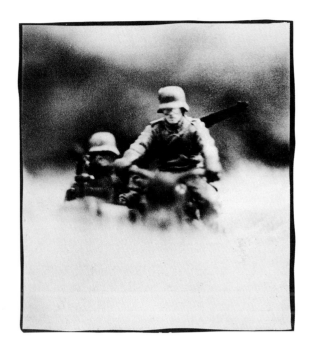

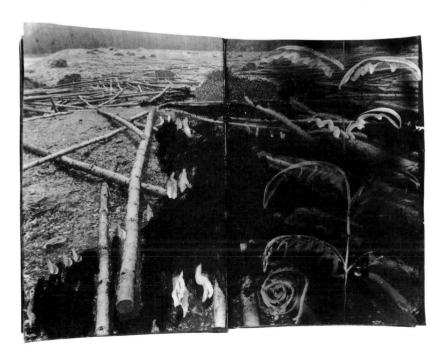

top: **Art Spiegelman**
Drawings for "Prisoners of War,"
Chapter three of *Maus: A Survivor's
Tale*, 1982
Ink on paper
Twenty-eight pages with title page
(illustrated)
8½ x 11 each
Courtesy the artist

middle: **David Levinthal**
Untitled (from *Hitler Moves East*), 1974
Kodalith print
8¾ x 7¾
Courtesy Laurence Miller Gallery,
New York City
Photo: courtesy the artist

bottom: **Anselm Kiefer**
Johannisnacht IV (Midsummer Night IV),
1980
Book of thirty-two double-page photo-
graphic images with acrylic, emulsion,
and graphite mounted on cardboard
and bound.
23⅛ x 16½ x 4⅝
Collection Marian Goodman,
New York City
Photo: courtesy Marian Goodman
Gallery, New York City
(Not in exhibition)

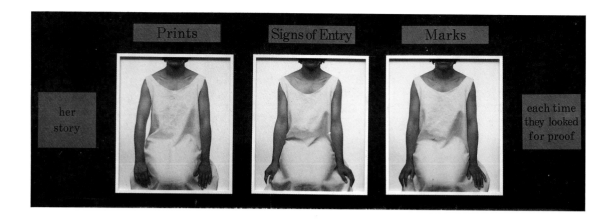

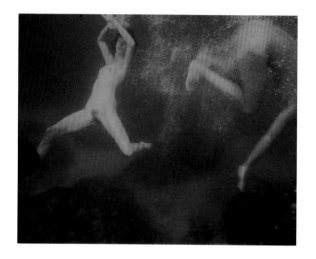

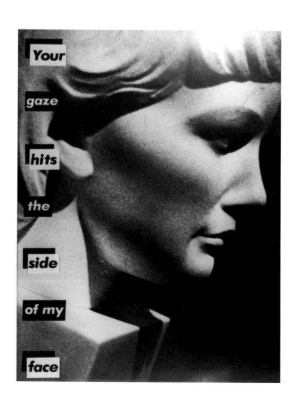

top: **Lorna Simpson**
Three Seated Figures, 1989
Three color Polaroids with five plastic
plaques
24 X 70 overall
Edition of 2
Arthur and Carol Goldberg Collection,
New York City
Photo: courtesy Josh Baer Gallery, New
York City

middle: **Laurie Simmons**
Calumny (Parade), 1981
Color photograph
16 x 20
Edition of 10
Courtesy Metro Pictures, New York City

bottom: **Barbara Kruger**
Untitled (Your gaze hits the side of my
face), 1981
Photograph
55 x 41
Collection Vijak Mahdavi/Bernardo
Nadal-Ginard, Boston
Photo: courtesy Mary Boone Gallery,
New York City

Elizabeth Murray
Force of Circumstance (for Simone de Beauvoir), 1986
Oil on canvas
Two panels: 122 x 150¼ x 13 overall
Saatchi Collection, London
Photo: courtesy Paula Cooper Gallery,
New York City

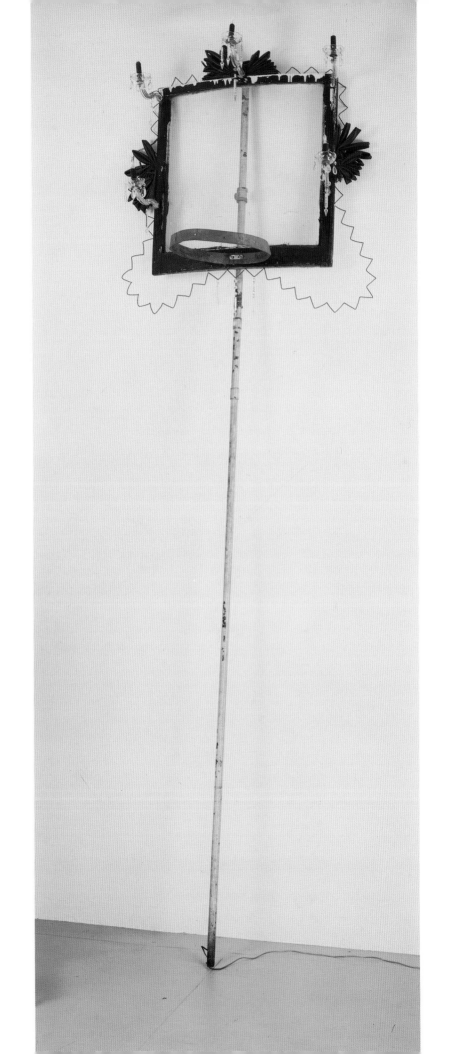

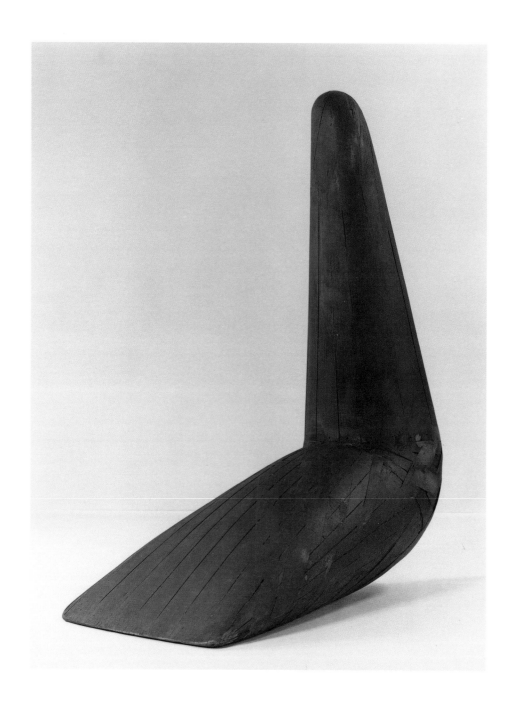

Martin Puryear
Lever (#4), 1989
Painted red cedar
96 x 81 x 43
Collection Mr. and Mrs Harry W.
Anderson, Atherton, California

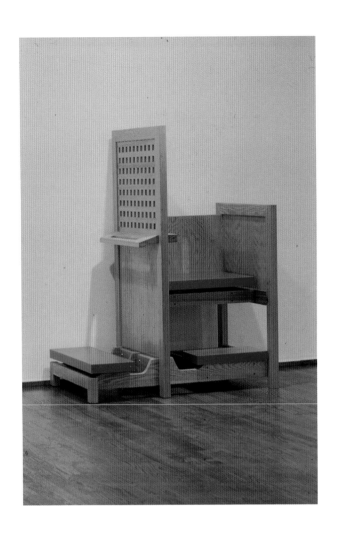

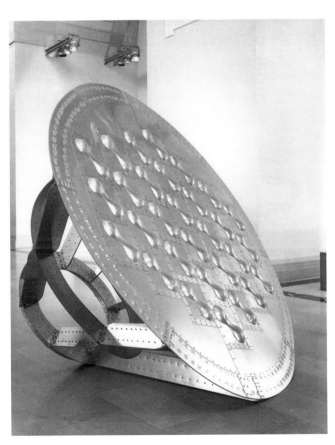

top: **Richard Artschwager**
Tower III (Confessional), 1980
Formica on wood
60 x 47 x 32
Saatchi Collection, London
Photo: courtesy Leo Castelli Gallery,
New York City

bottom: **Richard Deacon**
More Light, 1987-88
Plywood and aluminum
106 x 132 x 79
Collection Saint Louis Art Museum;
purchase, with funds given by Mr. and
Mrs. James E. Schneithorst, the
Siteman Contemporary Art Fund,
Aurelia and George Schlapp, and the
Contemporary Art Fund

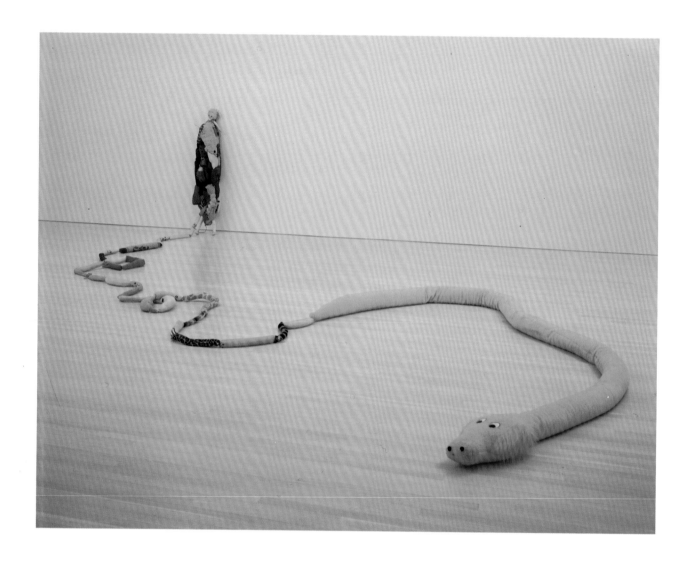

Mike Kelley
Eviscerated Corpse, 1989
Stuffed toys
99½ x 166
Collection Lannan Foundation,
Los Angeles

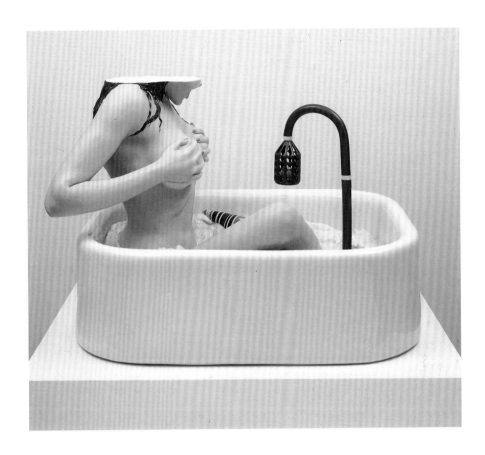

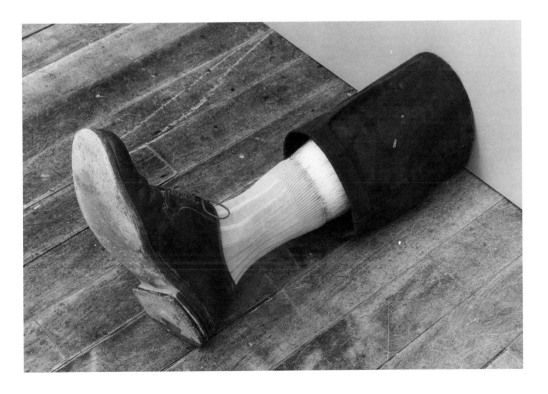

top: **Jeff Koons**
Woman in Tub, 1988
Porcelain
24¾ x 36 x 27
Edition of 3
Collection Leo Castelli, New York City
Photo: courtesy Sonnabend Gallery,
New York City

bottom: **Robert Gober**
Untitled Leg, 1989-90
Wax, cotton, leather, wood, human hair
12½ x 5 x 20
Collection Elaine and Werner
Dannheisser, New York City
Photo: courtesy Paula Cooper Gallery,
New York City

opposite: **Ilya Kabakov**
The Man Who Flew into His Picture,
1981 and 1988 (from *Ten Characters*)
Installation consisting of diptych,
noticeboard, twenty-eight drawings,
four-panel text, chair
Diptych: 102½ x 150½; noticeboard: 47 x
42½; twenty-eight drawings: 13 x 9 each;
four-panel text: 13¼ x 46; overall dimen-
sions variable
Courtesy Ronald Feldman Fine Arts,
New York City

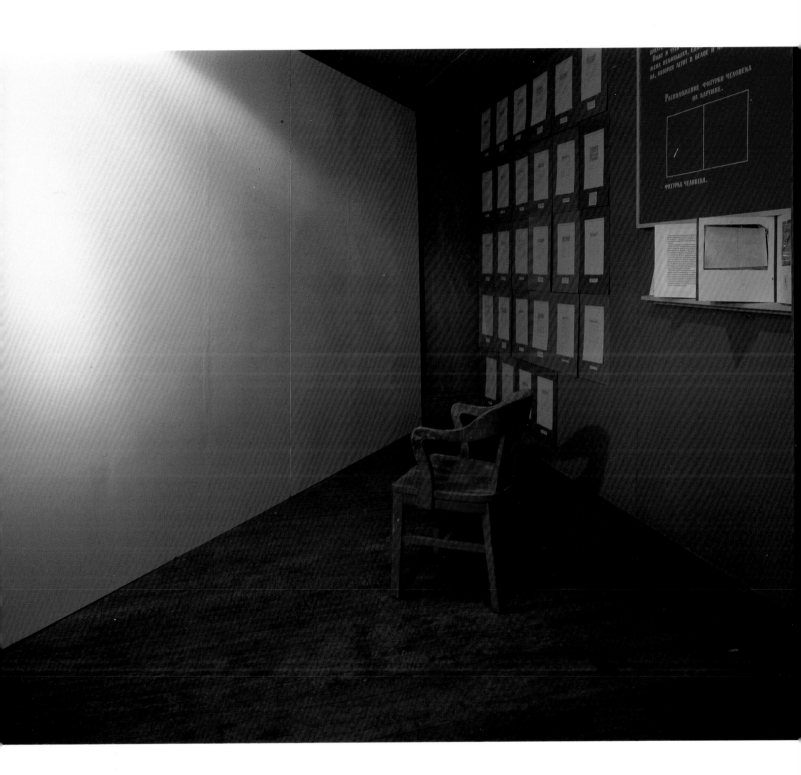

top: **Brice Marden**
Green (Earth), 1983-84
Oil on canvas
84 x 109
Courtesy Pace Gallery, New York City
Photo: courtesy Mary Boone Gallery,
New York City

bottom: **Robert Ryman**
Pace, 1984
Lascaux acrylic on fiberglass with wood
and aluminum
59⅝ x 26 x 27
Courtesy Galerie Lelong,
New York City

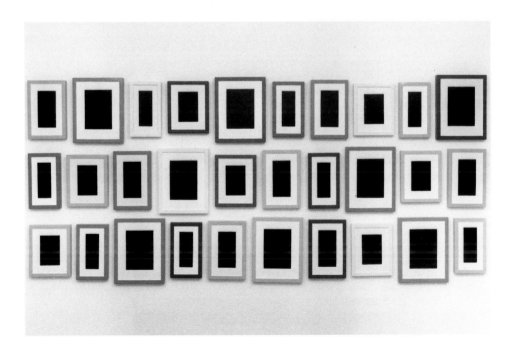

top left: **Sherrie Levine**
Untitled (Broad Stripe: 5), 1985
Casein on wood
24 x 20
Collection Raymond J. Learsy,
New York City
Photo: courtesy Mary Boone Gallery,
New York City

top right: **Andres Serrano**
Circle of Blood, 1987
Cibachrome
40 x 60
Edition of four
Courtesy of the artist and Stux Gallery,
New York City

bottom: **Allan McCollum**
30 Plaster Surrogates No. 4, 1990
Enamel on solid-cast Hydrocal
Dimensions variable
Courtesy John Weber Gallery,
New York City
(Variation of work in exhibition)

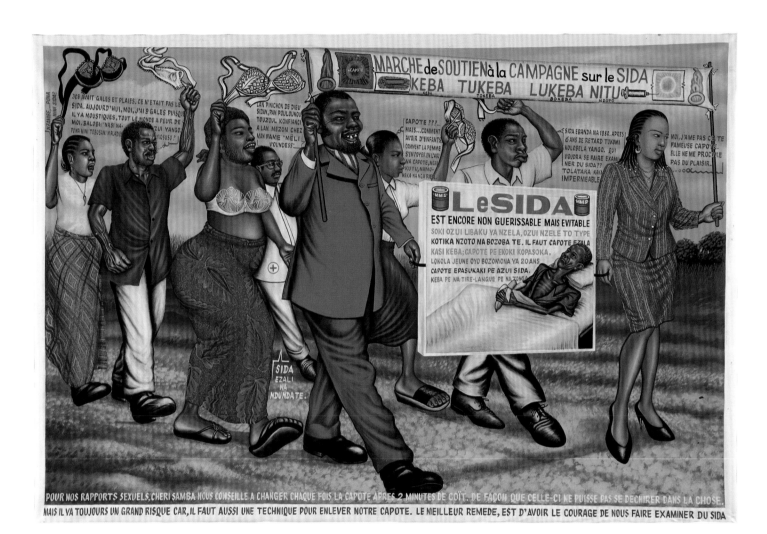

Chéri Samba
Marche de Soutien à la Campagne sur le SIDA [March in Support of the AIDS Campaign], 1989
Oil on canvas
53½ x 78¾
Collection Musée National d'Art Moderne, Centre Georges Pompidou, Paris

"If I had a dollar to spend for healthcare I'd rather spend it on a baby or innocent person with some defect or illness not of their own responsibility; not some person with Aids... " says the healthcare official on national television and this is in the middle of an hour long video of people dying on camera because they can't afford the limited drugs available that might extend their lives and I can't even remember what this official looked like because I reached in through the t.v. screen and ripped his face in half and I was diagnosed with Arc recently and this was after the last few years of losing count of the friends and neighbors who have been dying slow vicious and unnecessary deaths because fags and dykes and junkies are expendable in this country "If you want to stop Aids shoot the queers..." says the governor of texas on the radio and his press secretary later claims that the governor was only joking and didn't know the microphone was turned on and besides they didn't think it would hurt his chances for re-election anyways and I wake up every morning in this killing machine called america and I'm carrying this rage like a blood filled egg and there's a thin line between the inside and the outside a thin line between thought and action and that line is simply made up of blood and muscle and bone and I'm waking up more and more from daydreams of tipping amazonian blowdarts in 'infected blood' and spitting them at the exposed necklines of certain politicians or government healthcare officials or those thinly disguised walking swastika's that wear religious garments over their murderous intentions or those rabid strangers parading against Aids clinics in the nightly news suburbs there's a thin line a very thin line between the inside and the outside and I've been looking all my life at the signs surrounding us in the media or on peoples lips; the religious types outside st. patricks cathedral shouting to men and women in the gay parade: "You won't be here next year - you'll get Aids and die ha ha..." and the areas of the u.s.a. where it is possible to murder a man and when brought to trial one only has to say that the victim was a queer and that he tried to touch you and the courts will set you free and the difficulties that a bunch of republican senators have in albany with supporting an anti-violence bill that includes 'sexual orientation' as a category of crime victims there's a thin line a very thin line and as each T-cell disappears from my body it's replaced by ten pounds of pressure ten pounds of rage and I focus that rage into non-violent resistance but that focus is starting to slip my hands are beginning to move independent of self-restraint and the egg is starting to crack america seems to understand and accept murder as a self defense against those who would murder other people and its been murder on a daily basis for eight count them eight long years and we're expected to pay taxes to support this public and social murder and we're expected to quietly and politely make house in this windstorm of murder but I say there's certain politicians that had better increase their security forces and there's religious leaders and healthcare officials that had better get bigger dogs and higher fences and more complex security alarms for their homes and queer-bashers better start doing their work from inside howitzer tanks because the thin line between the inside and the outside is beginning to erode and at the moment I'm a thirty seven foot tall one thousand one hundred and seventy-two pound man inside this six foot frame and all I can feel is the pressure all I can feel is the pressure and the need for release

David Wojnarowicz
Untitled (Hujar Dead), 1988-89
Acrylic and collage on Masonite
39 x 32
Courtesy Burt Minkoff, Steven Johnson,
and Walter Sudal, New York City
Photo: courtesy P.P.O.W., New York City

opposite: **Louise Lawler**
Vacuum Cleaner, 1988
Cibachrome
26 x 39
Lent by the artist, courtesy Metro
Pictures, New York City

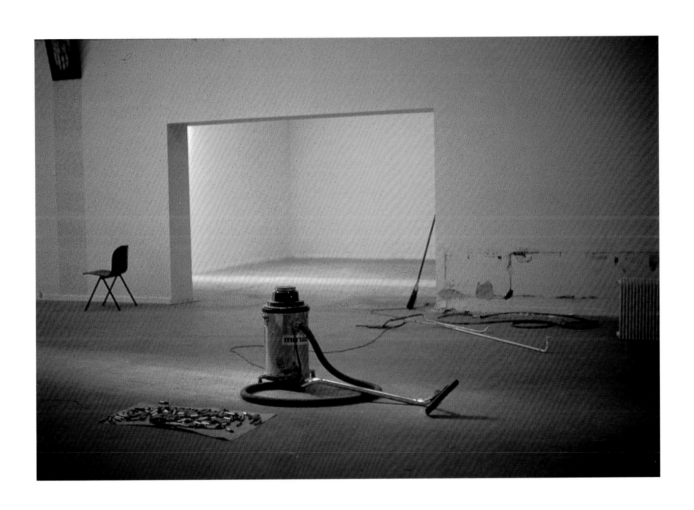

Dimensions are in inches; height precedes width precedes depth.
*Illustrated in catalogue.
†Presented only at the Institute of Contemporary Art, Philadelphia.
††Presented only at Newport Harbor Art Museum, Newport Harbor, California.

John Ahearn
*Mario and Norma, 1979-83
Acrylic on cast plaster
22½ x 17 x 7½
Collection Earl and Betsy Millard, St. Louis

John Ahearn
Clyde, 1982
Oil on fiberglass
26 x 15 x 9
Collection PaineWebber Group Inc., New York City

John Ahearn
Tom, 1983
Acrylic on cast plaster
24½ x 23½ x 10½
Collection Martin Sklar, New York City

John Ahearn
Pedro's Sister, Lettie, 1984
Acrylic on cast plaster
20 x 20 x 9
Speyer Family Collection, New York City

Ida Applebroog
*Noble Fields, 1987
Oil on canvas
Five panels: 86 x 132 overall
Collection Solomon R. Guggenheim Museum, New York City; gift of Stewart and Judy Colton, 1987

Richard Artschwager
*Tower III (Confessional), 1980
Formica on wood
60 x 47 x 32
Saatchi Collection, London

John Baldessari
*Running Man/Man Carrying Box, 1988-90
Black-and-white photographs, vinyl paint, oil tint
48 x 105
Courtesy Sonnabend Gallery, New York City

Jean Michel Basquiat
Untitled, 1982
Oilstick on paper
42½ x 30⅛
Principle Management, Ltd., Dublin

Jean Michel Basquiat
Untitled, 1982
Graphite and masking tape on paper
23 x 14½
Courtesy Robert Miller Gallery, New York City

Jean Michel Basquiat
Untitled (21st April 1945), 1983
Oilstick on paper
38 x 25⅛
Courtesy Robert Miller Gallery, New York City

Jean Michel Basquiat
*Untitled (External Capsule), 1983
Acrylic and oilstick on paper
38 x 25¼
Courtesy Robert Miller Gallery, New York City

Jean Michel Basquiat
Untitled (Harlem Air Shaft), 1985
Crayon, oilstick, colored pencil on paper
41¾ x 29⅝
Courtesy Robert Miller Gallery, New York City

Joseph Beuys
Ja Ja Ja Ja, Nee Nee Nee Nee, 1970
Audiotape made from original record
Collection Jürgen Becker, Hamburg
Courtesy Josh Baer Gallery, New York City

Ross Bleckner
*One Day Fever, 1986
Oil on linen
48 x 40
Collection Achille and Ida Maramotti, Albinea, Italy
Courtesy Mary Boone Gallery, New York City

Ross Bleckner
*Remember Me, 1987
Oil on canvas
110¼ x 86
Collection Mr. and Mrs. John Pappajohn, Des Moines
Courtesy Mary Boone Gallery, New York City

Jonathan Borofsky
*Spinning Figure 8 with Three Chattering Men, 1986
Figure 8: aluminum tubing, motor, cable
96 x 48
Men: aluminum, wood, Bondo primer, electric motor, speaker
82½ x 24 x 13 each
Courtesy Paula Cooper Gallery, New York City

Louise Bourgeois
* †Spiral Woman, 1984
Bronze with slate disk
Bronze: 11½ x 3½ x 4½
Slate: 34¾ diameter
Collection Elaine and Werner Dannheisser, New York City

Francesco Clemente
*What I Saw and What I See, 1990
Pigment on linen
91 x 122
Courtesy Sperone Westwater Gallery, New York City

Richard Deacon
*More Light, 1987-88
Plywood and aluminum
106 x 132 x 79
Collection Saint Louis Art Museum; purchase, with funds given by Mr. and Mrs. James E. Schneithorst, Siteman Contemporary Art Fund, Aurelia and George Schlapp, and Contemporary Art Fund

Eric Fischl
* †Costa del Sol, 1986
Oil on canvas
103 x 156½
Collection Douglas S. Cramer Foundation, North Hollywood, California

Robert Gober
Two Doors, 1989
Wood, enamel paint
Each door: 84 x 31 x 1½; overall: 84 x 73 x 1½
Courtesy Thomas Ammann, Zurich

Robert Gober
* †Untitled Leg, 1989-90
Wax, cotton, leather, wood, human hair
12½ x 5 x 20
Collection Elaine and Werner Dannheisser, New York City

Nan Goldin
Man and Woman in Slips, 1980
Color photograph
20 x 24
Courtesy Pace/MacGill Gallery, New York City

Nan Goldin
Vivienne in the Green Dress, New York City, 1980
Color photograph
20 x 24
Courtesy Pace/MacGill Gallery, New York City

Nan Goldin
Cookie at Tin Pan Alley, 1983
Color photograph
20 x 24
Courtesy Pace/MacGill Gallery, New York City

Nan Goldin
Nan after Being Battered, 1984
Color photograph
20 x 24
Courtesy Pace/MacGill Gallery, New York City

Nan Goldin
Suzanne in the Green Bathroom, Pergamon Museum, East Berlin, 1984
Color photograph
20 x 24
Courtesy Pace/MacGill Gallery, New York City

Nan Goldin
April Crying at 7th and B, New York City, 1985
Color photograph
20 x 24
Courtesy Pace/MacGill Gallery, New York City

Leon Golub
Mercenaries IV, 1980
Oil on canvas
120 x 230
Saatchi Collection, London

David Hammons
High Falutin', 1990
Metal (some parts painted with oil), oil on wood, glass, rubber, velvet, plastic, and electric bulbs
158 x 48 x 30½
Collection Museum of Modern Art, New York City; Robert and Meryl Meltzer Fund and purchase, 1990

Keith Haring
Untitled, 1982
Chalk on black paper
46 x 29
Collection Barry Blinderman, Bloomington, Illinois

Keith Haring
*Untitled, 1985
Chalk on black paper
40 x 29
Private collection

Keith Haring
Untitled, 1983
Chalk on black paper
83 x 41
Collection Larry Warsh, New York City

Keith Haring
Untitled, 1984
Chalk on black paper
80 x 42
Collection Michael and Cynthia Sweeney, New York City

Keith Haring
Untitled (Still Alive in '85), 1985
Chalk on black paper
46 x 29
Courtesy Arts Four, Paris

Jenny Holzer
Truisms, 1978-79
Offset posters
Set of eight: 36 x 24 each
Unlimited, unsigned edition
Courtesy Barbara Gladstone Gallery, New York City

Jörg Immendorff
* †*Deutschland in Ordnung Bringen,* 1983
Oil on canvas
111 x 130
Collection Norman and Irma Braman, Miami

Ilya Kabakov
The Man Who Flew into His Picture, 1981 and 1988 (from *Ten Characters*)
Installation consisting of diptych, noticeboard, twenty-eight drawings, four-panel text, chair
Diptych: 102½ x 150½; noticeboard: 47 x 42½; twenty-eight drawings: 13 x 9 each; four-panel text: 13¼ x 46; overall dimensions variable
Courtesy Ronald Feldman Fine Arts, New York City

Mike Kelley
Eviscerated Corpse, 1989
Stuffed toys
99½ x 166
Collection Lannan Foundation, Los Angeles

Anselm Kiefer
†*Johannisnacht III* [Midsummer Night III], 1980
Book of twenty-three double-page photographs with synthetic polymer paint and graphite mounted on cardboard, and cover of graphite and synthetic polymer paint on paper mounted on cardboard, bound with cloth
23¾ x 17¾ x 5
Collection Museum of Modern Art, New York City; gift of Agnes Gund, 1991

Anselm Kiefer
Kyffhäuser, 1980-81
Book of twenty-three double-page photographs with oil and emulsion mounted on cardboard and bound
23¾ x 16½ x 3¼
Collection Francesco and Alba Clemente, New York City

Vitaly Komar and Alexander Melamid
†*The Red Flag,* 1982-83
Oil on canvas
96 x 80
Collection Refco Group, Ltd.

Vitaly Komar and Alexander Melamid
Thirty Years Ago 1953, 1982-83
Oil on canvas
72 x 47
Collection Refco Group, Ltd.

Jeff Koons
Woman in Tub, 1988
Porcelain
24¾ x 36 x 27
Edition of 3
Collection Leo Castelli, New York City

Barbara Kruger
*Untitled (Your gaze hits the side of my face), 1981
Photograph
55 x 41
Collection Vijak Mahdavi/Bernardo Nadal-Ginard, Boston
Courtesy Mary Boone Gallery, New York City

Louise Lawler
MoCA, 1986
Cibachrome
26¼ x 39
Lent by the artist, courtesy Metro
Pictures, New York City

Louise Lawler
You Could Hear a Rat Piss on Cotton, 1987
Cibachrome
26¼ x 39
Lent by the artist, courtesy Metro
Pictures, New York City

Louise Lawler
Vacuum Cleaner, 1988
Cibachrome
26 x 39
Lent by the artist, courtesy Metro
Pictures, New York City

Sherrie Levine
Untitled (Broad Stripe: 3), 1985
Casein on wood
24 x 20
Collection Vijak Mahdavi/Bernardo
Nadal-Ginard, Boston
Courtesy Mary Boone Gallery, New
York City

Sherrie Levine
Untitled (Broad Stripe: 4), 1985
Casein on wood
24 x 20
Fredrik Roos Collection, Switzerland

Sherrie Levine
*Untitled (Broad Stripe: 5), 1985
Casein on wood
24 x 20
Collection Raymond J. Learsy, New
York City
Courtesy Mary Boone Gallery, New
York City

Sherrie Levine
Untitled (Broad Stripe: 12), 1985
Casein on wood
24 x 20
Collection Richard and Lois Plehn,
New York City
Courtesy Mary Boone Gallery, New
York City

David Levinthal
Untitled (from *Hitler Moves East*), 1974
Kodalith print
8 x 7⅜
Courtesy Laurence Miller Gallery,
New York City

David Levinthal
Untitled (from *Hitler Moves East*),
1974
Kodalith print
10½ x 13
Courtesy Laurence Miller Gallery,
New York City

David Levinthal
Untitled (from *Hitler Moves East*),
1974
Kodalith print
10⅝ x 13½
Courtesy Laurence Miller Gallery,
New York City

David Levinthal
*Untitled (from *Hitler Moves East*),
1974
Kodalith print
8¾ x 7¾
Courtesy Laurence Miller Gallery,
New York City

David Levinthal
Untitled (from *Hitler Moves East*),
1974
Kodalith print
9 x 11⅛
Courtesy Laurence Miller Gallery,
New York City

David Levinthal
Untitled (from *Hitler Moves East*),
1974
Kodalith print
9½ x 11¼
Courtesy Laurence Miller Gallery,
New York City

Brice Marden
* †*Green (Earth),* 1983-84
Oil on canvas
84 x 109
Courtesy Pace Gallery, New York
City

Allan McCollum
30 Plaster Surrogates, 1991
Enamel on solid-cast Hydrocal
Dimensions variable
Courtesy John Weber Gallery, New
York City

Ana Mendieta
Untitled, 1982-84
Drawings on leaves
5 x 3 to 8 x 4½
Courtesy Galerie Lelong, New York
City

Ana Mendieta
Nacida del Nilo [Nile Born], 1984
Sand and binder on wood
61½ x 19½ x 2½
Courtesy Galerie Lelong, New York
City

Elizabeth Murray
Painter's Progress, 1981
Oil on canvas
Nineteen parts: 116 x 93 overall
Collection Museum of Modern Art,
New York City; acquired through the
Bernhill Fund and gift of Agnes
Gund, 1983

Elizabeth Murray
*Force of Circumstance (for Simone
de Beauvoir),* 1986
Oil on canvas
Two parts: 122 x 150¼ x 13 overall
Saatchi Collection, London

Bruce Nauman
Marching Figure, 1985
Color pencil and watercolor on
paper
77 x 65½
Collection Donald Young, Seattle

Adrian Piper
Ur Mutter #10, 1989
Photocollage with silkscreen text
36 x 88½
Courtesy John Weber Gallery, New
York City

Sigmar Polke
Reaganbild I-III, 1980
Dispersion on linen
Five parts: 77½ x 181½ overall
Courtesy Michael Werner Gallery,
New York City

Martin Puryear
Lever (#4), 1989
Painted red cedar
96 x 81 x 43
Collection Mr. and Mrs. Harry W.
Anderson, Atherton, California

Gerhard Richter
*Untitled 545-4, 1983
Oil on canvas
27¾ x 19⅞
Collection Betty Harris, Chicago

Gerhard Richter
* †697 Schwann (2), 1989
Oil on canvas
118 x 98½
Collection Katherine and Keith
Sachs, Rydal, Pennsylvania

Tim Rollins + K.O.S.
* †Ignorance Is Strength, 1981-83
Mixed media on book pages mount-
ed on linen
57 x 124
Collection Barry and Arlene
Hockfield, Penn Valley, Pennsylvania

Susan Rothenberg
Red Head, 1980-81
Acrylic and flashe on canvas
107 x 114
Private collection

Susan Rothenberg
*Bone Heads, 1989-90
Oil on canvas
77 x 152
Collection Eli and Edythe L. Broad,
Los Angeles

Robert Ryman
*Pace, 1984
Lascaux acrylic on fiberglass with
wood and aluminum
59⅝ x 26 x 27
Courtesy Galerie Lelong, New York
City

David Salle
*Muscular Paper, 1985
Acrylic and oil on canvas and
printed fabric
98 x 187½
Collection Douglas S. Cramer
Foundation, North Hollywood,
California

Chéri Samba
*Marche de Soutien à la Campagne
sur le SIDA [March in Support of the
AIDS Campaign], 1989
Oil on canvas
53½ x 78¾
Collection Musée National d'Art
Moderne, Centre Georges
Pompidou, Paris

Andres Serrano
Milk Blood, 1986
Cibachrome
40 x 60
Edition of 4
Collection Ezra Mack, New York City
Courtesy Stux Gallery, New York City

Andres Serrano
*Circle of Blood, 1987
Cibachrome
40 x 60
Edition of 4
Courtesy of the artist and Stux
Gallery, New York City

Cindy Sherman
Untitled #92, 1981
Color photograph
24 x 48
Collection Martin Sklar, New York
City

Cindy Sherman
*Untitled #122, 1988
Color photograph
74½ x 45¾
Saatchi Collection, London

Laurie Simmons
Walking Underwater, 1980
Color photograph
20 x 24
Edition of 10
Collection Carroll Dunham, New
York City

Laurie Simmons
White Man Coming, 1981
Color photograph
14 x 11
Edition of 10
Collection Carroll Dunham, New
York City

Laurie Simmons
Red Man Going, 1981
Color photograph
14 x 11
Edition of 10
Collection Carroll Dunham, New
York City

Laurie Simmons
*Calumny (Parade), 1981
Color photograph
16 x 20
Edition of 10
Collection Carroll Dunham, New
York City

Laurie Simmons
Boy/Bottle Green Background, 1981
Color photograph
8 x 10
Edition of 10
Lent by the artist, courtesy Metro
Pictures, New York City

Lorna Simpson
*Three Seated Figures, 1989
Three color Polaroids with five
plastic plaques
24 x 70 overall
Edition of 2
Arthur and Carol Goldberg
Collection, New York City

Nancy Spero
* ††Notes in Time on Women II, 1979
Typewritten collage, handprinted
collage, and handprinting on paper
Twenty-two panels: 20 x 210 feet
overall
Courtesy Josh Baer Gallery, New
York City

Nancy Spero
†Vulture Goddess, 1991
Site-specific installation
Handprinting on wall

Art Spiegelman
*Drawings for "Prisoners of War,"
chapter three of Maus: A Survivor's
Tale, 1982
Ink on paper
Twenty-eight pages, 8½ x 11 each
Courtesy the artist

Jeff Wall
* †Mimic, 1982
Cibachrome transparency back-
illuminated with fluorescent light,
mounted in display case
78 x 90
Fredrik Roos Collection, Switzerland

The Witness Project, 1989-present
Compilation of names of people in
the arts who have died of AIDS
Chairpersons: Jerry Saltz and Simon
Watson

David Wojnarowicz
Peter Hujar Dreaming/Yukio
Mishima St. Sebastian, 1982
Spray paint on Masonite
48 x 48
Collection Evan Lurie, New York City

David Wojnarowicz
*Untitled (Hujar Dead), 1988-89
Acrylic and collage on Masonite
39 x 32
Courtesy Burt Minkoff, Steven
Johnson, and Walter Sudal, New
York City

Note: The following information has been selected from more extensive histories, with the intention of emphasizing the time and place that each artist emerged on the art scene. For artists whose careers were established well before the eighties, the focus is on their activities during the decade in review rather than the earlier period. In a number of cases, the content reflects what the artists themselves deemed the significant events in their careers (as they indicated in their response to a brief questionnaire).

John Ahearn

Born 1951, Binghamton, New York.
Lives in Bronx, New York.
Cornell University, Ithaca, New York, B.F.A., 1973.

Selected Individual Exhibitions
1979 "South Bronx Hall of Fame," Fashion Moda, Bronx, New York.
1982 Galerie Rudolf Zwirner, Cologne.
1983 "John Ahearn and Rigoberto Torres: Recent Sculpture from Dawson Street," Brooke Alexander, New York City.
1985 "John Ahearn and Rigoberto Torres: Portraits from the Bronx: Life Casts from 1979 to Present," Bronx Museum of the Arts, Bronx, New York.
"Investigations 11" (with Rigoberto Torres), Institute of Contemporary Art, Philadelphia. Brochure with text by Ann Jarmusch.

Selected Group Exhibitions
1978 "Batman Show," 591 Broadway, New York City.
1980 "Times Square Show," New York City. Organized by Collaborative Projects.
Lisson Gallery, London.
1981 "Westkunst—Heute," Museen der Stadt, Cologne. Catalogue.
"Figures: Forms and Expressions," Albright-Knox Art Gallery, CEPA Gallery, and Hallwalls, Buffalo. Catalogue.
1982 "74th American Exhibition," Art Institute of Chicago. Catalogue with text by Anne Rorimer.
"New Figuration in America," Milwaukee Art Museum. Catalogue with text by Russell Bowman and Peter Schjeldahl.
1983 "Art and Social Change, U.S.A.," Allen Memorial Art Museum, Oberlin, Ohio. Catalogue with text by David Deitcher, Jerry Kearns, Lucy R. Lippard, William Olander, and Craig Owens.
1984 "Content: A Contemporary Focus, 1974-84," Hirshhorn Museum and Sculpture Garden, Washington, D.C. Catalogue with text by Howard Fox, Miranda McClintic, and Phyllis Rosenzweig.

Selected Bibliography
deAk, Edit. "John Ahearn, 'We Are Family' 877 Intervale Avenue, the Bronx." *Artforum* (November 1982): 73-74.
Lippard, Lucy R. "Real Estate and Real Art a la Fashion Moda." Seven Days (April 1980): 32-34.
_____. "Sex and Death and Shock and Schlock: A Long Review of the Times Square Show." *Artforum* (October 1980).
Ricard, Rene. "Radiant Child." *Artforum* (November 1981).
Rickey, Carrie. "John Ahearn, New Museum Windows." *Artforum* (March 1980): 75.
Robinson, Walter. "Art Strategies: The 80s." *Addix Magazine* (1979).

Ida Applebroog

Born 1929, Bronx, New York.
Lives in New York City.
New York Institute of Applied Arts and Sciences, B.A., 1950.
School of the Art Institute of Chicago, 1965-68.

Selected Individual Exhibitions
1973 Newport Harbor Art Museum, Newport Beach, California.
1976 Women's Inter-Art Center, New York City.
1978 Whitney Museum of American Art (Film and Video Department), New York City.
1979 "Manuscripts," Franklin Furnace, New York City.
Williams College Museum of Art, Williamstown, Massachusetts.
1980 Rotterdam Arts Foundation.
Ronald Feldman Fine Arts, New York City.
1981 Galleria del Cavallino, Venice.
1982 Nigel Greenwood Gallery, London.
"Projects at the Chamber: Past Events," Great Hall, Chamber of Commerce, New York City. Catalogue with text by Nancy Princenthal.
"Current Events," Ronald Feldman Fine Arts, New York City.
1983 "Common Causes," Koplin Gallery, Los Angeles.
1984 Chrysler Museum, Norfolk, Virginia.
Carl Solway Gallery, Cincinnati.
"Inmates and Others," Ronald Feldman Fine Arts, New York City.
1985 Real Art Ways, Hartford.
1986 "Investigations 16," Institute of Contemporary Art, Philadelphia. Brochure with text by Judith Tannenbaum.
1987 "Matrix 96," Wadsworth Atheneum, Hartford. Brochure with text by Andrea Miller-Keller.
1989 High Museum of Art, Atlanta. Catalogue with text by Susan Krane.
1990 "Ida Applebroog: Happy Families, A Fifteen-Year Survey," Contemporary Arts Museum, Houston. Traveled to The Power Plant, Toronto. Catalogue with text by Marilyn Zeitlin, Thomas Sokolowski, and Lowery Sims.

Selected Group Exhibitions
1972 "21 Artists: Invisible/Visible," Long Beach Art Museum, California. Catalogue with text by Judy Chicago and Dextra Frankel.
1977 "The Proscenium: The Staged Words of Ida Applebroog, Manny Farber, and Patricia Patterson," Institute for Art and Urban Resources, P.S. 1, Long Island City, New York.
1979 "With a Certain Smile," Halle für international neue Kunst (INK), Zurich.
1983 "Directions '83," Hirshhorn Museum and Sculpture Garden, Washington, D.C. Catalogue with text by Phyllis Rosenzweig.
1984 "An International Survey of Recent Painting and Sculpture," Museum of Modern Art, New York City. Catalogue with text by Kynaston McShine.
1987 "Documenta 8," Kassel, West Germany. Catalogue.
1989 "Making Their Mark: Women Artists Move into the Mainstream, 1970-1985," Cincinnati Art Museum. Traveled to Pennsylvania Academy of the Fine Arts, Philadelphia, among others. Catalogue.

Selected Bibliography
Bass, Ruth. "Ordinary People." *ArtNews* (May 1988): 151-54.
Feldman, Ronald, and Carrie Rickey, Lucy R. Lippard, Linda F. McGreevy, and Carter Ratcliff. *Ida Applebroog.* New York: Ronald Feldman Fine Arts, 1987.
McGreevy, Linda F. "Chiliastic Reflections on the Old Adage, `Three's the Charm.'" *Arts Magazine* (January 1985): 93-102.
Schor, Mira. "Medusa Redux." *Artforum* (March 1990): cover, 116-22.
Schwendenwien, Jude. "Social Surrender: An Interview with Ida Applebroog." *Real Life Magazine* (Winter 1987): 40-44.

Richard Artschwager

Born 1923, Washington, D.C.
Lives in New York City.
Cornell University, B.A., 1948.

Selected Individual Exhibitions
1965 Leo Castelli Gallery, New York City.
1968 Galerie Konrad Fischer, Düsseldorf.
1975 Leo Castelli Gallery, New York City.
1979 "Zu Gast in Hamburg—Richard Artschwager," Kunstverein, Hamburg. Traveled to Neue Galerie—Sammlung Ludwig, Aachen, West Germany. Catalogue with text by Catherine Kord.
"Richard Artschwager's Theme(s)," Albright-Knox Art Gallery, Buffalo. Traveled to Institute of Contemporary Art, Philadelphia; La Jolla Museum of Contemporary Art, California; and Contemporary Arts Museum, Houston. Catalogue with text by Richard Armstrong, Linda L. Cathcart, and Suzanne Delehanty.
1980 "Sculpture by Richard Artschwager," Rhode Island School of Design, Providence.
Daniel Weinberg Gallery, San Francisco.
1981 "Richard Artschwager: Paintings and Objects from 1962-1979," Young-Hoffman Gallery, Chicago.
Leo Castelli Gallery, New York City.
1982 "Richard Artschwager: New Work," Susanne Hilberry Gallery, Birmingham, Michigan.
1983 Mary Boone Gallery, New York City.
Daniel Weinberg Gallery, Los Angeles.
1984 "Matrix 82," University Art Museum, Berkeley. Traveled to Wadsworth Atheneum, Hartford. Brochure with text by Constance Lewallen.
1985 Kunsthalle, Basel. Traveled to Stedelijk van Abbemuseum, Eindhoven, Netherlands, and CAPC, Musée d'Art Contemporain de Bordeaux, France. Catalogue with text by Jean-Christophe Ammann.
1988 "Artschwager, Richard," Whitney Museum of American Art, New York City. Traveled to San Francisco Museum of Modern Art and Museum of Contemporary Art, Los Angeles. Catalogue with text by Richard Armstrong.

Selected Group Exhibitions
1966 "Primary Structures," Jewish Museum, New York City. Catalogue with text by Kynaston McShine.
1969 "Live in Your Head. When Attitudes Become Form: Works—Concepts—Processes—Situations—Information," Kunsthalle, Bern. Catalogue with text by Scott Burton, Gregoire Muller, Harald Szeemann, and Tommaso Trini.
1974 "American Pop Art," Whitney Museum of American Art, New York City. Catalogue with text by Lawrence Alloway.
1977 "Improbable Furniture," Institute of Contemporary Art, Philadelphia. Traveled to La Jolla Museum of Contemporary Art, California. Catalogue with text by Suzanne Delehanty and Robert Pincus-Witten.
1981 "Rooms: Installations by Richard Artschwager, Cynthia Carlson, Richard Haas," Hayden Gallery, Massachusetts Institute of Technology, Cambridge.
1982 "Documenta 7," Kassel, West Germany. Catalogue.
1983 "Biennial Exhibition," Whitney Museum of American Art, New York City. Catalogue.
1984 "Content: A Contemporary Focus, 1974-1984," Hirshhorn Museum and Sculpture Garden, Washington, D.C. Catalogue with text by Howard Fox, Miranda McClintic, and Phyllis Rosenzweig.
1986 "In Tandem: The Painter-Sculptor in the Twentieth Century," Whitechapel Art Gallery, London. Catalogue.
1987 "Skulptur Projekte in 1987, Münster." Organized by Westfälisches Landesmuseum, Münster, West Germany. Catalogue with text by Klaus Bussman and Kasper Koenig.
"Similia/Dissimilia: Modes of Abstraction in Painting, Sculpture, and Photography Today," Kunsthalle, Düsseldorf. Traveled. Catalogue with text by Ascan Crone.

Selected Bibliography
Ammann, Jean-Christophe. "Richard Artschwager," in *Art of Our Time: The Saatchi Collection.* London: Lund Humphries, 1984.
Bleckner, Ross. "Transcendent Anti-Fetishism." *Artforum* (March 1979): 50-55.
Kuspit, Donald B. "Richard Artschwager." *Artforum* (April 1988). van Bruggen, Coosje. "Richard Artschwager." *Artforum* (September 1983): 44-51.
Yau, John. "Richard Artschwager's Linear Investigations." *Drawing* (January-February 1985).

John Baldessari

Born 1931, National City, California.
Lives in Santa Monica, California.
San Diego State University, California, B.A., 1953; M.A., 1957.

Selected Individual Exhibitions
1960 Art Center, La Jolla, California.
1970 Richard Feigen Gallery, New York City.
1971 Art and Project, Amsterdam.
1975 Stedelijk Museum, Amsterdam.
1978 "Blasted Allegories," Sonnabend Gallery, New York City.
1979 Halle für internationale neue Kunst (INK), Zurich. Catalogue.
1980 "Fugitive Essays," Sonnabend Gallery, New York City.
1981 "John Baldessari: Work 1966-1981," The New Museum of Contemporary Art, New York City. Traveled to Contemporary Arts Center, Cincinnati, and Contemporary Arts Museum, Houston. Catalogue with text by Marcia Tucker and Robert Pincus-Witten.
Stedelijk van Abbemuseum, Eindhoven, Netherlands. Traveled to Folkwang Museum, Essen, West Germany. Catalogue with text by Rudi Fuchs and the artist.
1985 Le Consortium, Centre d'Art Contemporain, Dijon, France.
1986 "Matrix 94," University Art Museum, Berkeley, California. Brochure with text by Constance Lewallen.
"John Baldessari: California Viewpoints," Santa Barbara Museum of Art, California. Catalogue with text by Hunter Drohojowska.
1987 "Composition for Violin and Voices (Male)," Centre National d'Art Contemporain de Grenoble, France. Catalogue.
1988 "John Baldessari: Photoarbeiten," Kestner-Gesellschaft, Hannover, West Germany. Catalogue with text by Carl Haenlein and Germano Celant.
1990 Museum of Contemporary Art, Los Angeles. Traveled to Hirshhorn Museum and Sculpture Garden, Washington, D.C.; Walker Art Center, Minneapolis; Whitney Museum of American Art, New York City, among others. Catalogue with text by Coosje van Bruggen.

Selected Group Exhibitions
1969 "Pop Art," Hayward Gallery, London. Catalogue with text by John Russell and Suzi Gablik.
1970 "Information," Museum of Modern Art, New York City. Catalogue with text by Kynaston McShine.
1972 "Venice Biennale." Catalogue.
"Documenta 5," Kassel, West Germany. Catalogue.
1975 "Video Art," Institute of Contemporary Art, Philadelphia. Traveled to Contemporary Art Center, Cincinnati; Museum of Contemporary Art, Chicago; and Wadsworth Atheneum, Hartford. Catalogue.
1978 "Art about Art," Whitney Museum of American Art, New York City. Traveled to Portland Art Museum, Oregon, among others. Catalogue with text by Leo Steinberg, Jean Lipman, and Richard Marshall.
1979 "Biennial Exhibition," Whitney Museum of American Art, New York City. Catalogue.

1981 "Westkunst—Heute," Museen der Stadt, Cologne. Catalogue.
1982 "Documenta 7," Kassel, West Germany. Catalogue.
"74th American Exhibition," Art Institute of Chicago. Catalogue with text by Anne Rorimer.
1985 "Carnegie International," Museum of Art, Carnegie Institute, Pittsburgh. Catalogue.
1986 "Individuals: A Selected History of Contemporary Art, 1945-1986," Museum of Contemporary Art, Los Angeles. Catalogue.
1987 "This Is Not a Photograph: Twenty Years of Large-Scale Photography, 1966-1986," John and Mable Ringling Museum of Art, Sarasota, Florida. Traveled to Akron Art Museum, Ohio, and Chrysler Museum, Norfolk, Virginia. Catalogue with text by Joseph Jacobs and Marvin Heiferman.
"Avant-Garde in the Eighties," Los Angeles County Museum of Art. Catalogue with text by Howard Fox.
"25 años de selección y de actividad: Colección Sonnabend," Centro de Arte Reina Sofia, Madrid. Traveled to Hamburger Bahnhof, West Berlin, and Galleria Nazionale d'Arte Moderna, Rome, among others. Catalogue.

Selected Bibliography
Foster, Hal. "John Baldessari's `Blasted Allegories.'" *Artforum* (October 1979): 52-55.
Owens, Craig. "Telling Stories." *Art in America* (May 1981): 29-35.
Selwyn, Marc. "John Baldessari." *Flash Art* (Summer 1987): 62-64.
Siegel, Jeanne. "John Baldessari: Recalling Ideas." *Arts Magazine* (April 1988): 86-89.

Jean Michel Basquiat

Born 1960, Brooklyn, New York.
Died 1988, New York City.

Selected Individual Exhibitions
1981 Annina Nosei Gallery, New York City.
1982 Gagosian Gallery, Los Angeles.
Mario Diacono Gallery, Rome.
Galerie Bruno Bischofberger, Zurich.
Fun Gallery, New York City.
1983 Akira Ikeda Gallery, Tokyo.
1984 Mary Boone Gallery, New York City. Catalogue with essay by A. R. Penck.
"Jean Michel Basquiat Paintings 1981-1984," Fruitmarket Gallery, Edinburgh. Traveled to Institute of Contemporary Art, London, and Museum Boymans-van Beuningen, Rotterdam. Catalogue with text by Mark Francis.
1986 Galerie Thaddaeus Ropac, Salzburg. Catalogue.
1987 Tony Shafrazi Gallery, New York City.
1990 "Jean Michel Basquiat: A Survey of Drawings," Robert Miller Gallery, New York City. Catalogue with text by Robert Storr.

Selected Group Exhibitions
1981 "New York—New Wave," Institute for Art and Urban Resources, P.S. 1, Long Island City, New York.
1982 "Documenta 7," Kassel, West Germany. Catalogue.
"Biennial Exhibition," Whitney Museum of American Art, New York City. Catalogue.
1983 "Post-Graffiti Art," Sidney Janis Gallery, New York City.
"Mary Boone and Her Artists," Seibu Museum, Tokyo. Catalogue.
1984 "An International Survey of Recent Painting and Sculpture," Museum of Modern Art, New York City. Catalogue with text by Kynaston McShine.
"The East Village Scene," Institute of Contemporary Art, Philadelphia. Catalogue with text by Janet Kardon, Carlo

McCormick, and Irving Sandler.
"Figuration Libre France/USA," Musée d'Art Moderne de la Ville de Paris.
"Aspekte Amerikanischer Kunst der Gegenwart," Neue Galerie—Sammlung Ludwig, Aachen, West Germany.
1985 "Collaborations—Basquiat, Clemente, and Warhol," Akira Ikeda Gallery, Tokyo.
1986 "Zeichen, Symbole, Graffiti in der aktuellen Kunst," Suermondt-Ludwig Museum and Museumverein, Aachen, West Germany.
1988 "Collaborations—Andy Warhol, Jean Michel Basquiat," Mayor Gallery, London.
1989 "Jean Michel Basquiat/Julian Schnabel," Rooseum, Malmo, Sweden. Catalogue with text by Jeffrey Deitch.

Selected Bibliography
Davvetas, Demosthenes. "Lines, Chapters, and Verses: The Art of Jean Michel Basquiat." *Artforum* (April 1987): 116-20.
Faflick, Philip. "SAMO Graffiti: Boosh-Wah or CIA?" *The Village Voice* (11 December 1978).
Geldzahler, Henry. "Art from Subways to SoHo: Jean Michel Basquiat." *Interview* (January 1983).
Hoban, Phoebe. "Samo Is Dead." *New York* (26 September 1988): 36-44.
McGuigan, Cathleen. "New Art, New Money—The Marketing of an American Artist." *The New York Times Magazine* (10 February 1985).
Thompson, Robert Farris. *Jean Michel Basquiat.* Hannover, West Germany: Kestner-Gesellschaft, 1986.

Joseph Beuys

Born 1921, Krefeld, West Germany.
Died 1986, Düsseldorf, West Germany.
Kunstakademie, Düsseldorf, 1947-52.

Selected Individual Exhibitions
1965 "How To Explain Paintings To a Dead Hare," Galerie Schmela, Düsseldorf.
1967 Städtisches Museum Mönchengladbach, West Germany. Catalogue.
1968 Stedelijk van Abbemuseum, Eindhoven, Netherlands. Catalogue with text by Otto Mauer.
1974 "The Secret Block for a Secret Person in Ireland," Museum of Modern Art, Oxford. Traveled to National Gallery of Modern Art, Edinburgh; Institute of Contemporary Art, London; Municipal Gallery of Modern Art, Dublin; and Arts Council Gallery, Belfast. Catalogue with text by Caroline Tisdale and Nicholas Serota.
1979 Solomon R. Guggenheim Museum, New York City. Catalogue with text by Caroline Tisdale.
"News from the Coyote," Ronald Feldman Fine Arts, New York City.
1981 Galerie Schellmann and Klüser, Munich.
1983 Musée Cantonal des Beaux-Arts, Lausanne. Catalogue.
"Vitrines—Forms of the '60s," Anthony d'Offay, London.
1984 Seibu Museum of Art, Tokyo.
1986 "Lighting with Stag in Its Glare," Galerie Rudolf Zwirner, Cologne.
1987 "Beuys vor Beuys: Frühe Arbeiten aus der Sammlung van der Grinten," Adademie der Künste der DDR, East Berlin. Traveled. Catalogue.
1988 Dia Art Foundation, New York City. Catalogue with text by Gary Garrels and Charles Wright.
"Joseph Beuys—Sculptures and Objects," Martin-Gropius-Bau, West Berlin. Traveled. Catalogue with text by Heiner Bastian et al.

Selected Group Exhibitions
1974 "Art into Society, Society into Art: Duchamp, Warhol, Beuys," Institute of Contemporary Art, London. Catalogue.
1977 "The Honey Pump at Your Workplace," at "Documenta

6," Kassel, West Germany. Catalogue.
1980 "Das Kapital Raum 1970-77," at "Venice Biennale." Catalogue.
1982 "7,000 Oaks" at "Documenta 7," Kassel, West Germany. Catalogue.
"Zeitgeist," Martin-Gropius-Bau, West Berlin. Catalogue.
1987 "Brennpunkt Düsseldorf," Kunstmuseum, Düsseldorf. Traveled. Catalogue.
"Warhol/Beuys/Polke," Milwaukee Art Museum. Traveled to Contemporary Arts Museum, Houston. Catalogue with text by Donald B. Kuspit.
"Documenta 8," Kassel, West Germany. Catalogue.

Selected Bibliography
Artstudio (Spring 1987). Entire issue devoted to Beuys.
Buchloh, Benjamin H. D. "Beuys: The Twilight of the Idol: Preliminary Notes for a Critique." *Artforum* (January 1980): 35-43.
Harlan, Volker. *Was ist Kunst? Werstattgesprache mit Beuys.* Stuttgart, 1986.
Morgan, Stewart. "Interview with Joseph Beuys." *Parkett* (January 1986): 64-73.
Raussmuller-Sauer, Christel, ed. *Joseph Beuys.* Schaffhausen 1988.
Stachelhaus, Heiner. *Joseph Beuys.* Düsseldorf, 1987.
Staeck, Klaus, and Gerhard Steidl. *Beuys in Amerika.* Heidelberg, 1987.
Verspohl, Franz-Joachim. *Joseph Beuys, Das Kapital/Raum 1970-77.* Frankfurt, 1984.
Vischer, Theodora. *Beuys und die Romantik.* Cologne, 1983.

Ross Bleckner

Born 1949, New York City.
Lives in New York City.
New York University, B.A., 1972.
California Institute of the Arts, Valencia, M.F.A., 1973.

Selected Individual Exhibitions
1975 Cuningham-Ward Gallery, New York City.
1979 Mary Boone Gallery, New York City.
1980 Mary Boone Gallery, New York City.
1982 Patrick Verelst Galerie, Antwerp.
Portico Row Gallery, Philadelphia.
1984 Nature Morte, New York City.
1986 Mario Diacono Gallery, Boston.
1987 Margo Leavin Gallery, Los Angeles.
1988 Waddington Gallery, London. Catalogue with text by Peter Schjeldahl.
San Francisco Museum of Modern Art. Brochure with text by John R. Lane.
1989 Galerie Max Hetzler, Cologne.
Milwaukee Art Museum. Traveled to Contemporary Arts Museum, Houston; Carnegie Museum of Art, Pittsburgh; and Art Gallery of Ontario, Toronto. Catalogue with text by Dean Sobel.

Selected Group Exhibitions
1975 Paula Cooper Gallery, New York City.
1979 "New Painting/New York," Hayward Gallery, London.
1981 "Tenth Anniversary Exhibition," California Institute of the Arts, Valencia.
1984 "The Meditative Surface," Renaissance Society, University of Chicago.
1986 "Endgame: Reference and Simulation in Recent American Painting and Sculpture," Institute of Contemporary Art, Boston. Catalogue with text by Thomas Crow, Yve-Alain Bois, Elisabeth Sussman, et al.
1987 "New York Art Now: The Saatchi Collection," London. Catalogue.
"Biennial Exhibition," Whitney Museum of American Art, New York City. Catalogue.

1988 "Carnegie International," Carnegie Museum of Art, Pittsburgh. Catalogue.
"The BiNational: American Art of the Late Eighties," Museum of Fine Arts and Institute of Contemporary Art, Boston; Städtische Kunsthalle and Kunstsammlung Nordheim-Westfalen, Düsseldorf. Catalogue.
1989 "10 + 10," Modern Art Museum of Fort Worth, Texas. Traveled. Catalogue.

Selected Bibliography
Cameron, Dan. "On Ross Bleckner's `Atmosphere' Paintings." *Arts Magazine* (February 1987): 30-33.
Halley, Peter. "Ross Bleckner: Painting at the End of History." *Arts Magazine* (May 1982).
Liebmann, Lisa. "Ross Bleckner's Mood Indigo." *ArtNews* (May 1988): 128-33.
Mantegna, Gianfranco. "The Ellipse of Reality: Ross Bleckner." *Tema Celeste* (May 1987): 35-39, 77-78.
Morgan, Stuart. "Strange Days." *Artscribe* (March 1988): 48-51.
Pincus-Witten, Robert. "Defenestrations: Robert Longo and Ross Bleckner." *Arts Magazine* (November 1982): 94-95.
Rankin, Aimee. "Ross Bleckner." *BOMB* (April 1987): 22-27.
Steir, Pat. "Where the Birds Fly, What the Lines Whisper." *Artforum* (May 1987): 107-11.
Wei, Lilly. "Talking Abstract." *Art in America* (July 1987): 80-97.

Jonathan Borofsky

Born 1942, Boston, Massachusetts.
Lives in Maine.
Carnegie-Mellon University, Pittsburgh, B.F.A., 1964.
Yale School of Art and Architecture, New Haven, M.F.A., 1966.

Selected Individual Exhibitions
1973 Artists Space, New York City.
1975 Paula Cooper Gallery, New York City.
1978 "I Dreamed I Found a Red Ruby," Corps de Garde, Groningen, Netherlands.
"Projects," Museum of Modern Art, New York City.
1979 Halle für internationale neue Kunst (INK), Zurich.
1980 "2699475—Jonathan Borofsky: An Installation," Hayden Gallery, Massachusetts Institute of Technology, Cambridge. Catalogue with interview by Kathy Halbreich.
1981 "Jonathan Borofsky: Dreams, 1973-81," Kunsthalle, Basel. Catalogue with text by Joan Simon.
Institute of Contemporary Art, London. Catalogue.
1982 "Werkers," Museum Boymans-van Beuningen, Rotterdam.
Museum van Hedendaagse Kunst, Ghent. Catalogue with text by Jan Hoet.
1983 "Jonathan Borofsky: Zeichnungen 1960-1983," Kunstmuseum, Basel. Traveled to Städtisches Kunstmuseum, Bonn; Kunstverein, Hamburg; Kunsthalle, Bielefeld; Mannheimer Kunstverein; and Moderna Museet, Stockholm. Catalogue with text by Christian Geelhaar and Dieter Koepplin.
1984 Israel Museum, Jerusalem. Catalogue.
Philadelphia Museum of Art. Traveled to Whitney Museum of American Art, New York City; University Art Museum, Berkeley, California; Walker Art Center, Minneapolis; Corcoran Gallery of Art, Washington, D.C.; and Museum of Contemporary Art, Los Angeles. Catalogue with text by Mark Rosenthal and Richard Marshall.
1987 Tokyo Metropolitan Art Museum. Traveled to Museum of Modern Art, Shiga, Japan.

Selected Group Exhibitions
1969 "No. 7," Paula Cooper Gallery, New York City.
1976 "International Events '72-76: Venice Biennale." Catalogue.
1980 "Art in the Seventies—Aperto '80: Venice Biennale." Catalogue.

1981 "Westkunst—Heute," Museen der Stadt, Cologne. Catalogue.
"Murs," Musée National d'Art Moderne, Centre Georges Pompidou, Paris. Catalogue.
1982 "New Work on Paper 2," Museum of Modern Art, New York City. Catalogue with text by Bernice Rose.
"Documenta 7," Kassel, West Germany. Catalogue.
"Zeitgeist," Martin-Gropius-Bau, West Berlin. Catalogue.
1983 "Biennial Exhibition," Whitney Museum of American Art, New York City. Catalogue.
1984 "An International Survey of Recent Painting and Sculpture," Museum of Modern Art, New York. Catalogue with text by Kynaston McShine.
1985 "Carnegie International," Museum of Art, Carnegie Institute, Pittsburgh. Catalogue.
"Bienal de São Paulo," Brazil. Catalogue.
1987 "L'Epoque, La Mode, La Morale, La Passion: Aspects de l'art d'aujourd'hui 1977-87," Musée National d'Art Moderne, Centre Georges Pompidou, Paris. Catalogue.
"Avant-Garde in the Eighties," Los Angeles County Museum of Art. Catalogue with text by Howard Fox.

Selected Bibliography
Borofsky, Jonathan. "STRIKE: A Project by Jonathan Borofsky." *Artforum* (February 1981): 50-55.
_____. "Dreams." *The Paris Review* (Winter 1981): 89-101.
Silverthorne, Jeanne. "Jonathan Borofsky: What Kind of Fool Is This?" *Artforum* (February 1985): 52-54.
Simon, Joan. "An Interview with Jonathan Borofsky." *Art in America* (November 1981): 156-67.
Zelevansky, Lynn. "Jonathan Borofsky's Dream Machine." *ArtNews* (May 1984): 108-15.

Louise Bourgeois

Born 1911, Paris; moved to New York City in 1938.
Lives in New York City.
Sorbonne, Paris, 1932-35.
École du Louvre, 1936-37; École des Beaux-Arts, 1936-38; Académie de la Grande Chaumière, 1937-38.

Selected Individual Exhibitions
1949 Peridot Gallery, New York City.
1964 Stable Gallery, New York City.
1978 "Triangles: New Sculpture and Drawings," Xavier Fourcade Gallery, New York City.
Hamilton Gallery, New York City.
1980 "The Iconography of Louise Bourgeois," Max Hutchinson Gallery, New York City.
1981 "Louise Bourgeois: Femme Maison," Renaissance Society, University of Chicago.
1982 "Louise Bourgeois: Retrospective," Museum of Modern Art, New York City. Traveled to Contemporary Arts Museum, Houston; Museum of Contemporary Art, Chicago; and Akron Art Museum, Ohio. Catalogue with text by Deborah Wye.
1985 Serpentine Gallery, London.
1987 Taft Museum, Cincinnati. Traveled to Florida International University Art Museum, Miami; Laguna Gloria Art Museum, Austin, Texas; Washington University Art Gallery, St. Louis; Henry Art Gallery, Seattle; and Everson Museum of Art, Syracuse. Catalogue with text by Stuart Morgan.
1989 "Louise Bourgeois: A Retrospective Exhibition," Kunstverein, Frankfurt. Traveled to Städtische Galerie im Lenbachhaus, Munich; Riverside Studios, London; Musée d'Art Contemporain, Lyons; Fondación Tapies, Barcelona; Kunstmuseum, Bern; and Kröller-Müller Museum, Otterlo, Netherlands. Catalogue with text by Peter Weiermair, Lucy R. Lippard, Rosalind Krauss, et al.

Selected Group Exhibitions
1939 "Fine Prints for Mass Production," Brooklyn Museum, Brooklyn, New York.
1945 "Annual Exhibition of Contemporary American Painting," Whitney Museum of American Art, New York City.
"The Women," Art of This Century Gallery, New York City.
1981 "Figuratively Sculpting," Institute for Art and Urban Resources, P.S. 1, Long Island City, New York.
1983 "Biennial Exhibition," Whitney Museum of American Art, New York City. Catalogue.
1984 "Content: A Contemporary Focus, 1974-1984," Hirshhorn Museum and Sculpture Garden, Washington, D.C. Catalogue with text by Howard Fox, Miranda McClintic, and Phyllis Rosenzweig.
"The Third Dimension: Sculpture of the New York School," Whitney Museum of American Art, New York City. Catalogue with text by Lisa Phillips.
"Primitivism in Twentieth Century Art: Affinity of the Tribal and the Modern," Museum of Modern Art, New York City. Catalogue with text by William Rubin et al.
1986 "Individuals: A Selected History of Contemporary Art, 1945-1986," Museum of Contemporary Art, Los Angeles. Catalogue.
1989 "Magicians de la Terre," Musée National d'Art Moderne, Centre George Pompidou, Paris. Catalogue with text by Jean-Hubert Martin et al.

Selected Bibliography
Bourgeois, Louise. "A Project by Louise Bourgeois." *Artforum* (December 1982): cover, 40-47.
Gardner, Paul. "The Discreet Charm of Louise Bourgeois." *ArtNews* (February 1980): 80-86.
Kirili, Alain. "The Passion for Sculpture—A Conversation with Louise Bourgeois." *Arts Magazine* (March 1989): 68-75.
Kuspit, Donald B. *Bourgeois: An Interview with Louise Bourgeois.* New York: Vintage Contemporary Artists, 1988.
Storr, Robert. "Louise Bourgeois: Gender and Possession." *Art in America* (April 1983): 128-37.
Thurman, Judith. "Artist's Dialogue, Passionate Self-Expression—The Art of Louise Bourgeois." *Architectural Digest* (November 1984): 234-46.

Francesco Clemente

Born 1952, Naples, Italy.
Lives in Rome, Madras, and New York City.
University of Rome, 1970.

Selected Individual Exhibitions
1971 Galleria Valle Giulia, Rome.
1975 Galleria Gian Enzo Sperone, Rome and Turin.
1978 Centre d'Art Contemporain, Geneva.
Galerie Paul Maenz, Cologne.
1979 Art and Project, Amsterdam.
1980 Sperone Westwater Fischer, New York City.
Padiglione d'Arte Contemporanea, Milan.
1981 Museum van Hedendaagse Kunst, Ghent.
"Matrix 46," University Art Museum, Berkeley, California. Traveled to Art Museum and Galleries, California State University, Long Beach, and Wadsworth Atheneum, Hartford. Brochure with text by Mark Rosenthal.
1982 Galerie Bruno Bischofberger, Zurich.
1983 "Francesco Clemente: The Fourteen Stations," Whitechapel Art Gallery, London. Traveled to Groninger Museum, Groningen, Netherlands; Badischer Kunstverein, Karlsruhe; Galerie d'Art Contemporain, Nice; and Moderna Museet, Stockholm. Catalogue with text by Mark Francis and Henry Geldzahler.
1984 "Francesco Clemente: Pastels 1973-1983," Nationalgalerie, West Berlin. Traveled to Museum Folkwang, Essen; Stedelijk Museum, Amsterdam; Fruitmarket Gallery, Edinburgh; and Kunsthalle,

Tübingen, West Germany. Catalogue with text by Rainer Crone et al.
1985 John and Mable Ringling Museum of Art, Sarasota, Florida. Traveled to Walker Art Center, Minneapolis; Dallas Museum of Art; University Art Museum, Berkeley; Albright-Knox Art Gallery, Buffalo; and Museum of Contemporary Art, Los Angeles. Catalogue with text by Michael Auping.
1987 "Francesco Clemente affreschi: Pinturas al fresco," Fundación Caja de Pensiones, Madrid. Catalogue with text by Henry Geldzahler, Rainer Crone, and Diego Cortez.
1988 "Francesco Clemente: Funerary Paintings," Dia Art Foundation, New York City.
1990 "Francesco Clemente: Three Worlds," Philadelphia Museum of Art. Traveled to Wadsworth Atheneum, Hartford, and San Francisco Museum of Modern Art. Catalogue with text by Ann Percy et al.

Selected Group Exhibitions
1973 "Italy Two," Civic Center Museum, Philadelphia. Catalogue.
1975 "Bienal de São Paulo," Brazil. Catalogue.
1980 "Aperto '80: Venice Biennale." Catalogue. "Westkunst—Heute," Museen der Stadt, Cologne. Catalogue.
1982 "Documenta 7," Kassel, West Germany. Catalogue.
1983 "Sandro Chia, Francesco Clemente, Enzo Cucchi," Kunsthalle, Bielefeld. Catalogue with interviews by Heiner Bastien.
1985 "Carnegie International," Museum of Art, Carnegie Institute, Pittsburgh. Catalogue.
"La Biennale de Paris."
1988 "Venice Biennale," Italian Pavilion.

Selected Bibliography
Berger, Danny. "Francesco Clemente at the Metropolitan: An Interview." *The Print Collector's Newsletter* (March-April 1982): 12. Reprinted in *An Exhibition and Sale of Francesco Clemente Prints 1981-1985.* New York: Metropolitan Museum of Art, 1985.
"Collaboration Francesco Clemente." *Parkett* (June 1986): 16-81. Contributions by David Shapiro, Francesco Pellizzi, Rainer Crone, and the artist.
Crone, Rainer, and Georgia Marsh. *Clemente: An Interview with Francesco Clemente.* New York: Vintage Books, 1987.
deAk, Edit. "A Chameleon in a State of Grace." *Artforum* (February 1981): 36-41.
Politi, Giancarlo. Interview. "Francesco Clemente." *Flash Art* (April-May 1984): 12-21.
Storr, Robert. "Realm of the Senses." *Art in America* (November 1987): 132-45, 199.
White, Robin. Interview. "Francesco Clemente." *View* 3 (November 1981): 1-28 (entire issue).

Richard Deacon

Born 1949, Bangor, Wales.
Lives in London.
Somerset College of Art, Taunton, 1968-69.
St. Martin's College of Art, London, B.A., 1972.
Royal College of Art, London, M.A.R.C.A., 1977.

Selected Individual Exhibitions
1978 "Spring Programme," The Gallery, Brixton, London.
1983 Lisson Gallery, London.
Orchard Gallery, Derry. Catalogue with text by Lynne Cooke.
1984 Riverside Studios, London.
"Richard Deacon—Sculpture 1980–84," Fruitmarket Gallery, Edinburgh. Traveled to Le Nouveau Musée, Villeurbanne, France. Catalogue with text by Michael Newman.
1986 Marian Goodman Gallery, New York City.
1987 "Richard Deacon—Recent Sculpture 1985-87,"

Bonnefantenmuseum, Maastricht, Netherlands. Traveled to Kunstmuseum, Lucerne; Fundación Caja de Pensiones, Madrid; and Museum van Hedendaagse Kunst, Ghent. Catalogue with text by Charles Harrison.
1988 "Distance No Object," Museum of Contemporary Art, Los Angeles.
Whitechapel Art Gallery, London. Catalogue with text by Lynne Cooke and Marjorie Allthorpe-Guyton.
1989 "10 Sculptures 1987-89," Musée d'Art Moderne de la Ville de Paris/ARC, Paris. Catalogue with text by Suzanne Page, Jerome Sans, and Richard Deacon.

Selected Group Exhibitions
1981 "Objects and Sculpture," Institute of Contemporary Art, London, and Arnolfini Gallery, Bristol. Catalogue with text by Lewis Bigg.
1982 "Englische Plastik Heute—British Sculpture Now," Kunstmuseum, Lucerne. Catalogue with text by Martin Kunz and Michael Newman.
1983 "New Art at the Tate Gallery," London. Catalogue with text by Michael Compton.
"Transformations: New Sculpture from Britain: Bienal de São Paulo," Brazil. Catalogue published by the British Council, London, with text on Richard Deacon by Lynne Cooke.
1984 "An International Survey of Recent Painting and Sculpture," Museum of Modern Art, New York City. Catalogue with text by Kynaston McShine.
1985 "Carnegie International," Museum of Art, Carnegie Institute, Pittsburgh. Catalogue.
1987 "A Quiet Revolution: British Sculpture since 1965," Museum of Contemporary Art, Chicago, and San Francisco Museum of Modern Art. Traveled to Newport Harbor Art Museum, Newport Beach, California; Hirshhorn Museum and Sculpture Garden, Washington, D.C.; and Albright-Knox Art Gallery, Buffalo. Catalogue with text by Mary Jane Jacob.
"Skulptur Projekte in 1987, Münster." Organized by Westfälisches Landesmuseum, Münster, West Germany. Catalogue with text by Klaus Bussman and Kasper Koenig.

Bibliography
Francis, Richard. Interview. *Richard Deacon Talking about For Those Who Have Ears No. 2 and Other Works,* London: Patrons of New Art, Tate Gallery, 1985.
Schjeldahl, Peter. *Richard Deacon* [exhibition catalogue]. New York: Marian Goodman Gallery, 1988.

Eric Fischl

Born 1948, New York City.
Lives in New York City.
California Institute of the Arts, Valencia, B.F.A., 1972.

Selected Individual Exhibitions
1975 Dalhousie Art Gallery, Halifax.
1978 Gallery B., Montreal.
1980 Edward Thorp Gallery, New York City.
1981 Sable-Castelli Gallery, Toronto.
1982 University of Colorado Art Galleries, Boulder.
1983 Gagosian Gallery, Los Angeles.
Mario Diacono Gallery, Rome.
Nigel Greenwood Gallery, London.
1984 Mary Boone Gallery, New York City.
1985 "Eric Fischl: Paintings," Mendel Art Gallery, Saskatoon, Saskatchewan. Traveled to Stedelijk van Abbemuseum, Eindhoven, Netherlands; Kunsthalle, Basel; Institute of Contemporary Art, London; Art Gallery of Ontario, Toronto; Museum of Contemporary Art, Chicago; and Whitney Museum of American Art, New York City. Catalogue with text by Bruce W. Ferguson, Jean-Christophe Ammann, and Donald B. Kuspit.

1988 Galerie Michael Werner, Cologne.
1990 Akademie der Bildenden Kunste, Vienna.
 "Scenes and Sequences: Recent Monotypes by Eric
 Fischl," Grunwald Center for the Graphic Arts,
 University of California, Los Angeles. Traveled to Walker
 Art Center, Minneapolis; Yale University Art Gallery,
 New Haven; and Hood Museum of Art, Dartmouth
 College, Hanover, New Hampshire. Book published by
 Hood Museum of Art, Dartmouth College, 1990; dis-
 tributed by Harry N. Abrams, New York. Text by
 E. L. Doctorow et al.

Selected Group Exhibitions
1976 "Seventeen Artists: A Protean View," Vancouver Art
 Gallery.
1978 "Neun Kanadische Kunstler," Kunsthalle, Basel.
 Edward Thorp Gallery, New York City.
1979 "The Great Big Drawing Show," Institute for Art and
 Urban Resources, P.S. 1, Long Island City, New York.
1982 "New Figuration in America," Milwaukee Art Museum.
 Catalogue with text by Russell Bowman and Peter
 Schjeldahl.
1983 "Biennial Exhibition," Whitney Museum of American
 Art, New York City. Catalogue.
1984 "Paradise Lost—Paradise Regained: Venice Biennale,"
 American Pavilion. Catalogue.
 "An International Survey of Recent Painting and
 Sculpture," Museum of Modern Art, New York City.
 Catalogue with text by Kynaston McShine.
1985 "Carnegie International," Museum of Art, Carnegie
 Institute, Pittsburgh. Catalogue.
1986 "Europa/Amerika," Museum Ludwig, Cologne. Catalogue.
 "Individuals: A Selected History of Contemporary Art,
 1945-1986," Museum of Contemporary Art, Los Angeles.
 Catalogue.
1987 "Past/Imperfect: Eric Fischl, Vernon Fisher, Laurie
 Simmons," Walker Art Center, Minneapolis. Traveled to
 Institute of Contemporary Art, Philadelphia, among oth-
 ers. Catalogue with text by Marge Goldwater.
 "Documenta 8," Kassel, West Germany. Catalogue.

Selected Bibliography
Danto, Arthur C. "Art: Eric Fischl." The Nation (31 May 1986):
769-72.
Grimes, Nancy. "Eric Fischl's Naked Truths." ArtNews
(September 1986): 70-78.
Lawson, Thomas. "Too Good To Be True." Real Life Magazine
(Fall 1981): 2-7.
Linker, Kate. "Eric Fischl: Involuted Narratives." Flash Art
(January 1984): 56-58.
Marzorati, Gerald. "I Will Not Think Bad Thoughts—An
Interview with Eric Fischl." Parkett (June 1985): 9-30.
Schjeldahl, Peter. "Post-Innocence: Eric Fischl and the Social
Fate of American Painting." Parkett (June 1985): 31-43.
Storr, Robert. "Desperate Pleasures." Art in America
(November 1984): 124-30.
Wechsler, Lawrence. "The Art of Eric Fischl." Interview (May
1988): 62-70.

Robert Gober

Born 1954, Wallingford, Connecticut.
Lives in New York City.
Middlebury College, Middlebury, Vermont, B.A., 1976.

Selected Individual Exhibitions
1984 "Slides of a Changing Painting," Paula Cooper Gallery,
 New York City.
1985 Daniel Weinberg Gallery, Los Angeles.
 "Recent Sculpture," Paula Cooper Gallery.
1987 Galerie Jean Bernier, Athens.
1988 Tyler School of Art, Temple University, Philadelphia.
 Brochure with text by Paolo Colombo.

Art Institute of Chicago. Brochure with text by Neal
Benezra.
Galerie Max Hetzler, Cologne.
Galerie Gisela Capitain, Cologne.
1990 Museum Boymans-van Beuningen, Rotterdam. Traveled
 to Kunsthalle, Bern. Catalogue with text by Karel
 Schampers, Ulrich Loock, and Trevor Fairbrother.

Selected Group Exhibitions
1979 "Amore Store," 112 Greene Street, New York City.
1981 "Domestic Situations: Three Look into American Home
 Life," Ian Berkstedt Gallery, New York City.
1986 "Objects from the Modern World: Richard Artschwager,
 R. M. Fischer, Robert Gober, Jeff Koons," Daniel
 Weinberg Gallery, Los Angeles.
 "Robert Gober and Kevin Larmon: An Installation,"
 Nature Morte, New York City.
 "New Sculpture: Robert Gober, Jeff Koons, Haim
 Steinbach," Renaissance Society, University of Chicago.
 Catalogue with text by Gary Garrels.
 "Art and Its Double: A New York Perspective,"
 Fundación Caja de Pensiones, Madrid and Barcelona.
 Catalogue with text by Dan Cameron.
1987 "New York Art Now: The Saatchi Collection (Part I),"
 London. Catalogue with text by Dan Cameron.
1988 "Utopia Post Utopia: Configurations of Nature and
 Culture in Recent Sculpture and Photography," Institute
 of Contemporary Art, Boston. Catalogue.
 "Sculpture Inside Outside," Walker Art Center,
 Minneapolis. Traveled to Museum of Fine Arts, Houston.
 Catalogue with text by Peter Boswell.
 "The BiNational: American Art of the Late Eighties,"
 Institute of Contemporary Art and Museum of Fine Arts,
 Boston; Städtische Kunsthalle and Kunstsammlung
 Nordheim-Westfalen, Düsseldorf. Catalogue.
 "Aperto 88: Venice Biennale." Catalogue.
1990 "Culture and Commentary: An Eighties Perspective,"
 Hirshhorn Museum and Sculpture Garden, Washington,
 D.C. Catalogue with text by Kathy Halbreich et al.

Selected Bibliography
Collins, Tricia, and Richard Milazzo. "Robert Gober: The
Subliminal Function of Sinks." Kunstforum (June-August
1986): 30-33.
Flood, Richard. "Robert Gober: Special Editions, An Interview."
The Print Collector's Newsletter (March-April 1990): 6-9.
Joselit, David. "Investigating the Ordinary." Art in America
(May 1988): 148-54.
Liebmann, Lisa. "The Case of Robert Gober." Parkett 21
(1989): 6-9.
Saltz, Jerry, Roberta Smith, and Peter Halley. Beyond
Boundaries. New York: Alfred van der Marck Editions, 1986.

Nan Goldin

Born 1953, Washington, D.C.
Lives in New York City.
School of Museum of Fine Arts and Tufts University, Boston,
B.A., B.F.A., 1977; M.F.A., 1978.

Selected Individual Exhibitions
1973 Project, Inc., Boston.
1984 Galerie 't Venster, Rotterdam Kunststiching.
1985 Christminster Gallery, New York City.
 "Currents," Institute of Contemporary Art, Boston.
1986 Burden Gallery, New York City. 1987
 Les Rencontres d'Arles, Arles, France.
1988 Real Art Ways, Hartford.
 "Houston Foto Fest," Rice University Media Center,
 Houston.
 "Couples," Pace/MacGill Gallery, New York City.
1989 Finnfoto, Helsinki.
 Mira Gallery, Stockholm.

1990　"Cookie Mueller," Pace/MacGill Gallery, New York City. Catalogue with text by Cookie Mueller and the artist.

Selected Group Exhibitions
1977　Atlantic Gallery, Boston.
1979　"Pictures/Photographs," Castelli Graphics, New York City.
1980　"Times Square Show," New York City. Organized by Collaborative Projects.
1981　"New Wave/New York," Institute for Art and Urban Resources, P.S. 1, Long Island City, New York.
1982　"Licht Bild Nisse," Rheinisches Landesmuseum, Bonn. "Faces Photographed," Grey Art Gallery and Study Center, New York University, New York City.
1984　"Face to Face: Recent Portrait Photography," Institute of Contemporary Art, Philadelphia. Brochure with text by Paula Marincola.
1985　"Self-Portrait: The Photographer's Persona, 1840-1985." Museum of Modern Art, New York City.
1987　"Twelve Photographers Look at U.S.," Philadelphia Museum of Art. Catalogue with text by Martha Chahroudi. "Art and Photography: Interactions Since 1946," Los Angeles County Museum of Art. Traveled to Museum of Art, Fort Lauderdale, Florida; Queens Museum, Flushing, New York; and Des Moines Art Center, Iowa. Catalogue with text by Andy Grundberg and Kathleen McCarthy Gauss.
1988　"Real Faces," Whitney Museum of American Art, Philip Morris Branch, New York City.
1990　"Figuring the Body," Museum of Fine Arts, Boston. "The Indomitable Spirit," International Center of Photography, New York City.

Selected Bibliography
Goldin, Nan. *The Ballad of Sexual Dependency.* New York: Aperture, 1986; London: Secker & Warburg, 1989.
Grundberg, Andy. Review. *The New York Times* (April 1985).
Kozloff, Max. "The Family of Nan." *Art in America* (November 1987).
Liebmann, Lisa. Review. *Artforum* (Summer 1985).

Leon Golub

Born 1922, Chicago, Illinois.
Lives in New York City.
University of Chicago, B.A., 1942.
School of the Art Institute of Chicago, B.F.A., 1949; M.F.A., 1950.

Selected Individual Exhibitions
1950　Contemporary Gallery, Chicago.
1954　Artists Gallery, New York City.
1960　Centre Culturel Americain, Paris.
1974　"Leon Golub Retrospective," Museum of Contemporary Art, Chicago. Catalogue with text by Lawrence Alloway.
1982　Institute of Contemporary Art, London. Catalogue with interview with Michael Newman and Jon Bird.
1983　"Leon Golub: Mercenaries, Interrogations and Other Works," Sarah Campbell Blaffer Gallery, University of Houston. Traveled to Portland Center for Visual Arts, Oregon; University of Arizona Museum of Art, Tucson; Miami University Art Museum, Oxford, Ohio; University of Connecticut at Storrs; and Everson Museum, Syracuse, New York. Catalogue with text by Jon Bird and Michael Newman.
1984　The New Museum of Contemporary Art, New York City. Traveled to La Jolla Museum of Contemporary Art, California; Museum of Contemporary Art, Chicago; Musée des Beaux Arts, Montreal; and Corcoran Gallery of Art, Washington, D.C. Catalogue with text by Lynn Gumpert and Ned Rifkin.
1986　Barbara Gladstone Gallery, New York City. Catalogue with text by Peter Schjeldahl.

Kunstmuseum, Lucerne. Traveled to Kunstverein, Hamburg. Catalogue with text by Donald B. Kuspit. "Leon Golub: Selected Paintings 1967-1986," Orchard Gallery, Derry. Traveled to Douglas Hyde Gallery, Dublin. Catalogue with text by John Roberts.
1988　Saatchi Collection, London.

Selected Group Exhibitions
1954　"Younger American Painters," Solomon R. Guggenheim Museum, New York City.
1959　"New Images of Man," Museum of Modern Art, New York City.
1977　"Paris—New York," Musée National d'Art Moderne, Centre Georges Pompidou, Paris. Catalogue.
1983　"Biennial Exhibition," Whitney Museum of American Art, New York City. Catalogue.
1984　"Content: A Contemporary Focus, 1974-84," Hirshhorn Museum and Sculpture Garden, Washington, D.C. Catalogue with text by Howard Fox, Miranda McClintic, and Phyllis Rosenzweig.
1987　"Documenta 8," Kassel, West Germany. Catalogue. "Avant-Garde in the Eighties," Los Angeles County Museum of Art. Catalogue with text by Howard Fox.
1988　"Committed to Print," Museum of Modern Art, New York City. Traveled to Wright State University Art Galleries, Dayton, Ohio, and Newport Harbor Art Museum, Newport Beach, California, among others. Catalogue with text by Deborah Wye. "Democracy: Politics and Election," Group Material installation, Dia Art Foundation, New York City.

Selected Bibliography
Brooks, Rosetta. "Undercover Agent." *Artforum* (January 1990): 114-21.
Danto, Arthur C. "Art: Golub." *The Nation* (17 November 1984): 531-33.
Kuspit, Donald B. "Leon Golub's Murals of Mercenaries: Aggression 'Ressentiment,' and the Artist's Will to Power." *Artforum* (May 1981): 52-57.
Levin, Kim. "Leon Golub," in *Art of Our Time: The Saatchi Collection.* London: Lund Humphries; New York: Rizzoli, 1985.
Marzorati, Gerald. "Leon Golub's Mean Streets." *ArtNews* (February 1985): cover, 74-87.
Ratcliff, Carter. "Theater of Power." *Art in America* (January 1984): cover, 74-82.
Schjeldahl, Peter. "Red Planet." *The Village Voice* (26 October 1982): 96, 111.
Storr, Robert. "Riddled Sphinx." *Art in America* (March 1989): 126-31.

David Hammons

Born 1943, Springfield, Illinois.
Lives in New York City and Rome.
Chouinard Art Institute, Los Angeles, 1966-68.
Otis Art Institute, Los Angeles, 1968-72.

Selected Individual Exhibitions
1971　Brockman Gallery, Los Angeles.
1975　"Greasy Bags and Barbeque Bones," Just Above Midtown, New York City.
1976　"Dreadlock Series," Just Above Midtown, New York City.
1977　"Nap Tapestry: Wire and Wiry Hair," Neighborhood Art Center, Atlanta.
1980　Window installation, The New Museum of Contemporary Art, New York City.
1986　Just Above Midtown, New York City.
1989　Exit Art, New York City.
1990　"Rousing the Rubble," Institute for Contemporary Art, P.S. 1 Museum, Long Island City, New York. Traveled to Institute of Contemporary Art, Philadelphia, and San Diego Museum of Contemporary Art.

Jack Tilton Gallery, New York City. Catalogue.

Selected Group Exhibitions
1980 "Times Square Show," New York City. Organized by Collaborative Projects.
Franklin Furnace, New York City.
Betty Parsons Gallery, New York City.
1983 "Messages to the Public," Spectacolor billboard, Times Square, New York City.
1985 "Art on the Beach" (sponsored by Creative Time, Inc.), Battery Park Landfill, New York City.
1986 Kenkeleba House, New York City. 1987 "Art As a Verb," Maryland Institute College of Art, Baltimore. Traveled to Studio Museum in Harlem and Met Life Gallery, New York City.
1989 "Strange Attractions: Signs of Chaos," The New Museum of Contemporary Art, New York City.
"Awards in the Visual Arts 8." Organized by Southeastern Center for Contemporary Art, Winston-Salem, North Carolina. Traveled to High Museum of Art, Atlanta, and Henry Art Gallery, Seattle, among others. Catalogue with text by Jane Addams Allen.
"Committed to Print," Museum of Modern Art, New York City. Traveled to Wright State University Art Galleries, Dayton, Ohio, and Newport Harbor Art Museum, Newport Beach, California, among others. Catalogue with text by Deborah Wye.
"The Blues Aesthetic," Washington Project for the Arts, Washington, D.C. Catalogue.
1990 "Ponton Temse," Museum van Hedendaagse, Ghent.
"The Decade Show: Frameworks of Identity in the 1980s," The New Museum of Contemporary Art, Museum of Contemporary Hispanic Art, and Studio Museum in Harlem, New York City. Catalogue.
"Re-writing History," Kettle's Yard, Cambridge, England. Catalogue with text by Nikos Papastergiadis.
"Black USA," Museum Overholland, Amsterdam. Catalogue.
1991 "Places with a Past," Spoleto Festival, Charleston, South Carolina. Catalogue with text by Mary Jane Jacob et al.

Selected Bibliography
Berger, Maurice. Interview. *Art in America* (September 1990).
Hess, Elizabeth. "Train of Thought." *The Village Voice* (30 June 1989).
_____. "Getting His Due," *The Village Voice* (1 January 1991).
Jones, Kellie. Interview. *Real Life Magazine* (Autumn 1986).

Keith Haring

Born 1958, Kutztown, Pennsylvania.
Died 1990, New York City.
School of Visual Arts, New York City, 1978-79.

Selected Individual Exhibitions
1978 Pittsburgh Center for the Arts.
1981 P.S. 122, New York City.
Club 57, New York City.
1982 Rotterdam Arts Council. Catalogue with text by Richard Flood.
Tony Shafrazi Gallery, New York City. (With LA II.) Catalogue with text by Robert Pincus-Witten, Jeffrey Deitch, and David Shapiro.
1983 Fun Gallery, New York City. (With LA II.)
Galerie Watari, Tokyo. (With LA II.)
"Matrix 75: Keith Haring—New York City Subway Drawings," Wadsworth Atheneum, Hartford. Brochure with text by Andrea Miller-Keller.
Tony Shafrazi Gallery, New York City. "Investigations 2," Institute of Contemporary Art, Philadelphia. Brochure with text by Janet Kardon.
1984 Galerie Paul Maenz, Cologne.
Salvatore Ala Gallery, Milan. (With LA II.)

1985 Leo Castelli Gallery, New York City.
Musée d'Art Contemporain de Bordeaux, France. Catalogue.
1986 Stedelijk Museum, Amsterdam. Catalogue with text by Jeffrey Deitch.
Galerie Daniel Templon, Paris.
1989 Casa Sin Nombre, Sante Fe, New Mexico. (With William Burroughs.)
1990 "A Memorial Exhibition of Works on Paper," Tony Shafrazi Gallery, New York City. Catalogue.
"Keith Haring: Future Primeval," Illinois State University, Normal. Traveled to Queens Museum, Flushing, New York; and Tampa Museum of Art, Florida. Catalogue with text by Barry Blinderman et al.

Selected Group Exhibitions
1980 "Times Square Show," New York City. Organized by Collaborative Projects.
"Events: Fashion Moda," The New Museum of Contemporary Art, New York City.
1981 "New York/New Wave," Institute for Art and Urban Resources, P.S. 1, Long Island City, New York.
Patrick Verelst Gallery, Antwerp.
1982 "Documenta 7," Kassel, West Germany. Catalogue.
1983 "Biennial Exhibition," Whitney Museum of American Art, New York City. Catalogue.
"Back to the U.S.A.," Kunstmuseum, Lucerne.
"Bienal de São Paulo," Brazil.
"Post-Graffiti Artists," Sidney Janis Gallery, New York City.
1984 "Aperto '84: Venice Biennale." Catalogue.
"Content: A Contemporary Focus, 1974—1984," Hirshhorn Museum and Sculpture Garden, Washington, D.C. Catalogue with text by Howard Fox, Miranda McClintic, and Phyllis Rosenzweig.
"Disarming Images: Art for Nuclear Disarmament." Organized by Art Museum Association, San Francisco. Traveled to Contemporary Art Center, Cincinnati, and Munson Williams Proctor Museum of Art, Utica, New York, among others. Catalogue with text by Nina Felshin.
1985 "La Biennale de Paris," Grand Palais.
1987 "Skulptur Projekte in 1987, Münster," organized by Westfälisches Landesmuseum, Münster, West Germany. Catalogue with text by Klaus Bussman and Kasper Koenig.
1988 "Committed to Print," Museum of Modern Art, New York City. Traveled to Wright State University Art Galleries, Dayton, Ohio, and Newport Harbor Art Museum, Newport Beach, California, among others. Catalogue with text by Deborah Wye.
1991 "American Graffiti: A Survey," Liverpool Gallery, Brussels.

Selected Bibliography
Adams, Brooks. "Keith Haring: Subways Are for Drawing." *The Print Collector's Newsletter* (May-June 1982).
deAk, Edit, and Diego Cortez. "Baby Talk." *Flash Art* (May 1982): 34-38.
Haring, Keith. *Art in Transit*. New York: Harmony Books, 1984.
Moufarrege, Nicholas A. "Lightning Strikes (Not Once, But Twice): An Interview with Graffiti Artists (of New York)." *Arts Magazine* (November 1982): 87-93.

Jenny Holzer

Born 1950, Gallipolis, Ohio.
Lives in New York City and New York State.
Ohio University, Athens, B.F.A., 1972.
Rhode Island School of Design, Providence, M.F.A., 1977.

Selected Individual Exhibitions
1980 "Living," Rudiger Schöttle Gallery, Munich.
"Position Papers," Onze rue Clavel, Paris.

1982 "Poster Project," A Space, Toronto.
American Graffiti Gallery, Amsterdam.
Artists Space, New York City
1983 "Survival Series," Barbara Gladstone Gallery,
New York City.
Institute of Contemporary Art, London.
"Investigations 3," Institute of Contemporary Art,
Philadelphia. Brochure with text by Paula Marincola.
1984 "Sign on a Truck," Grand Army Plaza, Brooklyn New
York, and Bowling Green Plaza, New York City.
Dallas Museum of Art.
Kunsthalle, Basel. Traveled to Le Nouveau Musée,
Villeurbanne, France. (With Barbara Kruger.)
"Electronic Signs," Galerie 't Venster, Rotterdam
Kunststitching.
1986 Galerie Monika Spruth, Cologne.
"Protect Me from What I Want," AmHof, Vienna.
Catalogue. (With Keith Haring.)
"Jenny Holzer: Signs," Des Moines Art Center, Iowa.
Traveled to Aspen Art Museum, Colorado; Artspace,
San Francisco; and Fruitmarket Gallery, Edinburgh.
Catalogue with text by Joan Simon and Bruce Ferguson.
1988 "Jenny Holzer: Signs and Benches," Brooklyn Museum,
Brooklyn, New York.
1989 Solomon R. Guggenheim Museum, New York City.
Catalogue with text by Diane Waldman and interview
with the artist.
"Lamentz," Dia Art Foundation, New York City.
1990 "The Venice Installation," at "Venice Biennale," U.S.
Pavilion. Traveled to Albright-Knox Art Gallery, Buffalo.
Catalogue with text by Michael Auping.

Selected Group Exhibitions
1978 "Artwords and Bookwords," Los Angeles Institute of
Contemporary Art.
Special Project, Institute for Art and Urban Resources,
P.S. 1, Long Island City, New York.
1980 "Times Square Show," New York City. Organized by
Collaborative Projects.
1981 "Westkunst—Heute," Museen der Stadt, Cologne.
Catalogue.
1982 "Documenta 7," Kassel, West Germany. Catalogue.
"74th American Exhibition," Art Institute of Chicago.
Catalogue with text by Anne Rorimer.
1983 "Biennial Exhibition," Whitney Museum of American
Art, New York City. Catalogue.
"Art and Social Change, U.S.A.," Allen Memorial Art
Museum, Oberlin, Ohio. Catalogue with text by David
Deitcher, Jerry Kearns, Lucy R. Lippard, William
Olander, and Craig Owens.
1984 "Content: A Contemporary Focus 1974-1984," Hirshhorn
Museum and Sculpture Garden, Washington, D.C.
Catalogue with text by Howard Fox, Miranda McClintic,
and Phyllis Rosenzweig.
1985 "Carnegie International," Museum of Art, Carnegie
Institute, Pittsburgh. Catalogue.
1986 "Jenny Holzer/Cindy Sherman: Personae,"
Contemporary Arts Center, Cincinnati. Catalogue with
text by Sarah Rogers-Lafferty.
"Europa/Amerika," Museum Ludwig, Cologne.
1987 "Documenta 8," Kassel, West Germany. Catalogue.
"Skulptur Projekte in 1987, Münster," organized by
Westfälisches Landesmuseum, Münster, West Germany.
Catalogue with text by Klaus Bussman and Kasper
Koenig.
1990 "Culture and Commentary: An Eighties Perspective,"
Hirshhorn Museum and Sculpture Garden, Washington,
D.C. Catalogue with text by Kathy Halbreich et al.
"High and Low: Modern Art and Popular Culture,"
Museum of Modern Art, New York City. Traveled to Art
Institute of Chicago and Museum of Contemporary Art,

Los Angeles. Catalogue with text by Kirk Varnedoe and
Adam Gopnik.

Selected Bibliography
Glueck, Grace. "And Now, A Few Words from Jenny Holzer." *The
New York Times Magazine* (3 December 1989): 42-43, /108-13.
Holzer, Jenny. *Truisms and Essays.* Halifax: Nova Scotia College
of Art and Design Press, 1983.
Ratcliff, Carter. "Jenny Holzer." *The Print Collector's Newsletter*
(November-December 1982): 149-52.

Jörg Immendorff

Born 1945, Bleckede, West Germany.
Lives in Düsseldorf, West Germany.
Kunstakademie, Düsseldorf, 1964-66.

Selected Individual Exhibitions
1966 Galerie Schmela, Dusseldorf.
1969 Galerie Michael Werner, Cologne.
1978 "Café Deutschland," Galerie Michael Werner, Cologne.
Catalogue.
1979 "Café Deutschland," Kunstmuseum, Basel. Catalogue
with text by Dieter Koepplin.
1980 Kunsthalle, Bern.
1981 Stedelijk van Abbemuseum, Eindhoven, Netherlands.
Galerie Neuendorf, Hamburg. Catalogue.
1982 Sonnabend Gallery, New York City.
"Café Deutschland/Adlerhalfte," Kunsthalle, Düsseldorf.
Catalogue with text by Jürgen Harten and Ulrich Krempel.
Galerie Daniel Templon, Paris.
1983 Kunsthalle, Düsseldorf.
Kunsthaus, Zurich. Catalogue.
1984 Mary Boone Gallery, New York City. Catalogue.
Museum of Modern Art, Oxford.
Galerie Ascan Crone, Hamburg. Catalogue.
1985 Maison de la Culture et de la Communication,
Saint-Étienne,
France. Catalogue.
1987 Galerie Michael Werner, Cologne.
1988 "Jörg Immendorff in Auckland," Auckland, New Zealand.
1990 Museum für Moderne Kunst, Vienna.

Selected Group Exhibitions
1969 "Düsseldorfer Szene," Kunstmuseum, Lucerne.
Catalogue with text by Jean-Christophe Ammann.
1972 "Documenta 5," Kassel, West Germany. Catalogue.
1976 "Venice Biennale." Catalogue.
1980 "The New Fauves," Neue Galerie—Sammlung Ludwig,
Aachen, West Germany.
1981 "German Art Today," Musée d'Art de la Ville de Paris.
"Westkunst—Heute," Museen der Stadt, Cologne.
Catalogue.
1982 "Documenta 7," Kassel, West Germany. Catalogue.
"Sydney Biennale: Vision in Disbelief." Catalogue.
"Zeitgeist," Martin-Gropius-Bau, West Berlin.
1983 "New Painting from Germany," Tel Aviv Museum.
"New Art at the Tate Gallery," London. Catalogue with
text by Michael Compton.
"Expressions: New Art from Germany," Saint Louis Art
Museum. Traveled to Institute for Art and Urban
Resources. P.S. 1, Long Island City, New York; Institute
of Contemporary Art, Philadelphia; Contemporary Arts
Center, Cincinnati; Museum of Contemporary Art,
Chicago; Newport Harbor Art Museum, Newport Beach,
California; and Corcoran Gallery of Art, Washington,
D.C. Catalogue with text by Jack Cowart.
1984 "An International Survey of Recent Painting and
Sculpture," Museum of Modern Art, New York City.
Catalogue with text by Kynaston McShine.
"Content: A Contemporary Focus, 1974-1984,"
Hirshhorn Museum and Sculpture Garden, Washington,
D.C. Catalogue with text by Howard Fox, Miranda

McClintic, and Phyllis Rosenzweig.
1985 "Creativity in Germany and Italy Today," Art Gallery of Ontario, Toronto.
"Carnegie International," Museum of Art, Carnegie Institute, Pittsburgh. Catalogue.
1986 "Europa/Amerika," Museum Ludwig, Cologne. Catalogue.
1987 "Avant-Garde in the Eighties," Los Angeles County Museum of Art. Catalogue with text by Howard Fox.
"Brennpunkt Düsseldorf," Kunstmuseum, Düsseldorf. Traveled. Catalogue.

Selected Bibliography
Gohr, Siegfried, and Johannes Gachnang. "Jörg Immendorff's 'Café Deutschland.'" Kunstforum International (May 1978): 238-42.
Huber, Jörg. "Jörg Immendorff." Flash Art (April-May 1984): 22-31.
Immendorff, Jörg. "Interview with Joseph Beuys." Spuren, Zeitschrift für Kunst und Gesellschaft, no. 5 (1978): 38-41.
Kuspit, Donald B. "Acts of Aggression. German Painting Today (Part I)." Art in America (September 1982): 141-51.
_____. "Acts of Aggression. German Painting Today (Part II)." Art in America (January 1983): 90-101, 131-35.

Ilya Kabakov

Born 1933, Dnepropetrovsk, Ukraine, U.S.S.R.
Lives in Moscow.
School of Fine Arts, Moscow, diploma, 1951.
Surikov Art Institute, Moscow, diploma, 1956.

Selected Individual Exhibitions
1968 Blue Bird Cafe, Moscow. (With Eric Bulatov.)
1985 Dina Vierny Gallery, Paris.
"Am Rande," Kunsthalle, Bern. Catalogue with text by Jean-Hubert Martin.
1986 Kunstverein, Graz, Austria.
Neue Galerie, Castle Gotzental, Dietikon, Switzerland.
1988 Kunstverein, Bonn, West Germany. (With Eric Bulatov.)
"Ten Characters," Ronald Feldman Fine Arts, New York City.
1989 "Communal Apartment—The Ship: Two Installations," Kunsthalle, Zurich.
"The Untalented Artist and Other Characters," Institute of Contemporary Art, London. Catalogue, Ilya Kabakov: Ten Characters, with text by the artist.
"Exhibition of a Book," DAADgalerie, West Berlin. Catalogue with text by Boris Groys.
"Who Are These Little People?" Institute of Contemporary Art, Philadelphia. Brochure with text by Judith Tannenbaum.
1990 "Ten Characters," Hirshhorn Museum and Sculpture Garden, Washington, D.C. Brochure with text by Ned Rifkin.

Selected Group Exhibitions
1976 "Contemporary Russian Painting," Palais de Congrès, Paris.
1977 "New Soviet Art, An Unofficial Perspective: Venice Biennale."
1979 "Twenty Years of Independent Art from the Soviet Union," Kunstmuseum, Bochum, West Germany.
1982 "One Evening Exhibition at the Soviet Artists' Union," Artists' Club, Kuznetskij Bridge, Moscow.
1985 Bielefeld University Museum, West Germany.
1987 FIAC/Galerie de France, Paris.
1988 "Aperto '88: Venice Biennale." Catalogue.
"ARCO," Madrid.
1989 "Kosuth's Show," Freud House, Vienna.
"Magiciens de la Terre," Musée National d'Art Moderne, Centre Georges Pompidou, Paris, Catalogue with text by Jean-Hubert Martin et al.

"The Green Show," Exit Art, New York City. Catalogue with essays by Margarita Tupitsyn et al.

Selected Bibliography
Cary, Katrina. "Ilya Kabakov—Profile of a Soviet Unofficial Artist." Art and Auction (February 1987): 86-87.
Gambrell, Jamey. "Notes on the Underground." Art in America (November 1988): 127-36, 193.
Groys, Boris. "Ilya Kabakov." A-Ya, no. 2 (1980): 17-23.
Kabakov, Ilya. The Window. Bern: Benteli Verlag, 1985.
Lloyd, Jill. "'The Untalented Artist'—An Interview with Ilya Kabakov." Art International (Autumn 1989): 70-73.
Morgan, Stuart. "Kabakov's Albums." Artscribe (May 1989): 57-59.

Mike Kelley

Born 1954, Detroit, Michigan.
Lives in Los Angeles.
University of Michigan, Ann Arbor, B.F.A., 1976.
California Institute of the Arts, Valencia, M.F.A., 1978.

Selected Individual Exhibitions
1981 Mizuno Gallery, Los Angeles.
1982 Metro Pictures, New York City.
1983 Rosamund Felsen Gallery, Los Angeles.
Hallwalls, Buffalo.
1988 "Mike Kelley: Three Projects," Renaissance Society, University of Chicago. Catalogue with text by John Miller and Howard Singerman.
1989 "Why I Got into Art—Vaseline Muses," Jablonka Galerie, Cologne. Catalogue with text by Christopher Knight.
Galerie Peter Pakesch, Vienna.
"Pansy Metal/Clovered Hoof," Metro Pictures, New York City.
1991 "Mike Kelley: 'Half a Man,'" Hirshhorn Museum and Sculpture Garden, Washington, D.C. Brochure with text by Amada Cruz.

Selected Group Exhibitions
1979 "Manifesto Show," 5 Bleecker Street, New York City.
"The Poltergeist," (collaboration with David Askevold); Foundation for Art Resources, Los Angeles.
1982 "John M. Miller, Michael Kelley, JoAnn Verburg," Minneapolis College of Art and Design.
1984 "Biennial of Sydney: Private Symbol—Social Metaphor," Gallery of New South Wales. Catalogue.
1985 "Biennial Exhibition," Whitney Museum of American Art, New York City. Catalogue.
1986 "Individuals: A Selected History of Contemporary Art, 1945-1986," Museum of Contemporary Art, Los Angeles. Catalogue.
1987 "Toyama Now '87," Museum of Modern Art, Toyama, Japan. Catalogue.
"Avant-Garde in the Eighties," Los Angeles County Museum of Art. Catalogue with text by Howard Fox.
"L.A. Hot and Cool," List Visual Arts Center, Massachusetts Institute of Technology, Cambridge. Catalogue with text by Dana Fries-Hanson.
1988 "Aperto '80: Venice Biennale." Catalogue.
"The BiNational: American Art of the Late Eighties," Museum of Fine Arts and Institute of Contemporary Art, Boston; Städtische Kunsthalle and Kunstsammlung Nordheim-Westfalen, Düsseldorf. Catalogue with interview by Elisabeth Sussman and David Joselit.
"Democracy," Dia Art Foundation, New York City.
1989 "A Forest of Signs: Art in the Crisis of Representation," Museum of Contemporary Art, Los Angeles. Catalogue with text by Ann Goldstein, Mary Jane Jacob, Anne Rorimer, and Howard Singerman.

Selected Bibliography
Cameron, Dan. "Mike Kelley's Art of Violation." *Arts Magazine* (June 1986): 14-17.
Gordon, Kim. "American Dreams." *Artforum* (April 1985).
Kelley, Mike. *Plato's Cave, Rothko's Chapel, Lincoln's Profile.* New City Editions, in association with Artists Space, 1986.
_____. "Foul Perfection: Thoughts on Caricature." *Artforum* (January 1989): 92-99.
Koether, Jutta. "C-Culture and B-Culture." *Parkett* 24 (1990).
Singerman, Howard. "The Artist As Adolescent." *Real Life Magazine* (Summer 1981).

Anselm Kiefer

Born 1945, Donaueschingen, West Germany.
Lives in Buchen, West Germany.
University of Freiburg, West Germany.
Kunstakademie, Karlsruhe, West Germany.

Selected Individual Exhibitions
1969 Galerie am Kaiserplatz, Karlsruhe.
1973 "Nothung," Galerie Michael Werner, Cologne.
1977 Kunstverein, Bonn. Catalogue.
1978 Kunsthalle, Bern. "Anselm Kiefer: Bilder und Bücher." Catalogue with text by Johannes Gachnang and Theo Kneubuhler.
1979 Stedelijk van Abbemuseum, Eindhoven, Netherlands.
1980 Kunstverein, Mannheim. Catalogue with text by R. H. Fuchs.
 "Anselm Kiefer—Verbrennen, verholzen, versenken, versanden: Venice Biennale," West German Pavilion. Catalogue.
1981 Galerie Paul Maenz, Cologne. Catalogue.
 Marian Goodman Gallery, New York City.
 "Anselm Kiefer: Bilder und Bücher," Museum Folkwang, Essen. Traveled to Whitechapel Art Gallery, London. Catalogue with text by Zdenek Felix and Nicholas Serota.
1982 Mary Boone Gallery, New York City.
1983 Anthony d'Offay Gallery, London. Catalogue.
1984 Städtische Kunsthalle, Düsseldorf. Traveled to Musée d'Art Moderne de la Ville de Paris/ARC, and Israel Museum, Jerusalem. Catalogue with text by R. H. Fuchs, Suzanne Page, and Jürgen Harten.
1985 "Anselm Kiefer: Departure from Egypt 1984-85," Marian Goodman Gallery, New York City. Catalogue.
1986 Stedelijk Museum, Amsterdam. Catalogue with text by Wim Beeren.
1987 Art Institute of Chicago and Philadelphia Museum of Art. Traveled to Museum of Contemporary Art, Chicago, and Museum of Modern Art, New York City. Catalogue with text by Mark Rosenthal.
1990 Nationalgalerie, Berlin. Catalogue.

Selected Group Exhibitions
1977 "Documenta 6," Kassel, West Germany. Catalogue.
 "Biennale de Paris," Musée d'Art Moderne de la Ville de Paris. Catalogue.
1981 "A New Spirit in Painting," Royal Academy of Arts, London. Catalogue.
 "Westkunst—Heute," Museen der Stadt, Cologne. Catalogue.
1982 "Documenta 7," Kassel, West Germany. Catalogue.
 "Zeitgeist," Martin-Gropius-Bau, West Berlin. Catalogue.
1983 "Expressions: New Art from Germany," Saint Louis Art Museum. Traveled to Institute for Art and Urban Resources, P.S. 1, Long Island City, New York; Institute of Contemporary Art, Philadelphia; Contemporary Art Center, Cincinnati; Museum of Contemporary Art, Chicago; Newport Harbor Art Museum, Newport Beach, California; and Corcoran Gallery of Art, Washington, D.C. Catalogue with text by Jack Cowart.

1984 "An International Survey of Recent Painting and Sculpture," Museum of Modern Art, New York. Catalogue with text by Kynaston McShine.
1985 "Carnegie International," Carnegie Institute, Museum of Art, Pittsburgh. Catalogue.
 "Anselm Kiefer—Richard Serra," Saatchi Collection, London.
1986 "Beuys, Cucchi, Kiefer, Kounnellis," Kunsthalle, Basel. Catalogue.
1987 "Documenta 8," Kassel, West Germany. Catalogue.

Selected Bibliography
Fisher, Jean. "A Tale of the German and the Jew." *Artforum* (September 1985): 106-10.
Kiefer, Anselm. "Gilgamesch und Enkidu im Zedernwald." *Artforum* (Summer 1981): 67-74.
Kuspit, Donald B. "The Night Mind." *Artforum* (September 1982): 64-67.
Schjeldahl, Peter. "Anselm Kiefer," in *Art of Our Time: The Saatchi Collection.* London: Lund Humphries, 1984.
Schwartz, Sanford. "Anselm Kiefer, Joseph Beuys, and the Ghosts of the Fatherland." *The New Criterion* (March 1983): 1-9.

Komar & Melamid

Vitaly Komar
Born 1943, Moscow, U.S.S.R.; moved to New York City, 1978.
Lives in New York City.
Stroganov Institute of Art and Design, Moscow, diploma, 1967.

Alexander Melamid
Born 1945, Moscow, U.S.S.R.; moved to New York City, 1978.
Lives in New York City.
Stroganov Institute of Art and Design, Moscow, diploma, 1967.

Selected Duo Exhibitions
1967 Blue Bird Cafe, Moscow.
1976 Ronald Feldman Fine Arts, New York City.
1977 Ohio University Gallery of Fine Arts, Columbus.
 A Space, Toronto.
1978 "Matrix 43," Wadsworth Atheneum, Hartford. Brochure with text by Andrea Miller-Keller.
1980 Edwin A. Ulrich Museum of Art, Wichita State University, Kansas. Catalogue.
1982 Ronald Feldman Fine Arts, New York City.
1983 Portland Center for Visual Arts, Oregon.
 Anderson Gallery, Virginia Commonwealth University, Richmond. Catalogue with text by Jamey Gambrell.
1984 Saidye Bronfman Center, Montreal.
 University of Iowa Museum of Art, Iowa City.
1985 Fruitmarket Gallery, Edinburgh. Traveled to Museum of Modern Art, Oxford; Musée des Arts Décoratifs, Paris; and Arts Council Gallery, Belfast. Catalogue with text by Peter Wollens.
1986 Temple Gallery, Temple University, Philadelphia.
1987 Artspace, Sydney, Australia. Traveled to Institute for Modern Art, Brisbane; University of Tasmania, Hobart; Australian Centre of Contemporary Art, Melbourne; Praxis, Perth; and Experimental Art Foundation, Adelaide.
1990 Grand Lobby installation, Brooklyn Museum, Brooklyn, New York.

Selected Group Exhibitions
1974 Outdoor exhibition ("Bulldozer Show"), Beljaevo, Moscow.
1977 "Dissident Art: Venice Biennale."
1978 "Couples," Institute for Art and Urban Resources, P.S. 1, Long Island City, New York.
1984 "An International Survey of Recent Painting and Sculpture," Museum of Modern Art, New York City. Catalogue with text by Kynaston McShine.
 "Artistic Collaboration in the 20th Century," Hirshhorn Museum and Sculpture Garden, Washington, D.C.

Catalogue with text by Cynthia Jaffee McCabe.

1985 "Alles und noch viel Mehr" [Everything and More], Kunsthalle and Kunstmuseum, Bern. Catalogue.

1986 "Sots Art," The New Museum of Contemporary Art, New York City. Traveled to Glenbow Museum, Calgary, Canada, and Everson Museum, Syracuse, New York. Catalogue with text by Margarita Tupitsyn and John E. Bowlt.

1987 "Documenta 8," Kassel, West Germany. Catalogue.

1989 "Image World: Art and Media Culture," Whitney Museum of American Art, New York City. Catalogue with text by Lisa Phillips, Marvin Heiferman, and John G. Hanhardt.

Selected Bibliography
Eco, Umberto. "Bevente Breshnev Cola." *L'Espresso* (7 March 1976): 64-71.
Frazier, Ian. "Profiles: Partners." *The New Yorker* (29 December 1986): 33-54.
Gambrell, Jamey. "Komar & Melamid—From Behind the Ironical Curtain." *Artforum* (April 1982): 58-63.
Indiana, Gary. "Komar & Melamid Confidential." *Art in America* (June 1985): cover, 94-101.
Komar, Vitaly, and Alexander Melamid. "The Barren Flowers of Evil." *Artforum* (March 1980): 46-52.
_____. "In Search of Religion." *Artforum* (May 1980): 36-46.
Ratcliff, Carter. *Komar & Melamid.* New York: Abbeville Press, 1988.

Jeff Koons

Born 1955, York, Pennsylvania.
Lives in New York City.
Maryland Institute College of Art, B.F.A., 1976.

Selected Individual Exhibitions
1980 "The New" (window installation), The New Museum of Contemporary Art, New York City.
1985 International With Monument Gallery, New York City. Feature Gallery, New York City.
1986 Daniel Weinberg Gallery, Los Angeles.
1988 Museum of Contemporary Art, Chicago. Sonnabend Gallery, New York City. Galerie Max Hetzler, Cologne.
1989 Galerie 't Venster, Rotterdam Kunststichting.

Selected Group Exhibitions
1981 "Lighting," Institute for Art and Urban Resources, P.S. 1, Long Island City, New York. Annina Nosei Gallery, New York City.
1984 "A Decade of New Art," Artists Space, New York City. Catalogue.
1986 "Damaged Goods: Desire and the Economy of the Object," The New Museum of Contemporary Art, New York City. Catalogue with text by Brian Wallis.
"Endgame: Reference and Simulation in Recent Painting and Sculpture," Institute of Contemporary Art, Boston. Catalogue with text by Thomas Crow, Yve-Alain Bois, Elisabeth Sussman, et al.
"Art and Its Double: A New York Perspective," Fundación Caja de Pensiones, Madrid and Barcelona. Catalogue with text by Dan Cameron.
"New Sculpture: Robert Gober, Jeff Koons, Haim Steinbach," Renaissance Society, University of Chicago. Catalogue with text by Gary Garrels.
1987 "Biennial Exhibition," Whitney Museum of American Art, New York City. Catalogue.
"Avant-Garde in the Eighties," Los Angeles County Museum of Art. Catalogue with text by Howard Fox.
"Skulptur Projekte in 1987, Münster," organized by Westfälisches Landesmuseum, Münster, West Germany. Catalogue with text by Klaus Bussman and Kasper Koenig.

"New York Art Now: The Saatchi Collection," London. Catalogue.
"Romance," Knight Gallery, Charlotte, North Carolina. Catalogue with text by Ronald Jones.
1988 "The BiNational: American Art of the Late Eighties," Institute of Contemporary Art and Museum of Fine Arts, Boston. Traveled to Städtische Kunsthalle and Kunstsammlung Nordheim-Westfalen, Düsseldorf. Catalogue.
"Carnegie International," Carnegie Museum of Art, Pittsburgh. Catalogue.
1989 "A Forest of Signs: Art in the Crisis of Representation," Museum of Contemporary Art, Los Angeles. Catalogue with text by Ann Goldstein, Mary Jane Jacob, Anne Rorimer, and Howard Singerman.
"Biennial Exhibition," Whitney Museum of American Art, New York City. Catalogue.
1990 "Aperto '90: Venice Biennale." Catalogue.
"Culture and Commentary: An Eighties Perspective," Hirshhorn Museum and Sculpture Garden, Washington, D.C. Catalogue with text by Kathy Halbreich et al.
"High and Low: Modern Art and Popular Culture," Museum of Modern Art, New York City. Traveled to Art Institute of Chicago and Museum of Contemporary Art, Los Angeles. Catalogue with text by Kirk Varnedoe and Adam Gopnik.

Selected Bibliography
Deitch, Jeffrey. "Mythologies: Art and the Market." *Artscribe* (April-May 1986).
Gopnik, Adam. "The Art World: Lost and Found." *The New Yorker* (20 February 1989): 107-11.
Koons, Jeff. "'Baptism': A Project for *Artforum*." *Artforum* (November 1987).
Koons, Jeff, and Martin Kippenberger. "Collaborations." *Parkett*, 19 (1989).
Pincus-Witten, Robert. "Entries: Concentrated Juice and Kitschy Kitschy Koons." *Arts Magazine* (February 1989): 34-39.
Politi, Giancarlo. "Luxury and Desire: An Interview with Jeff Koons." *Flash Art* (February-March 1987).
Smith, Roberta. "Rituals of Consumption." *Art in America* (May 1988): 164-70.

Barbara Kruger

Born 1945, Newark, New Jersey.
Lives in New York City.
Syracuse University, Syracuse, New York, 1965.
Parsons School of Design, New York City, 1966.

Selected Individual Exhibitions
1974 Artists Space, New York City.
1979 Franklin Furnace, New York City. Printed Matter, New York City.
1980 Institute for Art and Urban Resources, P.S. 1, Long Island City, New York.
1982 Gagosian Gallery, Los Angeles.
1983 Institute of Contemporary Art, London. Annina Nosei Gallery, New York City.
1984 Kunsthalle, Basel. Traveled to Le Nouveau Musée, Villeurbanne, France. (With Jenny Holzer.) Rhona Hoffman Gallery, Chicago. Crousel/Hussenot Gallery, Paris.
1985 "Matrix 83," Wadsworth Atheneum, Hartford, and Contemporary Arts Museum, Houston. Brochure with text by Andrea Miller-Keller.
1986 University Art Museum, Berkeley, California.
1987 Mary Boone Gallery, New York City. Catalogue with text by Jean Baudrillard and the artist. Galerie Monika Spruth, Cologne.
1988 National Art Gallery, Wellington, New Zealand.

Selected Group Exhibitions

1973 "Biennial Exhibition," Whitney Museum of American Art, New York City. Catalogue.
1981 "Nineteen Artists—Emergent Americans: Exxon National Exhibition," Solomon R. Guggenheim Museum, New York City. Catalogue with text by Peter Frank.
1982 "Documenta 7," Kassel, West Germany. Catalogue.
"Venice Biennale." Catalogue.
"Image Scavengers: Photography," Institute of Contemporary Art, Philadelphia. Catalogue with text by Paula Marincola and Douglas Crimp.
"74th American Exhibition," Art Institute of Chicago. Catalogue with text by Anne Rorimer.
"Art and Media," Renaissance Society, University of Chicago.
1983 "Currents," Institute of Contemporary Art, Boston.
"Biennial Exhibition," Whitney Museum of American Art, New York City. Catalogue.
1984 "Biennial of Sydney: Private Symbol—Social Metaphor," Sydney, Australia. Catalogue.
"Difference: On Representation and Sexuality," The New Museum of Contemporary Art, New York City. Traveled to Renaissance Society, University of Chicago, and Institute of Contemporary Art, London. Catalogue with text by Kate Linker, Craig Owens, et al.
1985 "Talking Back to the Media," Multi-Media Project, Amsterdam.
"Biennial Exhibition," Whitney Museum of American Art, New York City. Catalogue.
1986 "The Real Big Picture Show," Queens Museum, Flushing, New York. Catalogue with text by Marvin Heiferman.
"Barbara Kruger and Jenny Holzer," Israel Museum, Jerusalem.
1987 "Documenta 8," Kassel, West Germany. Catalogue.
1989 "A Forest of Signs: Art in the Crisis of Representation," Museum of Contemporary Art, Los Angeles. Catalogue with text by Ann Goldstein, Mary Jane Jacob, Anne Rorimer, and Howard Singerman.
"Magiciens de la Terre," Musée National d'Art Moderne, Centre Georges Pompidou, Paris. Catalogue with text by Jean-Hubert Martin et al.
"Image World: Art and Media Culture," Whitney Museum of American Art, New York City. Catalogue with text by Lisa Phillips, Marvin Heiferman, and John G. Hanhardt.

Selected Bibliography
Buchloh, Benjamin H. D. "Allegorical Procedures: Appropriation and Montage in Contemporary Art." *Artforum* (September 1982): 43-56.
Foster, Hal. "Subversive Signs." *Art in America* (November 1982): 88-92.
Lichtenstein, Therese. "Barbara Kruger's After-Effects: The Politics of Mourning." *Art and Text* (July 1989): 81-85.
Owens, Craig. "The Medusa Effect on the Specular Ruse." *Art in America* (January 1984): 97-105.
Squiers, Carol. "Diversionary (Syn)tactics/Barbara Kruger Has a Way with Words." *ArtNews* (February 1987): cover, 76-85.

Louise Lawler

Born 1947, Bronxville, New York.
Lives in New York City.
Cornell University, Ithaca, New York, B.F.A., 1969.

Selected Individual Exhibitions
1979 "A Movie Will Be Shown without the Picture," Aero Theater, Santa Monica, California. Sponsored by the Foundation for Art Resources.
1981 Jancar/Kuhlenschmidt Gallery, Los Angeles.
"A Picture Is No Substitute for Anything," Ronelle Gallery, Halifax, Nova Scotia.

1982 "Louise Lawler and Andy Warhol," I.D. Gallery, California Institute of the Arts, Valencia.
"Arrangement of Pictures," Metro Pictures, New York City.
1984 "Home/Museum—Arranged for Living and Viewing: Matrix 77," Wadsworth Atheneum, Hartford. Brochure
"For Presentation and Display: Ideal Setting" (collaboration with Allan McCollum), Diane Brown Gallery, New York City.
1985 Nature Morte, New York City.
1987 "Enough: Projects 9," Museum of Modern Art, New York City. Brochure with text by Cora Rosevear.
"As Serious As a Circus," Isabella Kacprzak, Stuttgart. Maison de La Culture et de la Communication de Saint-Étienne, France. Catalogue with text by Claude Gintz.
1988 "Investigations 26," Institute of Contemporary Art, Philadelphia. Brochure with text by Jack Bankowsky. Galerie Yvon Lambert, Paris.
1989 "The Show Isn't Over," Photographic Resource Center, Boston.
1990 "Connections," Museum of Fine Arts, Boston. Brochure with text by Trevor Fairbrother.

Selected Group Exhibitions
1978 Artists Space, New York City.
1981 "Extended Photography," Secessionist Museum, Vienna. Catalogue.
1982 "Public Vision," White Columns, New York City.
1985 "The Art of Memory/The Loss of History," The New Museum of Contemporary Art, New York City. Catalogue with text by William Olander.
1986 "The Real Big Picture," Queens Museum, Flushing, New York. Catalogue with text by Marvin Heiferman.
"Art and Its Double: A New York Perspective," Fundación Caja de Pensiones, Madrid and Barcelona. Catalogue with text by Dan Cameron.
"Damaged Goods: Desire and the Economy of the Object," The New Museum of Contemporary Art, New York City. Catalogue with text by Deborah Bershad, Hal Foster, and Brian Wallis.
1987 "Photography and Art: Interactions since 1946," Los Angeles County Museum of Art. Traveled to Queens Museum, Flushing, New York, and Des Moines Art Center, Iowa. Catalogue with text by Andy Grundberg and Kathleen McCarthy Gauss.
"Implosion: A Postmodern Perspective," Moderna Museet, Stockholm. Catalogue with text by Lars Nittve, Germano Celant, Kate Linker, and Craig Owens.
1988 "AIDS and Democray," Group Material installation, Dia Art Foundation, New York City.
1989 "A Forest of Signs: Art in the Crisis of Representation," Museum of Contemporary Art, Los Angeles. Catalogue with text by Ann Goldstein, Mary Jane Jacob, Anne Rorimer, and Howard Singerman.
"The Photography of Invention: American Pictures of the 1980s," National Museum of American Art, Washington, D.C. Catalogue with text by Joshua Smith and Merry A Foresta.

Selected Bibliography
Buchloh, Benjamin H. D. "Allegorical Procedures: Appropriation and Montage in Contemporary Art." *Artforum* (September 1982): 43-56.
Crimp, Douglas. "The Art of Exhibition." *October* (Fall 1984): 49-81.
Fehlau, Fred. "Louise Lawler Doesn't Take Pictures." *Artscribe* (May 1990): cover, 62-65.
Fraser, Andrea. "In and Out of Place." *Art in America* (June 1985): 122-30.
Lawler, Louise. "Arrangements of Pictures." *October* (Fall 1983): 3-6.
Linker, Kate. "Project: Rites of Exchange." *Artforum* (November

1986): 99-101.
Storr, Robert. "Louise Lawler: Unpacking the White Cube."
Parkett 22 (1989): 105-8.

Sherrie Levine

Born 1947, Hazleton, Pennsylvania.
Lives in New York City.
University of Wisconsin, Madison, B.A., 1969; M.F.A., 1973.

Selected Individual Exhibitions
1974 "Sherrie M. Levine: Betrayal," De Saisset Art Museum, University of Santa Clara, California.
1978 "Dogs and Triangles," Hallwalls, Buffalo.
1981 "Sherrie Levine: Photographs," Metro Pictures, New York City.
1983 Baskerville and Watson Gallery, New York City.
1984 "Self-Portraits by Sherrie Levine after Egon Shiele," A & M Artworks, New York City.
 "Sherrie Levine: 1917," Nature Morte, New York City.
1985 "Sherrie Levine Watercolors," Richard Kuhlenschmidt Gallery, Los Angeles.
1986 "Sherrie Levine: Recent Paintings," Daniel Weinberg Gallery, Los Angeles.
1987 Donald Young Gallery, Chicago.
 "Matrix 94," Wadsworth Atheneum, Hartford. Brochure with text by Andrea Miller-Keller.
 Mary Boone Gallery, New York City.
1988 "Directions—Sherrie Levine," Hirshhorn Museum and Sculpture Garden, Washington, D.C. Traveled to High Museum of Art, Atlanta: "Art at the Edge." Catalogue with text by Susan Krane and Phyllis Rosenzweig.
 Mario Diacono Gallery, Boston.

Selected Group Exhibitions
1977 "Pictures," Artists Space, New York City. Traveled to Allen Memorial Art Museum, Oberlin, Ohio; Los Angeles Institute of Contemporary Art; and University of Colorado, Boulder. Catalogue with text by Douglas Crimp.
1980 "Horror Pleni: Pitture d'oggi a New York," Padiglione d'Arte Contemporanea, Milan.
1982 "Documenta 7," Kassel, West Germany. Catalogue.
 "74th American Exhibition," Art Institute of Chicago. Catalogue with text by Anne Rorimer.
1984 "Content: A Contemporary Focus, 1974-1984," Hirshhorn Museum and Sculpture Garden, Washington, D.C. Catalogue with text by Howard Fox, Miranda McClintic, and Phyllis Rosenzweig.
 "Difference: On Representation and Sexuality," The New Museum of Contemporary Art, New York City. Traveled to Renaissance Society, University of Chicago, and Institute of Contemporary Art, London. Catalogue with text by Kate Linker, Craig Owens et al.
1985 "Biennial Exhibition," Whitney Museum of American Art, New York City. Catalogue.
 "Picture Taking: Weegee, Walker Evans, Sherrie Levine, Robert Mapplethorpe," Mary and Leigh Block Gallery, Northwestern University, Evanston, Illinois. Catalogue with text by David Deitcher.
1986 "Endgame: Reference and Simulation in Recent Painting and Sculpture," Institute of Contemporary Art, Boston. Catalogue with text by Thomas Crow, Yve-Alain Bois, Elisabeth Sussman, et al.
1988 "Cultural Geometry," Deste Foundation for Contemporary Art, Athens.
 "Carnegie International," Carnegie Museum of Art, Pittsburgh. Catalogue.
1989 "A Forest of Signs: Art in the Crisis of Representation," Museum of Contemporary Art, Los Angeles. Catalogue with text by Ann Goldstein, Mary Jane Jacob, Anne Rorimer, and Howard Singerman.
 "The Photography of Invention: American Pictures of

the 1980s," National Museum of American Art, Washington, D.C. Catalogue with text by Joshua Smith and Merry A. Foresta.

Selected Bibliography
Cameron, Dan. "Absence and Allure: Sherrie Levine's Recent Work." *Arts Magazine* (December 1983): 84-87.
Jones, Ronald. "Even Picasso: Sherrie Levine." *Artscribe* (November-December 1988): 50-52.
Levine, Sherrie. "Insert: Sherrie Levine `After Jan Vermeer.'" *Parkett* (July 1988): 123-34.
Morgan, Robert C. "Sherrie Levine: Language Games." *Arts Magazine* (December 1987): 86-88.
"Post-Modernism: A Symposium with Christian Hubert, Sherrie Levine, Craig Owens, David Salle and Julian Schnabel." *Real Life Magazine* (Summer 1981): 4-10.
Siegel, Jeanne. "After Sherrie Levine." *Arts Magazine* (Summer 1985): 141-44.

David Levinthal

Born 1949, San Francisco, California.
Lives in New York City.
Stanford University, Palo Alto, California, A.B., 1970.
Yale University School of Art and Architecture, New Haven, M.F.A., 1973.
Sloan School of Management, Massachusetts Institute of Technology, Cambridge, S.M., 1981.

Selected Individual Exhibitions
1977 Carpenter Center for Visual Arts, Harvard University, Cambridge.
 California Institute of the Arts, Valencia.
1978 George Eastman House, International Museum of Photography, Rochester, New York.
1985 Area X Gallery, New York City.
 "Modern Romance," Founders Gallery, University of San Diego, California. Catalogue with text by Barton Thurber.
1987 Philadelphia College of Art.
 303 Gallery, New York City.
1988 CEPA Gallery, Buffalo.
 Laurence Miller Gallery, New York City.
1989 "Centric 35," University Art Museum, California State University, Long Beach. Catalogue with text by Lucinda Barnes.
1990 "American Beauties," Pence Gallery, Santa Monica, California, and Laurence Miller Gallery, New York City. Catalogue with text by Rosetta Brooks.

Selected Group Exhibitions
1983 "In Plato's Cave," Marlborough Gallery, New York City. Catalogue with text by Abigail Solomon-Godeau.
1987 "Fabrications," International Center of Photography, New York City.
 "Avant-Garde in the Eighties," Los Angeles County Museum of Art. Catalogue with text by Howard Fox.
 "Photography and Art: Interactions since 1946," Los Angeles County Museum of Art. Traveled to Museum of Art, Fort Lauderdale, Florida; Queens Museum, Flushing, New York; and Des Moines Art Center, Iowa. Catalogue with text by Andy Grundberg and Kathleen McCarthy Gauss.
1988 "The Return of the Hero," Burden Gallery, New York City.
1989 "Constructed Realities," Kunstverein, Munich. Catalogue.
 "The Photography of Invention: American Pictures of the 1980s," National Museum of American Art, Washington, D.C. Catalogue with text by Joshua Smith and Merry A. Foresta.
 "Surrogate Selves: David Levinthal, Cindy Sherman, Laurie Simmons," Corcoran Gallery of Art, Washington, D.C. Catalogue with text by Terrie Sultan.

Selected Bibliography
Berry, Wendell. "Property, Patriotism and National Defense." *Aperture: The Return of the Hero* (Spring 1988): 32-40.
Grundberg, Andy. "Where Blurred Focus Makes Sharp Statements." *The New York Times* (20 December 1987): 106-11.
Levinthal, David, and Garry Trudeau. *Hitler Moves East: A Graphic Chronicle 1941-43.* New York: Sheed, Andrews & McMeel, 1977.

Brice Marden

Born 1938, Bronxville, New York.
Lives in New York City.
Boston University, School of Fine and Applied Arts, B.F.A., 1961.
Yale University School of Art and Architecture, M.F.A., 1963.

Selected Individual Exhibitions
1966 Bykert Gallery, New York City.
1969 Galerie Yvon Lambert, Paris.
1971 Galerie Konrad Fischer, Düsseldorf.
1974 "Drawings 1964-1974," Contemporary Arts Museum, Houston. Traveled to Fort Worth Art Museum and Minneapolis Institute of Arts. Catalogue with text by Dore Ashton.
1975 Solomon R. Guggenheim Museum, New York City. Catalogue with text by Linda Shearer.
1979 "Drawings 1964-1978," Kunstraum, Munich. Traveled to Institut für Moderne Kunst, Nuremberg. Catalogue with text by Hermann Kern and Klaus Kertess.
1980 Pace Gallery, New York City.
1981 Stedelijk Museum, Amsterdam. Traveled to Whitechapel Art Gallery, London. Catalogue with text by Stephen Bann and Roberta Smith.
1984 Daniel Weinberg Gallery, Los Angeles.
1987 Mary Boone Gallery, New York City. Catalogue with text by Peter Schjeldahl.
1988 Anthony d'Offay Gallery, London. Catalogue with text by John Yau.
1991 "Connections," Museum of Fine Arts, Boston. Brochure with text by Trevor Fairbrother.

Selected Group Exhibitions
1967 "A Romantic Minimalism," Institute of Contemporary Art, Philadelphia.
1970 "Modular Painting," Albright-Knox Art Gallery, Buffalo.
1971 "The Structure of Color," Whitney Museum of American Art, New York City. Catalogue with text by Marcia Tucker.
1972 "Documenta 5," Kassel, West Germany.
1974 "Eight Contemporary Artists," Museum of Modern Art, New York City. Catalogue.
1977 "Biennial Exhibition," Whitney Museum of American Art, New York City. Catalogue.
1981 "A New Spirit in Painting," Royal Academy of Arts, London. Catalogue.
1985 "Carnegie International," Museum of Art, Carnegie Institute, Pittsburgh. Catalogue.
1986 "The Spiritual in Art: Abstract Painting 1890-1985," Los Angeles County Museum of Art. Traveled to Museum of Contemporary Art, Chicago, and Gemeentemuseum, The Hague. Catalogue with text by Maurice Tuchman.
1988 "Carnegie International," Museum of Art, Carnegie Institute, Pittsburgh. Catalogue.
1989 "Biennial Exhibition," Whitney Museum of American Art, New York City. Catalogue.

Selected Bibliography
Liebmann, Lisa. "Brice Marden—The Duse of Minimalism." *Parkett* (January 1986): 37-44.
Ostrow, Saul. "Brice Marden." *BOMB* (December 1987): 30-37.
Poirier, Maurice. "Color-Coded Mysteries." *ArtNews* (January 1985): 52-61.
Ratcliff, Carter. "How To Study the Paintings of Brice Marden." *Parkett* (January 1986): 22-36.
Storr, Robert. "Brice Marden: Double Vision." *Art in America* (March 1985): 118-25.
Wei, Lilly. "Talking Abstract: Part One." *Art in America* (July 1987): 80-97.
White, Robin. "Brice Marden Interview." *View* (1980).

Allan McCollum

Born 1944, Los Angeles, California.
Lives in New York City.

Selected Individual Exhibitions
1971 Jack Glenn Gallery, Corona Del Mar, California.
1979 Julian Pretto & Co., New York City.
1980 112 Workshop, New York City.
 Galerie Yvon Lambert, Paris.
 Artists Space, New York City.
1983 "Plaster Surrogates," Marian Goodman Gallery, New York City.
1984 Richard Kuhlenschmidt Gallery, Los Angeles.
1985 Lisson Gallery, London.
1986 "Perfect Vehicles," Cash/Newhouse, New York City.
 "Investigations 18," Institute of Contemporary Art, Philadelphia. Brochure with text by Andrea Fraser.
 "Perpetual Photos," Diane Brown Gallery, New York City.
1988 "Individual Works," John Weber Gallery, New York City. Catalogue with text by Andrea Fraser.
 Portikus, Frankfurt, and Stichting De Appel, Amsterdam. Catalogue with text by Andrea Fraser and Ulrich Wilmes.
 Kunsthalle, Zurich.
1989 "Individual Works, Perpetual Photos," Kunstverein für die Rheinlande und Westfalen, Düsseldorf.
 Stedelijk van Abbemuseum, Eindhoven, Netherlands. Traveled to Serpentine Gallery, London, and IVAM Centre del Carme, Valencia. Catalogue with text by Anne Rorimer, Lynne Cooke, and Selma Klein Essink.
1990 Rooseum, Malmo, Sweden.

Selected Group Exhibitions
1971 "24 Young Los Angeles Artists," Los Angeles County Museum of Art. Catalogue.
1975 "Biennial Exhibition," Whitney Museum of American Art, New York City. Catalogue.
1982 "U.S. Art Now," Nordiska Kompaniet, Stockholm.
1983 "New York Now," Kestner-Gesellschaft, Hannover.
1984 "Ailleurs et Autrement," Musée d'Art Moderne de la Ville de Paris. Catalogue with text by Claude Gintz.
1986 "Damaged Goods: Desire and the Economy of the Object," The New Museum of Contemporary Art, New York City. Catalogue with text by Deobrah Bershad, Hal Foster, and Brian Wallis.
 "Dissent: The Issue of Modern Art in Boston, Part III, 'As Found,'" Institute of Contemporary Art, Boston. Catalogue with text by Benjamin H. D. Buchloh, Serge Guilbaut, et al.
1987 "Implosion: et Postmodernt Perspektiv," Moderna Museet, Stockholm. Catalogue with text by Germano Celant, Kate Linker, Lars Nittve, and Craig Owens.
1988 "Venice Biennale." Catalogue.
 Le Consortium, Centre d'Art Contemporain, Dijon. (Collaboration with Louise Lawler.)
1989 "A Forest of Signs: Art in the Crisis of Representation," Museum of Contemporary Art, Los Angeles. Catalogue with text by Ann Goldstein, Mary Jane Jacob, Anne Rorimer, and Howard Singerman.
 "Biennial Exhibition," Whitney Museum of American Art, New York City. Catalogue.
 "Image World: Art and Media Culture," Whitney Museum of American Art, New York City. Catalogue with text by Lisa Phillips, Marvin Heiferman, and John G. Hanhardt.

Selected Bibliography
Bourriaud, Nicholas. "L'Aura de McCollum." *New Art International* (October-November 1988): 82-83.
Collins, Tricia, and Richard Milazzo. "Szene New York, Tropical Codes: Allan McCollum—The Blank Spectacle." *Kunstforum* (June-August 1986): 314-416.
Foster, Hal. *Recoding: Art, Spectacle, Cultural Politics.* Seattle: Bay Press, 1986.
Jones, Ronald. "As Though We Knew What To Do." *C Magazine* (Summer 1987): 35-37.
Miller, John. "What You See Is What You Don't Get: Allan McCollum's Surrogates, Perpetual Photos, and Perfect Vehicles." *Artscribe* (January-February 1987): 32-36.
Owens, Craig. "Allan McCollum: Repetition and Difference." *Art in America* (September 1983): 130-32.
Robbins, D. A. "An Interview with Allan McCollum." *Arts Magazine* (October 1985): 40-44.

Ana Mendieta

Born 1948, Havana, Cuba; moved to Iowa, 1961.
Died 1985, New York City.
University of Iowa, Iowa City, B.F.A., 1969; M.A., 1972.

Selected Individual Exhibitions
1976 "Nanigo Burial and Filmworks," 112 Greene Street, New York City.
1979 "Silueta Series," A.I.R. Gallery, New York City.
1980 Museu de Arte Contemporaneo, São Paulo, Brazil.
"Earth/Body Sculptures," Colburn Gallery, University of Vermont, Burlington.
1981 "Rupestrian Sculptures," A.I.R. Gallery, New York City. Catalogue with text by Gerardo Mosquera.
1982 "Outdoor Sculpture," Lowe Art Museum, University of Miami, Florida.
"Amategrams and Photographs," Yvonne Sequy Gallery, New York City.
1983 "Geo-Imago," Museo Nacional de Bellas Artes, Havana. Catalogue with text by Alberto Quevedo and the artist.
1984 "Earth Archetypes," Primo Piano, Rome.
1985 "Duetto Pietro e Foglie," Gallery AAM, Rome. (With Carl Andre.)
1987 "Ana Mendieta: A Retrospective," The New Museum of Contemporary Art, New York City. Catalogue with text by John Perreault and Petra Barreras del Rio.

Selected Group Exhibitions
1977 "Feminist Statements," Women's Building, Los Angeles.
1979 "Window to the South: Works by Fourteen Contemporary Artists from Latin America," Henry Street Settlement, Louis Abrons Arts for Living Center, New York City. Catalogue with text by Renata Karlin.
"Exchanges I," Henry Street Settlement, Louis Abrons Arts for Living Center, New York City. Catalogue with text by Lucy R. Lippard.
1980 "Women/Image/Nature," Tyler School of Art, Temple University, Philadelphia. Traveled to Rochester Institute of Technology.
1981 "Streetworks," Washington Project for the Arts, Washington, D.C.
"Medellin Art Biennial," Museo de Arte Moderno de Medellin, Colombia.
1982 "Art across the Park," Museo del Barrio, New York City.
"Projects in Nature," Wave Hill, Riverdale, New York.
"Women of the Americas: Emerging Perspectives," Center for Inter-American Relations and Konkos Gallery, New York City.
"Ritual and Rhythm: Visual Forces for Survival," Kenkeleba House, New York City.
1983 "Seven Women: Image/Impact," Institute for Art and Urban Resources, P.S. 1, Long Island City, New York.
"Contemporary Latin American Art," Chrysler Museum,

Norfolk, Virginia.
"Aqui: 27 Latin American Artists Living and Working in the United States," Fisher Gallery, University of Southern California, Los Angeles. Catalogue with text by John Stringer and Donald Goodall.
1985 "Awards in the Visual Arts 4." Organized by Southeastern Center for Contemporary Art, Winston-Salem, North Carolina. Traveled to Albright-Knox Art Gallery, Buffalo, and Institute of Contemporary Art, Philadelphia. Catalogue with text by Peter Frank.
1986 "Race and Representation," Hunter Gallery, Hunter College, New York City.

Selected Bibliography
Coker, Gylbert. "Ana Mendieta at A.I.R." *Art in America* (April 1980): 133-34.
Heit, Janet. "Ana Mendieta." *Arts Magazine* (January 1980): 5.
Lippard, Lucy R. "Quite Contrary: Body, Nature, Ritual in Women's Art." *Chrysalis*, 2 (1977): 31-47.
Rich, Ruby. "The Screaming Silence." *The Village Voice* (16 September 1986): 23-24.

Elizabeth Murray

Born 1940, Chicago, Illinois.
Lives in New York City.
Art Institute of Chicago, B.F.A., 1962.
Mills College, Oakland, California, M.F.A., 1964.

Selected Individual Exhibitions
1976 Paula Cooper Gallery, New York City.
1978 Phyllia Kind Gallery, Chicago.
1980 Galerie Mukai, Tokyo.
Susanne Hilberry Gallery, Birmingham, Michigan.
1982 Daniel Weinberg Gallery, New York City.
Portland Center for the Visual Arts, Oregon.
1984 Knight Gallery, Spirit Square Art Center, Charlotte, North Carolina.
"Currents," Institute of Contemporary Art, Boston.
1986 "Elizabeth Murray: Drawings 1980-1986," Carnegie-Mellon University Art Gallery, Pittsburgh. Catalogue with text by Elaine King and Anne Sutherland Harris.
1987 "Elizabeth Murray: Paintings and Drawings," Dallas Museum of Fine Art and List Visual Arts Center, Massachusetts Institute of Technology, Cambridge. Traveled to Museum of Contemporary Art, Los Angeles; Des Moines Art Center, Iowa; Walker Art Center, Minneapolis; and Whitney Museum of American Art, New York City. Catalogue with text by Clifford S. Ackley et al.
1989 Mayor Rowen Gallery, London.

Selected Group Exhibitions
1972 "Annual Exhibition," Whitney Museum of American Art, New York City. Catalogue.
1977 "Nine Artists: Theodoron Awards," Solomon R. Guggenheim Museum, New York City. Catalogue.
1979 "New Painting/New York," Hayward Gallery, Arts Council of Great Britain, London. Catalogue.
"American Painting: The Eighties," Grey Art Gallery and Study Center, New York University, New York City. Catalogue with text by Barbara Rose.
1981 "Biennial Exhibition," Whitney Museum of American Art, New York City. Catalogue.
1982 "74th American Exhibition," Art Institute of Chicago. Catalogue with text by Anne Rorimer.
1983 "Directions 1983," Hirshhorn Museum and Sculpture Garden, Washington, D.C. Catalogue with text by Phyllis Rosenzweig.
1984 "Five Painters in New York," Whitney Museum of American Art, New York City. Catalogue with text by Richard Marshall.
"An International Survey of Recent Painting and Sculpture," Museum of Modern Art, New York City.

Catalogue with text by Kynaston McShine.
1985 "Correspondences: New York Art," LaForet Museum, Harajuku, Tokyo. Traveled in Japan. Catalogue with text by Nicholas A. Moufarrege.
1986 "Individuals: A Selected History of Contemporary Art, 1945-1986," Museum of Contemporary Art, Los Angeles. Catalogue.
1988 "Carnegie International," Carnegie Museum of Art, Pittsburgh. Catalogue.
"Jennifer Bartlett, Elizabeth Murray, Eric Fischl, Susan Rothenberg," Saatchi Collection, London. Catalogue with text by Mark Rosenthal.
1990 "High and Low: Modern Art and Popular Culture," Museum of Modern Art, New York City. Traveled to Art Institute of Chicago and Museum of Contemporary Art, Los Angeles. Catalogue with text by Kirk Varnedoe and Adam Gopnik.

Selected Bibliography
Gardner, Paul. "Elizabeth Murray Shapes Things Up." *ArtNews* (September 1984): 46-55.
Simon, Joan. "Mixing Metaphors: Elizabeth Murray." *Art in America* (April 1984): 140-47.
Smith, Roberta. "The Interplay of Real and Painted Forms." *The New York Times* (17 March 1989): 21.
Solomon, Deborah. "Elizabeth Murray: Celebrating Paint." *The New York Times Magazine* (31 March 1991): 21-25, 40, 46.
Storr, Robert. "Added Dimension." *Parkett 8* (1986): 8-19.

Bruce Nauman

Born 1941, Fort Wayne, Indiana.
Lives in Pecos, New Mexico.
University of Wisconsin, Madison, B.S., 1964.
University of California, Davis, M.F.A., 1966.

Selected Individual Exhibitions
1966 Nicholas Wilder Gallery, Los Angeles.
1968 Leo Castelli Gallery, New York City.
Galerie Konrad Fischer, Düsseldorf.
1973 Los Angeles County Museum of Art. Traveled to Whitney Museum of American Art New York City; Kunsthalle Bern; Städtische Kunsthalle, Düsseldorf; and Stedelijk van Abbemuseum, Eindhoven, Netherlands, among others. Catalogue with text by Jane Livingston and Marcia Tucker.
1978 "Floating Room," Halle für internationale neue Kunst (INK), Zurich.
1981 "Bruce Nauman: 1972-1981," Kröller-Müller Museum, Otterlo, Netherlands. Traveled to Staatliche Kunsthalle, Baden Baden, West Germany. Catalogue.
1982 "Bruce Nauman Neons," Baltimore Museum of Art. Catalogue with text by Brenda Richardson.
1983 "Dream Passage, Stadium Piece, Musical Chairs," Museum Haus Esters, Krefeld, West Germany. Catalogue with text by Julian Heynan.
1984 Sperone Westwater, New York City.
Leo Castelli Gallery, New York City.
1985 Donald Young Gallery, Chicago.
1986 Kunsthalle, Basel, and Whitechapel Art Gallery, London. Traveled to Musée d'Art Moderne de la Ville de Paris/ARC. Catalogue with text by Jean-Christophe Ammann, Nicholas Serota, and Joan Simon.
"Drawings 1965-86," Museum für Gegenwartskunst, Basel. Traveled to Städtisches Kunstmuseum, Bonn; Museum Boymans-van Beuningen, Rotterdam; The New Museum of Contemporary Art, New York City; and Museum of Contemporary Art, Los Angeles, among others. Catalogue.

Selected Group Exhibitions
1969 "Live in Your Head. When Attitudes Become Form: Works—Concepts—Processes—Situations—

Information," Kunsthalle, Bern. Catalogue with text by Scott Burton, Gregoire Muller, Harald Szeemann, and Tommaso Trini.
1970 "Information," Museum of Modern Art, New York City. Catalogue with text by Kynaston McShine.
1980 "Venice Biennale." Catalogue.
1982 "Documenta 7," Kassel, West Germany. Catalogue.
"74th American Exhibition," Art Institute of Chicago. Catalogue with text by Anne Rorimer.
"'60-'80: Attitudes/Concepts/Images," Stedleijk Museum, Amsterdam. Catalogue.
1984 "Content: A Contemporary Focus, 1974-1984," Hirshhorn Museum and Sculpture Garden, Washington, D.C. Catalogue with text by Howard Fox, Miranda McClintic, and Phyllis Rosenzweig.
1985 "Carnegie International," Museum of Art, Carnegie Institute, Pittsburgh. Catalogue.
"Biennial Exhibition," Whitney Museum of American Art, New York City. Catalogue.
1986 "Light: Perception-Projection," Centre Internationale d'Art Contemporain de Montréal. Catalogue.
"Individuals: A Selected History of Contemporary Art, 1945-1986," Museum of Contemporary Art, Los Angeles. Catalogue.
1988 "Marcel Duchamp und die Avantgarde seit 1950," Museum Ludwig, Cologne. Catalogue.

Selected Bibliography
"Collaboration Bruce Nauman." *Parkett* (July 1986). Contributions by Chris Dercon, Patrick Frey, Bruce Nauman, Jeanne Silverthorne, and Robert Storr.
Schjeldahl, Peter. "Minimalism," in *Art of Our Time: The Saatchi Collection.* London: Lund Humphries, 1985.
Smith, Roberta. "Bruce Nauman Retrospective." *The New York Times* (30 October 1987).

Adrian Piper

Born 1948, New York City.
School of Visual Arts, New York City, A.A., 1969.
City College of New York, B.A., 1974.
Harvard University, Cambridge, Ph.D., 1981.
Lives in Wellesley, Massachusetts.

Selected Individual Exhibitions
1969 "Three Untitled Projects" (mail art), 0 to 9 Press, New York City.
1980 "Matrix 56," Wadsworth Atheneum, Hartford, in conjunction with "Adrian Piper," Real Art Ways, Hartford. Brochure with text by Andrea Miller-Keller.
1981 And/Or, Seattle.
1987 "Adrian Piper: Reflections 1967-1987," The Alternative Museum, New York City. Traveled to Nexus Contemporary Art Center, Atlanta; Goldie Paley Gallery, Moore College of Art, Philadelphia; University of Colorado Art Gallery, Boulder; and Lowe Art Museum, University of Miami, Florida. Catalogue with text by Jane Farver and Clive Phillpot.
1989 "Cornered," John Weber Gallery, New York City.
"Matrix 130," University Art Museum, Berkeley, California. Brochure with text by Lawrence Rinder.
1990 "Pretend," John Weber Gallery, New York City. Catalogue with text by Adrian Piper and Mary Anne Staniszewski.
"Artworks: Adrian Piper," Williams College Museum of Art, Williamstown, Massachusetts. Brochure with text by Deborah Menaker.
Exit Art, New York City.

Selected Group Exhibitions
1969 "Language III," Dwan Gallery, New York City.
 "Konzeption/Conception," Städtisches Museum,
 Leverkusen, West Germany.
1970 "Information," Museum of Modern Art, New York City.
 Catalogue with text by Kynaston McShine.
1975 "Bodyworks," Museum of Contemporary Art, Chicago.
1980 "Issue: Twenty Social Strategies by Women Artists,"
 Institute of Contemporary Art, London.
1981 "The Gender Show," Group Material, New York City.
1983 "Language, Drama, Source, and Vision," The New
 Museum of Contemporary Art, New York City.
1984 "Disarming Images: Art for Nuclear Disarmament."
 Organized by Art Museum Association of America, San
 Francisco. Traveled to Contemporary Arts Center,
 Cincinnati, and Munson Williams Proctor Museum of
 Art, Utica, New York, among others. Catalogue with text
 by Nina Felshin.
1985 "The Art of Memory/The Loss of History," The New
 Museum of Contemporary Art, New York City.
 Catalogue.
1988 "Committed to Print," Museum of Modern Art, New
 York City. Traveled to Wright State University Art
 Galleries, Dayton, Ohio, and Newport Harbor Art
 Museum, Newport Beach, California, among others.
 Catalogue with text by Deborah Wye.
1989 "Conceptual Art: A Perspective," Musée d'Art Moderne
 de la Ville de Paris. Traveled to Fundación Caja de
 Pensiones, Madrid. Catalogue with text by Claude Gintz.
1990 "The Decade Show: Frameworks of Identity in the
 1980s," Museum of Contemporary Hispanic Art, New
 Museum of Contemporary Art, and Studio Museum in
 Harlem, New York City. Catalogue.
 "Word As Image," Milwaukee Art Museum. Catalogue.

Selected Bibliography
Barber, Bruce, and Serge Guilbaut. "Performance As Social
and Cultural Intervention: Interview with Adrian Piper."
Parachute (Fall 1981): 25-28.
Berger, Maurice. "Are Art Museums Racist?" and "Speaking
Out." *Art in America* (September 1990): 69-77, 78-85.
Kuspit, Donald B. "Adrian Piper: Self-Healing through Meta-
Art." *Art Criticism* (September 1987): 9-16.
Piper, Adrian. "A Paradox of Conscience." *The New Art
Examiner* (April 1989): 27-31.
_____. "The Triple Negation of Colored Women Artists," in *Next
Generation* [exhibition catalogue]. Winston-Salem, North
Carolina: Southeastern Center for Contemporary Art, 1990, 15-22.
Roth, Moira. "Adrian Piper," in *The Amazing Decade: Women
and Performance in America, 1970-1980*. Los Angeles:
AstroArtz, 1983.

Sigmar Polke

Born 1941, Oels, Silesia (now Olesnica, Poland); 1953, emigrat-
ed to West Germany.
Lives in Cologne.
Kunstakademie, Düsseldorf, 1961-67.

Selected Individual Exhibitions
1966 Galerie h, Hannover. Catalogue. (With Gerhard Richter.)
1967 Galerie Rene Block, West Berlin. Catalogue.
1976 "Bilder, Tücher, Objekte: Werkauswahl, 1962-1971,"
 Kunsthalle, Tübingen. Traveled to Städtische Kunsthalle,
 Düsseldorf, and Stedelijk van Abbemuseum, Eindhoven,
 Netherlands. Catalogue with text by Benjamin H. D.
 Buchloh.
1978 Halle für internationale neue Kunst (INK), Zurich.
 Catalogue with text by Christel Sauer.
1980 Galerie Klein, Bonn.
 Galerie Rudolf Zwirner, Cologne.
1981 Galerie Bama, Paris.

"Sigmar Polke: Works, 1972-1981," Holly Solomon
 Gallery, New York City.
1983 Museum Boymans-van Beuningen, Rotterdam. Traveled
 to Städtisches Kunstmuseum, Bonn. Catalogue with text
 by Wim Beeren et al.
1984 Kunsthaus, Zurich. Traveled to Josef-Haubrich Kunsthalle,
 Cologne. Catalogue with text by Harald Szeemann,
 Dietrich Helms, Siegfried Gohr, and Rainer Speck.
 "Sigmar Polke: Paintings," Marian Goodman Gallery,
 New York City.
1985 Mary Boone/Michael Werner Gallery, New York City.
 Anthony d'Offay Gallery, London.
1986 "Athanor Venice Biennale." Catalogue.
 "Sigmar Polke: Biennale Venedig 1986," Städtisches
 Museum Abteiberg, Mönchengladbach, West Germany.
 Catalogue.
1988 "Sigmar Polke: Zeichnungen, Aquarelle, Skizzenbücher,
 1962-1988," Städtisches Kunstmuseum, Bonn.
 Catalogue with text by Katharina Schmidt.
 Musée d'Art Moderne de la Ville de Paris/ARC.
1990 San Francisco Museum of Modern Art. Traveled to
 Hirshhorn Museum and Sculpture Garden, Washington,
 D.C.; Museum of Contemporary Art, Chicago; and
 Brooklyn Museum, Brooklyn, New York. Catalogue with
 text by John Caldwell, Peter Schjeldahl, John
 Baldessari, et al.

Selected Group Exhibitions
1972 "Documenta 5," Kassel, West Germany. Catalogue.
1975 "Day by Day They Take Some Brain Away," São Paulo
 Bienal, Brazil. (With Georg Baselitz and Blinky Palermo.)
 Catalogue.
1977 "Documenta 6," Kassel, West Germany. Catalogue.
 "A New Spirit in Painting," Royal Academy of Art,
 London. Catalogue.
1981 "Westkunst—Heute," Museen der Stadt, Cologne.
 Catalogue.
1982 "Avanguardia, Transavanguardia," Mura Aurealiane,
 Rome. Catalogue with text by Achille Bonito Oliva.
 "Documenta 7," Kassel, West Germany. Catalogue.
1983 "New Art at the Tate Gallery," London. Catalogue with
 text by Michael Compton.
1984 "An International Survey of Recent Painting and
 Sculpture," Museum of Modern Art, New York City.
 Catalogue with text by Kynaston McShine.
1985 "Carnegie International," Museum of Art, Carnegie
 Institute, Pittsburgh. Catalogue.
1987 "Warhol/Beuys/Polke," Milwaukee Art Museum.
 Traveled to Contemporary Arts Museum, Houston.
 Catalogue.
1988 "Carnegie International," Carnegie Museum of Art,
 Pittsburgh. Catalogue.

Selected Bibliography
Fuchs, Rudi. In *Art of Our Time: The Saatchi Collection*. vol. 3.
London: Lund Humphries, 1984.
Buchloh, Benjamin H. D. "Parody and Appropriation in Francis
Picabia, Pop and Sigmar Polke." *Artforum* (March 1982): 28-34.
Gintz, Claude. "Polke's Slow Dissolve." *Art in America*
(December 1985): 102-9.
Kuspit, Donald B. "At the Tomb of the Unknown Picture."
Artscribe (March 1988): 38-45.
Marcadé, Bernard. "Sigmar Polke: La Drougerie de Polke."
Artstudio (Fall 1986): 118-31.
Polke, Sigmar. "A Project." *Artforum* (December 1983): 51-55.

Martin Puryear

Born 1941, Washington, D.C.
Lives in New York State.
Catholic University of America, Washington, D.C., B.A., 1963.
Swedish Royal Academy of Art, Stockholm, 1966-68.

Yale University School of Art and Architecture, New Haven, Connecticut, M.F.A., 1971.

Selected Individual Exhibitions
1977 Corcoran Gallery of Art, Washngton, D.C.
1978 Protetch-McIntosh Gallery, Washington, D.C.
1980 Young Hoffman Gallery, Chicago.
Museum of Contemporary Art, Chicago. Brochure with text by Judith Russi Kirshner.
Joslyn Art Museum, Omaha, Nebraska. Brochure with text by Holliday T. Day.
1983 Donald Young Gallery, Chicago.
1984 University Gallery, University of Massachusetts, Amherst. Traveled to Berkshire Museum, Pittsfield, Massachusetts; The New Museum of Contemporary Art, New York City; and La Jolla Museum of Contemporary Art, California. Catalogue with text by Hugh M. Davies.
1985 "Matrix," University Art Museum, Berkeley, California.
1987 "Public and Personal," Chicago Cultural Center. Catalogue with text by Patricia Fuller and Judith Russi Kirshner.
"Sculpture and Works on Paper," Carnegie-Mellon University Art Gallery, Pittsburgh. Catalogue with text by Elaine King.
"Stereotypes and Decoys," McKee Gallery, New York City.
1988 Grand Lobby installation, Brooklyn Museum, Brooklyn, New York.
1989 "São Paulo Bienal," Brazil. Catalogue with text by Kellie Jones and Robert Storr.
1990 "Connections, Martin Puryear," Museum of Fine Arts, Boston. Brochure with text by Vishakha N. Desai and Kathy Halbreich.

Selected Group Exhibitions
1978 "Young American Artists: Exxon National Exhibition," Solomon R. Guggenheim Museum, New York City. Catalogue with text by Linda Shearer.
"The Presence of Nature," Whitney Museum of American Art, Downtown Branch, New York City. Catalogue.
1979 "Biennial Exhibition," Whitney Museum of American Art, New York City. Catalogue.
1980 "Afro-American Abstraction," Institute for Art and Urban Resources, P.S. 1, Long Island City, New York.
1981 "Biennial Exhibition," Whitney Museum of American Art, New York City. Catalogue.
1982 "Form and Function: Proposals for Public Art in Philadelphia," Pennsylvania Academy of the Fine Arts, Philadelphia. Catalogue with text by Penny Balkin Bach.
"74th American Exhibition," Art Institute of Chicago. Catalogue with text by Anne Rorimer.
1984 "An International Survey of Recent Painting and Sculpture," Museum of Modern Art, New York City. Catalogue with text by Kynaston McShine.
"Primitivism in 20th Century Art: Affinity of the Tribal and Modern," Museum of Modern Art, New York City. Catalogue with text by William Rubin, Kirk Varnedoe, et al.
1986 "Individuals: A Selected History of Contemporary Art, 1945-1986," Museum of Contemporary Art, Los Angeles. Catalogue.
1988 "Sculpture Inside Outside," Walker Art Center, Minneapolis. Catalogue with text by Peter Boswell.

Selected Bibliography
Brenson, Michael. "Maverick Sculptor Makes Good." *The New York Times Magazine* (1 November 1987).
_____. "A Sculptor's Struggles To Fuse Culture and Art." *The New York Times* (29 October 1989).
Crary, Jonathan. "Martin Puryear's Sculpture." *Artforum* (October 1979).
Princenthal, Nancy. "Intuition's Disciplinarian." *Art in America*

(January 1990).
Schwabsky, Barry. "The Obscure Objects of Martin Puryear." *Arts Magazine* (November 1987).
Spector, Buzz. "Martin Puryear." *The New Art Examiner* (April 1980).

Gerhard Richter

Born 1932, Dresden, Germany.
Lives in Cologne.
Kunstakademie, Dresden, 1951-56.
Staatlichen Kunstakademie, Düsseldorf, 1961-63.

Selected Individual Exhibitions
1964 Galerie Heiner Friedrich, Munich.
Galerie Alfred Schmela, Düsseldorf.
Galerie Rene Block, West Berlin.
1972 "Venice Biennale," German Pavilion. Catalogue with text by Dieter Honisch, Klaus Honnef, et al.
1973 Reinhard Onnasch Gallery, New York City.
1974 Städtisches Museum, Mönchengladbach, West Germany. Catalogue with text by Johannes Cladders.
1977 Musée National d'Art Moderne, Centre Georges Pompidou, Paris. Catalogue with text by Benjamin H. D. Buchloh.
1978 Stedelijk van Abbemuseum, Eindhoven, Netherlands. Catalogue with text by Benjamin H.D. Buchloh and Rudi Fuchs.
1980 Sperone Westwater Fischer, New York City.
1981 Galerie Konrad Fischer, Cologne.
Kunsthalle, Düsseldorf. (With Georg Baselitz.) Catalogue with text by Jürgen Harten and U. Krempel.
1982 "Gerhard Richter: Abstrakte Bilder 1976 bis 1981," Kunsthalle, Bielefeld, West Germany. Traveled to Kunstverein, Mannheim, West Germany. Catalogue with text by Rudi Fuchs and Herbert Heere.
1984 Musée d'Art et d'Industrie, Saint-Étienne, France.
1985 Staatsgalerie, Stuttgart.
1986 Kunsthalle, Düsseldorf. Traveled to Kunsthalle, Bern among others. Catalogue with text by Jürgen Harten.
1987 Marian Goodman Gallery and Sperone Westwater, New York City. Catalogue with text by Anne Rorimer and Denys Zacharopoulos.
1988 Art Gallery of Ontario, Toronto, and Museum of Contemporary Art, Chicago. Traveled to Hirshhorn Museum and Sculpture Garden, Washington, D.C., and San Francisco Museum of Modern Art. Catalogue with text by Roald Nasgaard, I. Michael Danoff, and Benjamin H. D. Buchloh.

Selected Group Exhibitions
1972 "Documenta 5," Kassel, West Germany. Catalogue.
1977 "Documenta 6," Kassel, West Germany. Catalogue.
1979 "Biennale of Sydney," Sydney, Australia. Catalogue.
1980 "Venice Biennale." Catalogue.
"Forms of Realism Today," Musée d'Art Contemporain, Montreal. Catalogue.
"Pier + Ocean," Hayward Gallery, London, and Kröller-Müller Museum, Otterlo, Netherlands. Catalogue.
1981 "A New Spirit in Painting," Royal Academy of Arts, London. Catalogue.
"Westkunst—Heute," Museen der Stadt, Cologne. Catalogue.
1982 "Documenta 7," Kassel, West Germany. Catalogue.
1984 "An International Survey of Recent Painting and Sculpture," Museum of Modern Art, New York City. Catalogue with text by Kynaston McShine.
1985 "The European Iceberg—Creativity in Germany and Italy Today." Art Gallery of Ontario, Toronto. Catalogue.
"Carnegie International," Museum of Art, Carnegie Institute, Pittsburgh. Catalogue with text by Germano Celant.

1986 "The Mirror and the Lamp," Fruitmarket Gallery and Institute of Contemporary Art, London. Catalogue.
1987 "Avant-Garde in the Eighties," Los Angeles County Museum of Art. Catalogue with text by Howard Fox.
1988 "Documenta 8," Kassel, West Germany. Catalogue.

Selected Bibliography

Harten, Jürgen. *Gerhard Richter: Bilder/Paintings 1962-1985.* Cologne: DuMont Buchverlag, 1986.
Loock, Ulrich, and Denys Zacharopoulos. *Gerhard Richter.* Munich: Verlag Silke Schreiber, 1985.
Pohlen, Annelie. ""The Beautiful and Ugly Pictures." *Art and Text* 12-13 (Summer 1983-Fall 1984): 60-73.
van Bruggen, Coosje. "Gerhard Richter: Painting As a Moral Act." *Artforum* (May 1985): 82-91.

Tim Rollins + K.O.S. (Kids of Survival)

Born 1955, Pittsfield, Maine.
Lives in New York City.
School of Visual Arts, New York City, B.F.A., 1978.
New York University, New York City, M.A., 1980.

Selected Individual Exhibitions
1985 Hostos University Gallery, Bronx Museum of the Arts, Bronx, New York.
1986 Jay Gorney Modern Art, New York City.
State University of New York, Old Westbury.
Fashion Moda, Bronx, New York.
1987 Lawrence Oliver Gallery, Philadelphia. Brochure with text by Lucy R. Lippard.
Knight Gallery, Charlotte, North Carolina.
1988 Institute of Contemporary Art, Boston.
Walker Art Center, Minneapolis.
Orchard Gallery, Derry.
Riverside Studios, London.
1989 Johnen & Schöttle, Cologne.
"Amerika," Dia Art Foundation, New York City. Catalogue with text by Gary Garrels et al.
Interim Art, London.
1990 "The Temptation of Saint Anthony," Museum für Gegenwartskunst, Basel. Catalogue with text by Dieter Koepplin.
"Matrix 109," Wadsworth Atheneum, Hartford. Brochure with text by Andrea Miller-Keller.

Selected Group Exhibitions
1980 Inaugural exhibition, Group Material headquarters, New York City.
1983 "Timeline," Institute for Art and Urban Resources, P.S. 1, Long Island City, New York. Organized by Group Material.
"The State of the Art: The New Social Commentary," Barbara Gladstone Gallery, New York City.
"The 1984 Show," Ronald Feldman Fine Arts, New York City. Catalogue.
1985 "Public Art," Nexus Art Center, Atlanta.
"Americana," Group Material installation at "Biennial Exhibition," Whitney Museum of American Art, New York City. Catalogue.
1986 "Art and Its Double: A New York Perspective," Fundación Caja de Pensiones, Madrid and Barcelona. Catalogue with text by Dan Cameron.
"Liberty and Justice," Alternative Museum, New York City. Catalogue.
1987 "Out of the Studio: Art with Community," Institute for Art and Urban Resources, P.S. 1, Long Island City, New York.
"Similia/Dissimilia: Modes of Abstraction in Painting, Sculpture, and Photography Today," Kunsthalle, Düsseldorf. Travelled. Catalogue with text by Ascan Crone.
"New York Art Now: The Saatchi Collection," London. Catalogue.
"The Castle," Group Material installation at "Documenta 8," Kassel, West Germany. Catalogue.
1988 "Aperto '88: Venice Biennale." Catalogue.
"The BiNational: American Art of the Late Eighties," Museum of Fine Arts and Institute of Contemporary Art, Boston; Städtische Kunsthalle and Kunstsammlung Nordheim-Westfälen, Düsseldorf. Catalogue.
"Committed to Print," Museum of Modern Art, New York City. Traveled to Wright State Universtiy Art Galleries, Dayton, Ohio, and Newport Harbor Art Museum, Newport Beach, California, among others. Catalogue with text by Deborah Wye.
1989 "Horn of Plenty: Sixteen Artists from New York," Stedelijk Museum, Amsterdam.

Selected Bibliography

Brooks, Rosetta. "Tim Rollins + K.O.S." *Artscribe* (May 1987): 40-47.
Decter, Joshua. "Tim Rollins + K.O.S.: The Workshop Survived Because We Love Each Other." *Flash Art* (January 1990): 89-93.
Lewallen, Constance. "Tim Rollins + K.O.S.: Interview at Crown Point Press, San Francisco, August 1989." *View* (Winter 1990).
Lippard, Lucy R. "America, Amerika: Art against the Odds." *Z Magazine* (December 1989): 75-77.
Rollins, Tim, + K.O.S. "Collaboration." *Parkett* 20 (1989).

Susan Rothenberg

Born 1945, Buffalo, New York.
Lives in Pecos, New Mexico.
Cornell University, Ithaca, New York, B.F.A., 1967.

Selected Individual Exhibitions
1975 "Three Large Paintings," 112 Greene Street Gallery, New York City.
1976 Willard Gallery, New York City.
1978 "Matrix 3," University Art Museum, Berkeley, California. Brochure with text by Mark Rosenthal.
Walker Art Center, Minneapolis. Catalogue.
1980 Mayor Gallery, London. Traveled to Galerie Rudolf Zwirner, Cologne.
1981 Akron Art Museum, Ohio.
Willard Gallery, New York City.
1982 Stedelijk Museum, Amsterdam. Catalogue with text by Alexander von Grevenstein.
1983 Los Angeles County Museum of Art. Traveled to San Francisco Museum of Modern Art, Detroit Institute of Arts, and Tate Gallery, London, among others. Brochure with text by Maurice Tuchman.
1985 Phillips Collection, Washington, D.C. Catalogue.
1987 "The Horse Paintings," Gagosian Gallery, New York City. Catalogue.
Sperone Westwater, New York City. Catalogue.
1988 "Drawing Now: Susan Rothenberg," Baltimore Museum of Art.
1990 "Susan Rothenberg: 15 Years—A Survey," Rooseum Center for Contemporary Art, Malmo, Sweden. Catalogue with text by Robert Storr.

Selected Group Exhibitions
1977 "American Drawn and Matched," Museum of Modern Art, New York City. Catalogue with text by William S. Lieberman.
1978 "New Image Painting," Whitney Museum of American Art, New York City. Catalogue with text by Richard Marshall.
1979 "Biennial Exhibition," Whitney Museum of American Art, New York City. Catalogue.
"American Painting: The Eighties," Grey Art Gallery and Study Center, New York University, New York City. Traveled to Contemporary Arts Museum, Houston, and American Center, Paris. Catalogue with text by Barbara Rose.
1980 "Venice Biennale." Catalogue.

1981 "Robert Moskowitz, Susan Rothenberg, Julian Schnabel," Kunsthalle, Basel. Traveled to Kunstverein, Frankfurt, and Louisiana Museum, Humlebaek, Denmark. Catalogue.
1982 "74th American Exhibition," Art Institute of Chicago. Catalogue with text by Anne Rorimer.
"Zeitgeist," Martin-Gropius-Bau, West Berlin. Catalogue.
"New Figuration in America," Milwaukee Art Museum. Catalogue with text by Russell Bowman and Peter Schjeldahl.
1983 "Biennial Exhibition," Whitney Museum of American Art, New York City. Catalogue.
1984 "Images and Impressions: Painters Who Print," Walker Art Center, Minneapolis. Traveled to Institute of Contemporary Art, Philadelphia, among others. Catalogue with text by Marge Goldwater.
"An International Survey of Recent Painting and Sculpture," Museum of Modern Art, New York City. Catalogue with text by Kynaston McShine.
1985 "Carnegie International," Museum of Art, Carnegie Institute, Pittsburgh. Catalogue.
1986 "Individuals: A Selected History of Contemporary Art 1945-1986," Museum of Contemporary Art, Los Angeles. Catalogue.
1988 "Jennifer Bartlett, Elizabeth Murray, Eric Fischl, Susan Rothenberg," Saatchi Collection, London. Catalogue with text by Mark Rosenthal.

Selected Bibliography
Glueck, Grace. "Susan Rothenberg: New Outlook for a Visionary Artist." *The New York Times Magazine* (22 July 1984).
Herrera, Hayden. "Expressionism Today: An Artist's Symposium." *Art in America* (December 1982).
Rosenthal, Mark. "Susan Rothenberg," in *Art of Our Time: The Saatchi Collection.* London: Lund Humphries, 1984.
Rothenberg, Susan. "Diffusions—A Project for *Artforum.*" *Artforum* (April 1988): 118-21.
Storr, Robert. "Spooks and Floats." *Art in America* (May 1983): cover, 153-59.

Robert Ryman

Born 1930, Nashville, Tennessee.
Lives in New York City.
Tennessee Polytechnic Institute, Cookville, 1948-49.
George Peabody College for Teachers, Nashville, Tennessee, 1949-50.

Selected Individual Exhibitions
1967 Paul Bianchini Gallery, New York City.
1968 Galerie Konrad Fischer, Dusseldorf.
1972 Solomon R. Guggenheim Museum, New York City. Catalogue with text by Diane Waldman.
1974 Stedelijk Museum, Amsterdam. Catalogue with text by Naomi Spector.
Westfälischer Kunstverein, Münster. Catalogue with text by Klaus Honnef.
1975 Kunsthalle, Basel. Catalogue with text by Carlo Huber.
1977 Whitechapel Art Gallery, London. Catalogue with text by Naomi Spector.
1979 Sidney Janis Gallery, New York City. Catalogue.
1980 Halle für internationale neue Kunst (INK), Zurich. Traveled to Musée National d'Art Moderne, Centre Georges Pompidou, Paris, and Kunsthalle, Düsseldorf. Catalogue with text by Yve-Alain Bois and Christel Sauer.
1982 Mayor Gallery, London.
1984 Galerie Maeght Lelong, New York City and Paris.
1986 "Currents," Institute of Contemporary Art, Boston. Brochure with text by Elisabeth Sussman.
1987 "The Charter Series: A Meditative Room for the Collection of Gerald S. Elliott," Art Institute of Chicago.

Traveled to San Francisco Museum of Art. Brochure with text by Neal Benezra.
1988 Dia Art Foundation, New York City. Catalogue.
1990 Pace Gallery, New York City. Catalogue.

Selected Group Exhibitions
1966 "Systemic Painting," Solomon R. Guggenheim Museum, New York City.
1969 "Live in Your Head. When Attitudes Become Form: Works—Concepts—Processes—Situations—Information. Kunsthalle, Bern. Catalogue with text by Scott Burton, Gregoire Muller, Harald Szeeman, and Tommaso Trini.
1976 "Rooms," Institute for Art and Urban Resources, P.S. 1, Long Island City, New York. Catalogue.
1977 "Documenta 6," Kassel, West Germany. Catalogue.
1978 "Venice Biennale." Catalogue.
1979 "Wall Painting," Museum of Contemporary Art, Chicago. Catalogue.
1980 "Minimal and Conceptual Art from the Panza Collection," Museum für Gegenwartskunst, Basel. Catalogue.
1981 "A New Spirit in Painting," Royal Academy of Arts, London. Catalogue.
"Westkunst—Heute," Museen der Stadt, Cologne. Catalogue.
1982 "Documenta 7," Kassel, West Germany. Catalogue.
1984 "The Meditative Surface," Renaissance Society, University of Chicago. Catalogue.
1985 "Carnegie International," Museum of Art, Carnegie Institute, Pittsburgh. Catalogue.
1986 "Art Minimal II," Musée d'Art Contemporain, Bordeaux. Catalogue.
"Individuals: A Selected History of Contemporary Art, 1945-85," Museum of Contemporary Art, Los Angeles. Catalogue.
1987 "Biennial Exhibition," Whitney Museum of American Art, New York City. Catalogue.
"L'Epoque, La Mode, La Morale, La Passion: Aspects de l'art d'aujourd 'hui 1977-87," Musée National d'Art Moderne, Centre Georges Pompidou, Paris. Catalogue.
1988 "La Couleur Seule, l'Experience du Monochrome," Musée St. Pierre, Art Contemporain, Lyons. Catalogue.

Selected Bibliography
Bois, Yve-Alain. "Ryman's Tact." *October* (Winter 1981).
"Dossier Ryman." *Macula* 3-4 (1978). Contributions by Barbara Riese, Stephen Rosenthal, Phyllis Tuchman, et al.
Grimes, Nancy. "Robert Ryman's White Magic." *ArtNews* (Summer 1986).
Hafif, Marcia. "Robert Ryman: Another View." *Art in America* (September 1979).
Ratcliff, Carter. "Mostly Monochrome." *Art in America* (April 1981).
Storr, Robert. "Robert Ryman: Making Distinctions." *Art in America* (June 1986).

David Salle

Born 1952, Norman, Oklahoma.
Lives in New York City.
California Institute of the Arts, Valencia, B.F.A., 1973; M.F.A., 1975.

Selected Individual Exhibitions
1976 Artists Space, New York City.
1977 Fondation de Appel, Amsterdam.
The Kitchen, New York City.
1978 Fondation Corps de Garde, Groningen, Netherlands.
1980 Annina Nosei Gallery, New York City.
Galerie Bischofberger, Zurich.
1981 Mary Boone Gallery, New York City.
Gagosian Gallery, Los Angeles.
1982 Mary Boone Gallery and Leo Castelli Gallery,

New York City.
Anthony d'Offay Gallery, London.
1983 Akira Ikeda Gallery, Tokyo. Catalogue.
Museum Boymans-van Beuningen, Rotterdam. Catalogue.
Galerie Ascan Crone, Hamburg. Catalogue.
Gallery Schellmann & Klüser, Munich. Catalogue.
1984 Galleria Mario Diacono, Rome.
1985 Galerie Daniel Templon, Paris.
Mary Boone Gallery. Catalogue with text by John Hawkes.
Galerie Michael Werner, Cologne. Catalogue with text by Peter Schjeldahl.
1986 Institute of Contemporary Art, Philadelphia. Traveled to Whitney Museum of American Art, New York City; Museum of Contemporary Art, Los Angeles; Art Gallery of Ontario, Toronto; and Museum of Contemporary Art, Chicago. Catalogue with text by Janet Kardon and Lisa Phillips.
1987 Fruitmarket Gallery, Edinburgh. Catalogue.
1988 Menil Collection, Houston.

Selected Group Exhibitions
1980 "Horror Pleni: Give Me Time To Look. Pictures in New York Today," Padiglione d'Arte Contemporanea, Milan. Catalogue.
"Apres le Classicisme," Musée d'Art et d'Industrie et Maison de la Culture, Saint-Étienne, France. Catalogue.
1981 "Westkunst—Heute," Museen der Stadt, Cologne. Catalogue.
"Figures: Forms and Expressions," Albright-Knox Art Gallery, CEPA Gallery, and Hallwalls, Buffalo. Catalogue.
1982 "74th American Exhibition," Art Institute of Chicago. Catalogue with text by Anne Rorimer.
"Aperto '82: Venice Biennale." Catalogue.
"Documenta 7," Kassel, West Germany. Catalogue.
"Zeitgeist," Martin-Gropius-Bau, West Berlin. Catalogue.
"Image Scavengers: Painting," Institute of Contemporary Art, Philadelphia. Catalogue with text by Janet Kardon.
1983 "Biennial Exhibition," Whitney Museum of American Art, New York City.
"New Art at the Tate Gallery," London. Catalogue with text by Michael Compton.
"São Paulo Bienal," Brazil. Catalogue.
1984 "An International Survey of Recent Painting and Sculpture," Museum of Modern Art, New York City. Catalogue with text by Kynaston McShine.
"Polke, Salle, Clemente," Seibu Contemporary Art Gallery, Tokyo. Catalogue.
1985 "Carnegie International," Museum of Art, Carnegie Institute, Pittsburgh. Catalogue.
1986 "Europa/Amerika," Museum Ludwig, Cologne. Catalogue.
1987 "L'Epoque, La Mode, La Morale, La Passion: Aspects de l'art d'aujourd 'hui 1977-87," Musée National d'Art Moderne, Centre Georges Pompidou, Paris. Catalogue.
1989 "Image World: Art and Media Culture," Whitney Museum of American Art, New York City. Catalogue with text by Lisa Phillips, Marvin Heiferman, and John G. Hanhardt.

Selected Bibliography
Liebmann, Lisa. "Harlequinade for an Empty Room: On David Salle." Artforum (February 1987): 94-99.
Marsh, Georgia. Interview. "David Salle." Bomb (Fall 1985): 20-25.
Marzorati, Gerald. "The Artful Dodger." ArtNews (Summer 1984): 47-55.
Millet, Catherine. "David Salle." Flash Art (Summer 1985): 30-34.
Ratcliff, Carter. "Expressionism Today: An Artists' Symposium." Art in America (December 1982): 58-75.
Schjeldahl, Peter. "The Real Salle." Art in America (September 1984): 180-87.
Schwartz, Sanford. "The Art World." The New Yorker (30 April 1984): 104-11.

Chéri Samba (Samba Wa Mbimba N'Zinga Nurimasi Ndombasa)

Born 1956, Kinto-M'Vuila, Zaire.
Lives in Kinshasa Ngiri-Ngiri, Zaire.

Selected Individual Exhibitions
1989 Galerie Jean-Marc Patras, Paris.
1990 Annina Nosei Gallery, New York City.
Galerie Jean-Marc Patras, Paris.
Provinciaal Museum voor Moderns Kunst, Ostend, Belgium. Catalogue with text by J. P. Jacquemin and W. van den Busshe.
1991 Museum of Contemporary Art, Chicago. Brochure with text by Bruce Guenther.
Miro Foundation, Barcelona.
Institute of Contemporary Art, London.
Portikus, Frankfurt.

Selected Group Exhibitions
1978 "Art Partout," Académie des Beaux-Arts, Kinshasa.
1982 "Sura Dji," Musée des Arts Décoratifs, Paris. Catalogue.
1984 "Zaire: Art Populaire," City 2, C.E.C., Brussels.
"Folkkonst fran Zaire," Kulturhuset, Stockholm.
1985 "Popular Painters of Zaire: The Living Art of Central Africa," University of Montreal.
1986 Musée Dynamique, Dakar, Senegal.
"Arts Africains: Peintures Populaires du Zaire," Festival d'Avignon, France.
1989 "Magiciens de la Terre," Musée National d'Art Moderne, Centre Georges Pompidou, Paris. Catalogue with text by Jean-Hubert Martin et al.
1991 "Africa Explores: 20th Century African Art," The New Museum of Contemporary Art and Center for African Art, New York City. Catalogue.

Selected Bibliography
Brenson, Michael. "Chéri Samba, Annina Nosei Gallery." The New York Times (27 April 1990).
Levin, Kim. "Morality Tales." The Village Voice (1 May 1990).
Rosen, Miriam. "Chéri Samba, Griot of Kinshasa and Paris." Artforum (March 1990).

Andres Serrano

Born 1950, New York City.
Lives in Brooklyn, New York.
Brooklyn Museum Art School, Brooklyn, New York, 1967-69.

Selected Individual Exhibitions
1985 Leonard Perlson Gallery, New York City.
"The Unknown Christ," Museum of Contemporary Hispanic Art, New York City.
1987 Galerie Hufkens-Noirehomme, Brussels.
1988 Stux Gallery, New York City.
Greenberg/Wilson Gallery, New York City.
1989 Stux Gallery, New York City.
1990 Blum Helman Gallery, Santa Monica, California.
Akira Ikeda Gallery, Tokyo.

Selected Group Exhibitions
1984 "Artists Call Against U.S. Intervention in Central America," Judson Church, New York City.
"Window Installation," Printed Matter, New York City.
1985 "Americana," Group Material installation at "Biennial Exhibition," Whitney Museum of American Art, New York City. Catalogue.
1986 "The Sacred and the Sacreligious," Photographic Resource Center, Boston.
"Liberty and Justice," Alternative Museum, New York City. Catalogue.
1987 "Fake," The New Museum of Contemporary Art, New York City. Catalogue with text by William Olander.
"The Castle," Group Material installation at "Documenta 8," Kassel, West Germany. Catalogue.

"Scared to Breath," Perspektief, Rotterdam.
"Art against AIDS," Jeffrey Neale Gallery, New York City.
1988 "AIDS and Democracy," Group Material Installation, Dia Art Foundation, New York City.
"Awards in the Visual Arts 7." Organized by Southeastern Center for Contemporary Art, Winston-Salem, North Carolina. Traveled to Los Angeles County Museum of Art; Carnegie-Mellon University Art Gallery, Pittsburgh; and Virginia Museum of Fine Arts, Richmond. Catalogue with text by Donald B. Kuspit.
1989 "Abstraction in Question," John and Mable Ringling Museum of Art, Sarasota, Florida. Catalogue with text by Bruce Ferguson, Joan Simon, and Roberta Smith.
"The Photography of Invention: American Pictures of the 1980s," National Museum of American Art, Washington, D.C. Catalogue with text by Joshua Smith and Merry A. Foresta..
"Elements: Money, Sex, Religion," Real Art Ways, Hartford.
1990 "The Decade Show: Frameworks of Identity in the 1980s," The New Museum of Contemporary Art, Museum of Contemporary Hispanic Art, and Studio Museum in Harlem, New York City. Catalogue.
"Serrano/Mapplethorpe: You Decide," Wright State University Art Galleries, Dayton, Ohio.

Selected Bibliography

Brenson, Michael. "Andres Serrano: Provocation and Spirituality." *The New York Times* (8 December 1989).
Hess, Elizabeth. "The Last Temptation of Jesse Helms." *The Village Voice* (26 December 1989).
Lippard, Lucy R. "The Spirit and the Letter." *Art in America* (April 1990).

Cindy Sherman

Born 1954, Glen Ridge, New Jersey.
Lives in New York City.
State University College at Buffalo, New York, B.A., 1976.

Selected Individual Exhibitions
1979 Hallwalls, Buffalo.
1980 Contemporary Arts Museum, Houston. Catalogue with text by Linda Cathcart.
Metro Pictures, New York City.
1981 Young/Hoffman Gallery, Chicago.
1982 Galerie Chantal Crousel, Paris.
Gagosian Gallery, Los Angeles.
Stedelijk Museum, Amsterdam. Traveled to Centre d'Art Contemporarin, Geneva, and Louisiana Museum, Humlebaek, Denmark, among others. Catalogue with text by Els Barents.
1983 "Currents 20," Saint Louis Art Museum. Brochure with text by Jack Cowart.
Musée d'Art et d'Industrie de Saint-Étienne, France. Catalogue with text by Christian Caujolle.
1984 Akron Art Museum, Ohio. Traveled to Institute of Contemporary Art, Philadelphia, and Museum of Art, Carnegie Institute, Pittsburgh, among others. Catalogue with text by I. Michael Danoff.
Seibu Museum of Art, Tokyo. Catalogue.
1985 Westfälischer Kunstverein, Münster. Catalogue with text by Marianne Stockebrand and the artist.
1987 Whitney Museum of American Art, New York City. Traveled to Institute of Contemporary Art, Boston, and Dallas Museum of Art. Catalogue with text by Lisa Phillips and Peter Schjeldahl.
1988 Galerie Monika Spruth, Cologne.
1989 Galerie der Wiener Secession, Vienna.
National Art Gallery, Wellington, New Zealand. Catalogue.

Selected Group Exhibitions

1978 Artists Space, New York City.
1980 "Ils se disent peintres/Ils se disent photographes," Musée d'Art Moderne de la Ville de Paris/ARC.
1981 "Young Americans," Allen Memorial Art Museum, Oberlin, Ohio. Catalogue with text by Douglas Crimp.
1982 "Aperto '82: Venice Biennale." Catalogue.
"Documenta 7," Kassel, West Germany. Catalogue.
"Image Scavengers: Photography," Institute of Contemporary Art, Philadelphia. Catalogue with text by Paula Marincola and Douglas Crimp.
1983 "Big Pictures by Contemporary Photographers," Museum of Modern Art, New York City.
"Biennial Exhibition," Whitney Museum of American Art, New York City. Catalogue.
"New Art at the Tate Gallery," London. Catalogue with text by Michael Compton.
1984 "Biennale of Sydney: Private Symbol—Social Metaphor," Art Gallery of New South Wales, Australia.
"Content: A Contemporary Focus, 1974-1984," Hirshhorn Museum and Sculpture Garden, Washington, D.C. Catalogue with text by Howard Fox, Miranda McClintic, and Phyllis Rosenzweig.
1985 "Carnegie International," Museum of Art, Carnegie Institute, Pittsburgh. Catalogue.
"Biennial Exhibition," Whitney Museum of American Art, New York City. Catalogue.
1986 "Jenny Holzer/Cindy Sherman: Personae," Contemporary Art Center, Cincinnati. Catalogue with text by Sarah Rogers-Lafferty.
1987 "This Is Not a Photograph: Twenty Years of Large-Scale Photography, 1966-1986," John and Mable Ringling Museum of Art, Sarasota, Florida. Catalogue with text by Joseph Jacobs and Marvin Heiferman.
1989 "The Photography of Invention: American Pictures of the 1980s," National Museum of American Art, Washington, D.C. Catalogue with text by Joshua Smith and Merry A. Foresta.
1990 "Culture and Commentary: An Eighties Perspective," Hirshhorn Museum and Sculpture Garden, Washington, D.C. Catalogue with text by Kathy Halbreich et al.

Selected Bibliography

Danto, Arthur C. *Cindy Sherman: Untitled Film Stills.* New York: Rizzoli International Publications, 1990.
Gambrell, Jamey. "Marginal Acts: Cindy Sherman's Role Playing." *Art in America* (March 1984): 114-19.
Kuspit, Donald B. "Inside Cindy Sherman." *Artscribe* (September-October 1987): 41-43.
Marzorati, Gerald. "Imitation of Life." *ArtNews* (September 1983): 79-87.

Laurie Simmons

Born 1949, Long Island, New York.
Lives in New York City.
Tyler School of Art, Temple University, Philadelphia, B.F.A., 1984.

Selected Individual Exhibitions
1979 Artists Space, New York City.
1981 Diane Brown Gallery, Washington, D.C.
1983 Metro Pictures, New York City.
CEPA Gallery, Buffalo.
1984 Galerie Tanja Grünert, Stuttgart.
International With Monument, New York City.
1985 "Actual Photos" (collaboration with Allan McCollum), Nature Morte, New York City. Traveled to David Heath Gallery, Atlanta; Rhona Hoffman Gallery, Chicago; and Texas Gallery, Houston.
Tyler School of Art, Philadelphia.
Josh Baer Gallery, New York City.
1989 Metro Pictures, New York City.
Daniel Weinberg Gallery, Los Angeles.

Galerie Jablonka, Cologne. Catalogue with text by Ronald Jones.
1990 San Jose Museum of Art, California.

Selected Group Exhibitions
1979 "Re: Figuration," Max Protetch Gallery, New York City.
1980 "Invented Images," Art Museum, University of California, Santa Barbara. Traveled to Portland Art Museum, Oregon, and Sesnon Art Gallery, University of California, Santa Cruz. Catalogue.
1981 "Body Language," Hayden Gallery, Massachusetts Institute of Technology, Cambridge. Traveled to Fort Worth Art Museum, among others.
 "Figures: Forms and Expressions," Albright-Knox Art Gallery, CEPA Gallery, and Hallwalls, Buffalo. Catalogue.
1982 "Staged Photo Events," Lijnbaancentrum, Rotterdam. Traveled to Neue Galerie—Sammlung Ludwig, Aachen, West Germany.
 "Image Scavengers: Photography," Institute of Contemporary Art, Philadelphia. Catalogue with text by Paula Marincola and Douglas Crimp.
1983 "Image Fabriquées," Musée National d'Art Moderne, Centre Georges Pompidou, Paris. Traveled to Musée des Beaux-Arts, Nantes, and Musée d'Art Actuel, Hasselt, Belgium. Catalogue.
1984 "Masking/Unmasking: Aspects of Post-Modernist Photography," Friends of Photography, Carmel, California.
1985 "Biennial Exhibition," Whitney Museum of American Art, New York City. Catalogue.
 "São Paulo Bienal," Brazil. Catalogue.
1986 "Implosion: A Postmodern Perspective," Moderna Museet, Stockholm. Catalogue with text by Lars Nittve, Germano Celant, Craig Owens, and Kate Linker.
1987 "Past/Imperfect: Eric Fischl, Vernon Fisher, Laurie Simmons," Walker Art Center, Minneapolis. Traveled to Institute of Contemporary Art, Philadelphia, among others. Catalogue with text by Marge Goldwater.
1989 "A Forest of Signs: Art in the Crisis of Representation," Museum of Contemporary Art, Los Angeles. Catalogue.
 "Image World: Art and Media Culture," Whitney Museum of American Art, New York City. Catalogue with text by Lisa Phillips, Marvin Heiferman, and John G. Hanhardt.
 "The Photography of Invention: American Pictures of the 1980s," National Museum of American Art, Washington, D.C. Catalogue with essay by Joshua Smith and Merry A. Foresta.

Selected Bibliography
Cameron, Dan. "Recent Work by Laurie Simmons." *Flash Art* (November 1989).
Grundberg, Andy. "The Mellowing of the Postmodernists." *The New York Times* (17 December 1989): 2:43.
Laurie Simmons. Tokyo: Parco Co., Ltd., 1987.
Simmons, Laurie. *Water Ballet/Family Collision.* Minneapolis: Walker Art Center, 1986.
_____. "Ventriloquism." *Artforum* (December 1987): 93-99.

Lorna Simpson

Born 1960, Brooklyn, New York.
Lives in Brooklyn, New York.
School of Visual Arts, New York City, B.F.A., 1982.
University of California, San Diego, M.F.A., 1985.

Selected Individual Exhibitions
1985 "Gestures/Reenactments," 5th Street Market Alternative Gallery, San Diego.
1986 "Screens," Just Above Midtown, New York City.
1988 Jamaica Art Center, Jamaica, New York.
1989 Josh Baer Gallery, New York City. Catalogue with text by Kellie Jones.

"Matrix 107," Wadsworth Atheneum, Hartford. Brochure with text by Andrea Miller-Keller.
1990 "Centric 38," University Art Museum, California State University, Long Beach. Traveled to University Art Museum, Berkeley, California. Catalogue with text by Yasmin Hargrove.
 "Projects 23," Museum of Modern Art, New York City. Brochure with text by Jennifer Wells.
 "Lorna Simpson: Recent Phototexts, 1989-1990," Denver Art Museum.

Selected Group Exhibitions
1982 "Working Women/Working Artists/Working Together," Bread and Roses Cultural Project, District 1199, New York City.
1984 "Contemporary Afro-American Photography," Allen Memorial Art Museum, Oberlin, Ohio. Traveled to University Center, Delta College, Detroit; Chicago Public Library and Cultural Center; Weatherspoon Art Gallery, University of North Carolina, Greensboro; Picker Art Gallery, Colgate University, Hamilton, New York; and Mary Louise Center for Black Culture, Duke University, Durham, North Carolina. Catalogue with text by William Olander.
1985 "Seeing Is Believing," Alternative Museum, New York City. Catalogue.
1986 "The Body," The New Museum of Contemporary Art, New York City. Catalogue.
1988 "Utopia Post Utopia: Configurations of Nature and Culture in Recent Painting and Sculpture," Institute of Contemporary Art, Boston. Catalogue.
 "Autobiography: In Her Own Image," Intar Gallery, New York City. Traveled. Catalogue with text by Howardena Pindell and Moira Roth.
 "The BiNational: Art of the Late Eighties," Museum of Fine Arts and Institute of Contemporary Art, Boston; Städtische Kunsthalle and Kunstsammlung Nordheim-Westfalen, Düsseldorf. Catalogue.
1989 "Constructed Images: New Photography," Studio Museum in Harlem, New York City. Traveled. Catalogue with text by Kellie Jones.
 "Image World: Art and Media Culture," Whitney Museum of American Art, New York City. Catalogue with text by Lisa Phillips, Marvin Heiferman, and John G. Hanhardt.
1990 "Aperto '90: Venice Biennale." Catalogue.
 "The Decade Show: Frameworks of Identity in the 1980s," The New Museum of Contemporary Art, Museum of Contemporary Hispanic Art, and Studio Museum in Harlem. Catalogue.

Selected Bibliography
Malen, Lenore. "The Real Politics of Lorna Simpson." *Woman Artist News*, 3 (1988): 4-8.
Heartney, Eleanor. "Lorna Simpson: Review." *Art in America* (November 1989): 185.
Joseph, Regina. "Interview with Lorna Simpson." *Balcon* (Madrid) 5-6 (1990).
Sims, Lowery Stokes. "The Mirror, The Other: The Politics of Esthetics." *Artforum* (March 1990).

Nancy Spero

Born 1926, Cleveland, Ohio.
Lives in New York City.
School of the Art Institute of Chicago, B.F.A., 1949.

Selected Individual Exhibitions
1962 Galerie Breteau, Paris.
1973 "Codex Artaud," A.I.R. Gallery, New York City.
1979 "Notes in Time on Women," A.I.R. Gallery, New York City.
1983 "Paintings from the Sixties and Recent Drawings," Willard Gallery, New York City.

"Nancy Spero 1974-1983," Rhona Hoffman Gallery, Chicago.

Gallery 345/Art for Social Change, Art Galaxy, and A.I.R. Gallery, New York City. (Simultaneous exhibitions.)

1984 "The Black Paintings," Renaissance Society, University of Chicago.

Riverside Studios, London.

"The First Language," Matrix Gallery, University Art Museum, Berkeley, California. Brochure with text by Constance Lewallen.

1985 Burnett Miller Gallery, Los Angeles.

Lawrence Oliver Gallery, Philadelphia.

1986 Josh Baer Gallery, New York City.

1987 "Nancy Spero: Works since 1950," Everson Museum of Art, Syracuse, New York. Traveled to Museum of Contemporary Art, Chicago; The Power Plant, Toronto; and The New Museum of Contemporary Art, New York City, among others. Catalogue with text by Dominique Nahas, Jo-Anna Isaak, Robert Storr, and Leon Golub.

"Nancy Spero: Retrospective," Institute of Contemporary Art, London. Traveled to Fruitmarket Gallery, Edinburgh, and Orchard Gallery, Derry. Catalogue with text by Jon Bird and Lisa Tickner.

1988 Douglas Hyde Gallery, Dublin. (With Leon Golub.)

1990 Lawrence Oliver Gallery, Philadelphia. Brochure with text by Rosetta Brooks.

Selected Group Exhibitions

1980 "Issue—Social Strategies by Women Artists," Institute of Contemporary Art, London.

1983 "The End of the World: Contemporary Visions of the Apocalypse," The New Museum of Contemporary Art, New York City. Catalogue with text by Lynn Gumpert.

"The Revolutionary Power of Women's Laughter," Protetch-McNeil Gallery, New York City.

1984 "Content: A Contemporary Focus, 1974-1984," Hirshhorn Museum and Sculpture Garden, Washington, D.C. Catalogue with text by Howard Fox, Miranda McClintic, and Phyllis Rosenzweig.

"Art and Ideology," The New Museum of Contemporary Art, New York City. Catalogue with text by Donald B. Kuspit.

"Tradition and Conflict: Images of a Turbulent Decade, 1963-1973," Studio Museum in Harlem, New York City. Catalogue with text by Mary Schmidt Campbell, Benny Andrews, Lucy R. Lippard, et al.

1986 "Biennial of Sydney," Sydney, Australia.

1988 "Committed to Print," Museum of Modern Art, New York City. Traveled to Wright State University Art Galleries, Dayton, Ohio, and Newport Harbor Art Museum, Newport Beach, California, among others. Catalogue with text by Deborah Wye.

1989 "Magiciens de la Terre," Musée National d'Art Moderne, Centre Georges Pompidou, Paris. Catalogue with text by Jean-Hubert Martin et al.

"Rebirth of Venus," in "Prospect 89," Cupola Schirn Kunsthalle, Frankfurt.

Selected Bibliography

Kuspit, Donald B. "Spero's Apocalypse." *Artforum* (April 1980): 34-35.

Lippard, Lucy R. *Get the Message? A Decade of Art for Social Change.* New York: E. P. Dutton, 1984.

Philippi, Desa. "The Conjunction of Race and Gender in Anthropology and Art History: A Critical Study of Nancy Spero's Work." *Third Text* (Autumn 1987): 34-54.

Spero, Nancy. "Sky Goddess—Egyptian Acrobat." *Artforum* (March 1988): 103-5.

Wye, Pamela. "Nancy Spero: Speaking in Tongues." *M/E/A/N/I/N/G* (November 1988): 33-41.

Art Spiegelman

Born 1948, Stockholm, Sweden.
Lives in New York City.
Harpur College, Binghamton, New York, 1965-68.

Individual Exhibitions

1986 Museum of Cartoon Art, Port Chester, New York.

1987 Smith Gallery, London.

1988 "Maus," Martyrs Memorial and Museum of the Holocaust, Los Angeles.

1991 Mercat del Born, Barcelona. Catalogue.

Selected Group Exhibitions

1969 "Phonus Bolonus," Corcoran Gallery of Art, Washington, D.C.

1971 "Seventy-five Years of the Comics," New York Cultural Center, New York City.

1982 "Graphic Rap," Institute of Contemporary Art, London. Traveled to Watershed Gallery, Bristol, and Blue Coat Gallery, Liverpool.

1983 "The Comic Art Show," Whitney Museum of American Art, New York City.

"Comic Relief," Hallwalls and CEPA. Gallery, Buffalo.

"Raw New York," Seibu Gallery, Tokyo.

1984 "Strip Language," Gimpel Fils Gallery, London.

"Telling Tales," University Art Galleries, University of Massachusetts, Amherst.

1986 "Avant-Garde Comics," Kulturhuset, Stockholm.

"Artists' Produced Periodicals," Art Institute of Chicago.

1987 "Contemporary Artists: Jewish Themes," Jewish Museum, New York City.

"Raw Images," Kansas City Art Institute, Missouri.

"The Raw Show," Lambiek Gallery, Amsterdam.

1989 "Second Generation Responses to the Holocaust," B'nai B'rith, Washington, D.C.

"Great American Comics: 100 Years of American Cartoon Art," Smithsonian Institution Traveling Exhibition Service, Washington, D.C.

Selected Publications by the Artist

Breakdowns. An Anthology of Strips by Art Spiegelman. New York: Belier Press, 1978.

Raw Magazine, co-founder and co-editor, 1980 - present.

Maus: A Survivor's Tale (Part I: My Father Bleeds History). New York: Pantheon Books, 1986.

Maus Part II: And Here My Troubles Began). New York: Pantheon Books, 1991.

"High Art Lowdown." *Artforum* (December 1990).

Jeff Wall

Born 1946, Vancouver, British Columbia.
Lives in Vancouver.
University of British Columbia, B.A., 1968; M.A., 1970.
Courtauld Institute, University of London, 1970-73.

Selected Individual Exhibitions

1978 Nova Gallery, Vancouver.

1979 Art Gallery of Greater Victoria, Victoria, Canada. Catalogue with text by the artist.

1982 David Bellman Gallery, Toronto.

1983 Renaissance Society, University of Chicago. Catalogue with text by Ian Wallace.

1984 "Jeff Wall: Transparencies," Institute of Contemporary Art, London. Traveled to Kunsthalle, Basel. Catalogue with text by Declan McGonagle, Jean-Christophe Ammann, and Ian Wallace.

1986 Galerie Johnen & Schöttle, Cologne.

Ydessa Gallery, Toronto.

1987 "Jeff Wall: Young Workers," Museum für Gegenwartskunst, Basel.

Galerie Ghislaine Hussenot, Paris.

1988 Le Nouveau Musée, Villeurbanne, France. Catalogue

with interview by Els Barents and text by Frederic Migayrou. Westfälischer Kunstverein, Münster, West Germany. Catalogue.

1989 Marian Goodman Gallery, New York City.

1990 "Jeff Wall 1990," Vancouver Art Gallery. Catalogue with text by Gary Dufour and Jerry Zaslove.

Selected Group Exhibitions

1969 "557,087," Seattle Art Museum. Catalogue with text by Lucy R. Lippard and the artist.

1970 "Information," Museum of Modern Art, New York City. Catalogue, edited by Kynaston McShine, text by the artist.

1981 "New Work: Mac Adams, Roger Cutforth, Dan Graham, John Hilliard, Jeff Wall," Hal Bromm Gallery, New York City.
"Pluralities 1980," National Gallery of Canada, Ottawa. Catalogue.
"Directions 1981," Hirshhorn Museum and Sculpture Garden, Washington, D.C. Catalogue with text by Miranda McClintic and the artist.
"Westkunst—Heute," Museen der Stadt, Cologne. Catalogue.

1982 "Documenta 7," Kassel, West Germany. Catalogue.

1984 "Difference: On Representation and Sexuality," The New Museum of Contemporary Art, New York City. Traveled to Renaissance Society, University of Chicago, and Institute of Contemporary Art, London. Catalogue with text by Kate Linker, Craig Owens, et al.

1987 "L'Epoque, La Mode, La Morale, La Passion," Musée National d'Art Moderne, Centre Georges Pompidou, Paris. Catalogue.
"Documenta 8," Kassel, West Germany. Catalogue.

1988 "Utopia Post Utopia: Configurations of Nature and Culture in Recent Sculpture and Photography," Institute of Contemporary Art, Boston. Catalogue.
"Carnegie International," Carnegie Museum of Art, Pittsburgh. Catalogue.

1989 "Magiciens de la Terre," Musée National d'Art Moderne, Centre Georges Pompidou, Paris. Catalogue with text by Jean-Hubert Martin et al.

Selected Bibliography

Barry, Judith. "Spiegelbeeld: Notities over de achtergrond van Jeff Wall's dubbel zelfportret." *Museumjournal* 6 (Amsterdam) (1984): 354-63.

Graham, Dan. "The Destroyed Room of Jeff Wall." *Real Life Magazine* (March 1980): 4-6.

Jeff Wall: Transparencies. With interview by Els Barents. Munich: Schirmer/Mosel, 1986; New York: Rizzoli, 1987.

Johnen, Jorg, and Rudiger Schöttle. *Kunstforum International* (September 1983): 101-9.

Kuspit, Donald B. "Looking Up at Jeff Wall's Modern `Appassionamento.'" *Artforum* (March 1982): 52-56.

Wood, William. "Three Theses on Jeff Wall." *C Magazine* (Fall 1984): 10-15.

David Wojnarowicz

Born 1954, Red Bank, New Jersey.
Lives in New York City.

Selected Individual Exhibitions

1983 Civilian Warfare, New York City.
Hal Bromm Gallery, New York City.

1984 Civilian Warfare, New York City.
Anna Friebe Galerie, Cologne.
Gracie Mansion Gallery, New York City.

1985 "Investigations 15," Institute of Contemporary Art, Philadelphia. Brochure with text by Carlo McCormick.

1986 Cartier Foundation, Paris.
Gracie Mansion Gallery, New York City.

1987 Ground Zero Gallery, New York City.

1989 P.P.O.W., New York City.

1990 "David Wojnarowicz: Tongues of Flame," University Galleries, Illinois State University, Normal. Traveled to Santa Monica Museum of Art, California; Exit Art, New York City; and Tyler School of Art, Philadelphia. Catalogue with text by Barry Blinderman et al.

Selected Group Exhibitions

1980 "Lower Manhattan Drawing Show," Mudd Club, New York City.

1984 "Neo York," University Art Museum, Santa Barbara, California. Catalogue with text by Phyllis Plous.
"The East Village Scene," Institute of Contemporary Art, Philadelphia. Traveled to Lowe Art Museum, University of Miami, Florida. Catalogue with text by Janet Kardon, Carlo McCormick, and Irving Sandler.
"New Narrative Paintings from the Metropolitan Museum of Art," Museo Tamayo, Mexico City. Catalogue with text by George S. Bolge and William S. Lieberman.

1985 "Biennial Exhibition," Whitney Museum of American Art, New York City. Catalogue.

1989 "Witnesses: Against Our Vanishing," Artists Space, New York City. Catalogue with text by the artist.

1990 "The Decade Show: Frameworks of Identity in the 1980s," The New Museum of Contemporary Art, Museum of Contemporary Hispanic Art, and Studio Museum in Harlem, New York City. Catalogue.

Selected Bibliography

Carr, C. "Portrait of the Artist in the Age of AIDS." *The Village Voice* (13 February 1989): 31-36.

Deitcher, David. "Ideas and Emotions." *Artforum* (May 1989): cover, 122-27.

Hess, Elizabeth. "Jesse Helms' Nightmare." *The Village Voice* (28 November 1989): 117.

_____. "Queer Is Normal." *The Village Voice* (13 February 1990): 97-99.

Rose, Matthew. "David Wojnarowicz: An Interview." *Arts Magazine* (May 1988): cover, 60-65.

Saltz, Jerry. "Not Going Gentle." *Arts Magazine* (February 1989): 14.

Wojnarowicz, David. *Sounds in the Distance*. Foreword by William S. Burroughs. London: Aloes Books, 1982.